I dedicate this book to my amazing wife Michelle Melissinos and our three wonderful children: Alexandra, Melina, and Thomas. Thank you all for your laughter, love, and light.

—Chris Melissinos

For my beautiful fiance, Michelle Collette, and the passion we share for gaming. Thank you for the amazing love and encouragement you gave to me throughout this process.

—Patrick O'Rourke

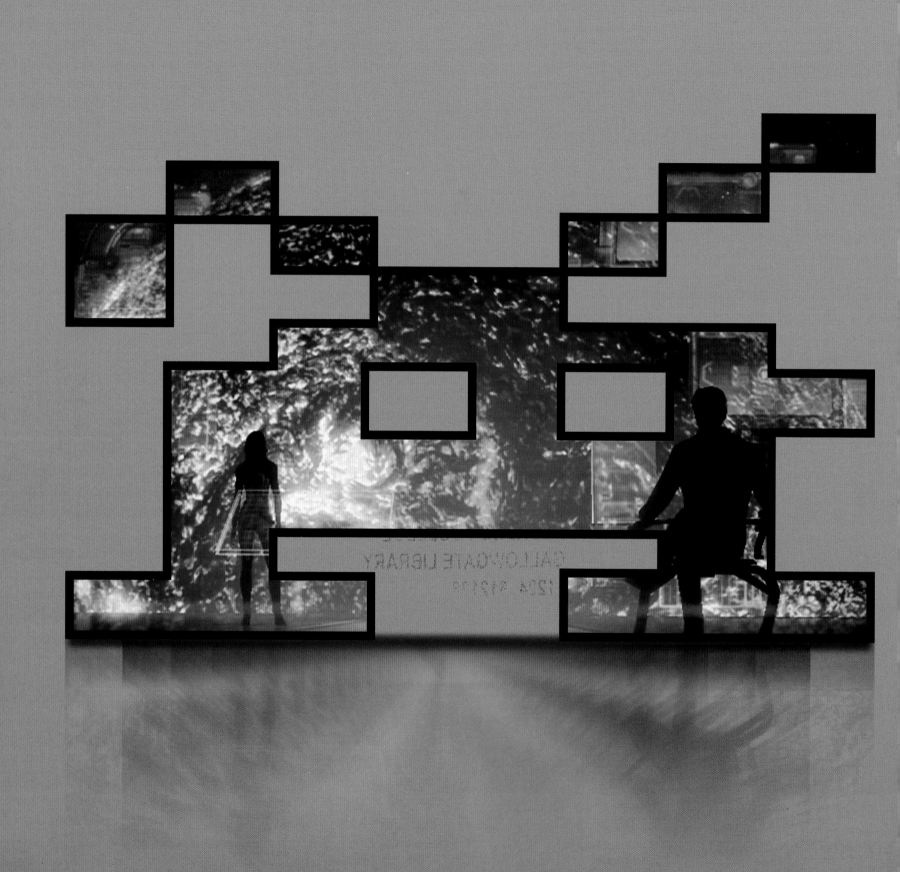

the art of video games

FROM PAC-MAN TO MASS EFFECT

Chris Melissinos & Patrick O'Rourke

welcome
BOOKS

NEW YORK

Published in cooperation with the Smithsonian American Art Museum

contents

foreword

Elizabeth Broun
The Margaret and Terry Stent Director
Smithsonian American Art Museum

Video games are a pervasive and exciting new medium that attracts exceptional and diverse artistic talent. The Smithsonian American Art Museum has always been open to exploring new and significant forms of visual culture, and I am thrilled to introduce this exhibition as one of the first in the world to look at video games as an art form.

Video games present a unique and powerful form of expression, in the same way that photography, film, and many other types of art did before them. We are at a critical moment in this emerging medium. The earliest examples of electronic games only date back to the late 1950s, and they didn't start appearing in people's homes until more than a decade later. As a result, we have a rare opportunity to talk to and showcase the creators of the first games as well as those at the cutting edge of contemporary game design.

The exhibition and accompanying book feature many games with incredible graphics, but also explore how designers combine visual artistry with narrative, audio, and player interaction to create immersive and meaningful experiences. It is continually fascinating to me to see how artists have interpreted familiar themes of ancient myth and history through this new and innovative format.

It is important to note, too, that video games are a global phenomenon. While we are an American art museum, the exhibition reflects the international community and universal themes that surround video games, transcending any one national culture.

I owe a huge debt of thanks to Chris Melissinos for helping us bridge the gap between the traditions of an art museum and the vast world of gaming. His knowledge of video games is eclipsed only by his passion for them, and working with him has been a delight. Exhibition coordinator Georgina Goodlander expertly managed myriad moving parts to keep us on track, from drafting contracts and securing licensing agreements to directing content production and spearheading online outreach. I am also grateful to exhibition designer David Gleeson and film and media arts specialist Michael Mansfield, who embraced the countless challenges presented by this complex art form to create an engaging and truly ground-breaking exhibition.

I hope this exhibition will mark the beginning of a new recognition and appreciation of video games by the art world. We could include only a fraction of the wealth of creativity and innovation offered by this field, and I look forward to seeing what comes next.

preface

the resonance of games as art

Chris Melissinos

The Christmas of 1980 would ultimately chart the trajectory for my future career. It was a year that a device of untold mystery and excitement was gifted to me: the Commodore VIC-20. This amazing little device was able to transport me to worlds beyond my dreams; worlds that I could create, control, and type into existence. What the VIC-20 gave me can be reduced to a single word: power.

Learning to program that little machine, with its severely limited canvas, opened up a fascinating world and a growing love for science, storytelling, and art. *Art*. It is a term that brings up a range of images, from the stark, marble-encrusted halls of old museums to a student studying late at night in the daunting pursuit of an art history degree. I believe that my definition of art is more service-able. When the viewer is able to understand the artist's intent in a work and finds something in it that resonates with him or her on a personal level, art is achieved. If it elicits an emotion—from disdain to delight—it can be viewed as art.

The short yet extremely prolific forty-year history of the video games industry has offered the world some of the most personal and most glob-ally connecting experiences in human history. Of course, many games never aspire to be anything

more than an adrenaline pump, where high scores rule and the loosest of stories are employed to hold the game together. But there are also a wealth of examples of games that force players into uncom-fortable moral quandaries, make statements about the act of war, and profoundly affect the player using music, environments, and whimsical details. Some games can make you cry, others can make you smile. The common thread throughout a major-ity of games, regardless of their intents, is that they are an amalgam of art disciplines whose sum is typically greater than its parts. This defines a new medium that is beyond traditional definitions used in the fine art world.

I find this fascinating and truly inspiring.

Computer games came into existence as a way for computer scientists to demonstrate the capabili-ties of archaic systems that marked the dawn of the information age. Over time these systems grew in complexity, and as they became more powerful, the potential to create deeper and richer experiences opened up to designers and artists. From "fill in the gaps" and text-based adventures that engage a player's imagination to deeply narrative games like *Heavy Rain* that pull the player in as the story unrav-els, video games have a unique ability to connect

with the player—and an unrivaled set of resources to do so. Combining fundamental elements—image, sound, story, and interaction—no other medium comes close to offering the audience so many points of connection.

It is precisely their interactivity that provides video games the potential to become a superior storytelling medium. I say *potential* because video games are still in adolescence. The advantage that books, movies, and television have over video games is with time only. Like all other forms of media, hindsight will tease inspired works from the digital past, and these will serve as the cornerstones of great works yet to be created. No doubt that some of those games are collected here.

As a denizen of the "Bit Baby" era, I realize that video games have had more of a profound impact on my development than any other form of media. Our children are being born into a world in which the digital and physical collide, and video games are the expressive voice of that collision. This trend will continue to change the way society at large views video games, which one day will be held in the same regard as painting, movies, writing, and music.

Opening in March 2012, *The Art of Video Games*

exhibition at the Smithsonian American Art Museum is yet another example of the attention this medium is starting to receive. Together with the museum and an advisory group of game developers, designers, pioneers, and journalists, we selected a group of 240 games in four different genres to represent a variety of art styles and story lines. The criteria used for selection included visual effects, creative use of new technologies, and how world events or popular culture influenced the game design. The museum created a website and invited the public to help select the games for the exhibition, and almost four million votes across 175 countries narrowed the list to the eighty games you'll read about here.

Using the cultural lens of an art museum, viewers will be left to determine whether the materials on display are indeed worthy of the title "art." A majority of visitors will most likely encounter a game that transports them back to their childhoods and tugs at their emotions, or they may learn about an artistic or design intent in a game that they never knew before. My hope is that people will leave the exhibition—and finish this book—with an understanding that video games are so much more than what they first thought.

They may even be art.

introduction

Mike Mika

I never doubted that one day video games would be recognized as art. For me, they've been art all along. In the late seventies, when I was about five years old, my Dad came home with the game *Pong*. Seeing that ball dash from side to side in its infinite simplicity and leaving behind a mesmerizingly beautiful trail of phosphor—it was the most amazing thing I'd ever seen. It was a new art form.

In the early seventies, most people still viewed computers as science fiction. Magazine articles would depict a future in which number-crunching machines the size of garages would help us with daily activities such as writing recipes. But at that point computers were complicated things that helped get us to the moon, something most of us would never get to experience firsthand. When computer games came along, however, those cold, calculating machines became a vehicle for something far more amazing than any of us could have imagined. If computers were the brains, then video games were the souls. For the first time, they could be used to create something beautiful and engaging.

One day when I was in fourth grade our teacher wheeled in an Apple II on a wooden cart. It was the first computer I had seen in real life. The teacher explained to us that it was like a calculator but, through no fault of her own, she couldn't articulate just how much a computer could do. At this point,

no one could. Instead, the Apple II spoke for itself. Once powered up, a whole world of possibility was revealed in glorious shades of green. Its small monitor became a portal to something vastly different than anything we'd experienced before. You could communicate with this machine in its own language, instructing it to draw detailed images or to animate characters. We had already come a long way since *Pong* in such a short period of time. It blew our little minds.

Within a year, I had a computer of my own. My Commodore 64 profoundly changed the trajectory of my life. I learned how to use it for writing, drawing, and composing music, and to improve the games that my friends and I made. Our games were crude at first, but they gradually began to show a complexity comparable to some of the most impressive games at the time. And while we were making them, we began to understand the real world. The computer was our Rosetta Stone, helping us decipher the fundamentals of physics and math, color and motion. We developed our own language; one that didn't fit into our school's curriculum. Every day there were new discoveries and revelations. We were modern day explorers with the power to create! We were the first computer generation.

Playing video games gave us the motivation to learn, but the euphoria of creating our own games

was overwhelming. We would enter every pixel of every frame of animation by hand, transcribed from numbers on graph paper. Later, we used more advanced software that allowed us to plot pixels with a joystick. To me, the images we painted on our television screens were beyond compare. They had meaning, and looking back at them now, I see an evolution. While our first works drew heavily from pop culture influences—comics, movies, and music—our later works became more original. They had more energy and more personality than the ones on the shelves. They were the culmination of programming techniques we'd gleaned through practice and mimicry, but the games themselves stood entirely on their own. Much of the knowledge we acquired came from taking apart another artist's work, changing it, learning from it, and then *playing* it.

Game designers are communicators, inventors, and dreamers. Like modern-day da Vincis, they stand at the creative intersection of mathematics, science, writing, music, and art. Games are the aggregate of these disciplines, plus one key element: none of it matters without the player. It's the human interface that makes it all work, that brings a game to life. Ultimately it is the element of human interaction that makes video game creation one of the most complex forms of art. Video games are like poetry under our control; they are not complete without that symbiotic connection. This is what sets games apart from other mediums. Games evolve *with* us.

There are gaps in the evolution. Unlike paintings or sculptures, digital art isn't tangible. It's stored as ones and zeroes, which were often erased to make room for another game. Much of our early work is now gone forever. I was in college when I learned the hard lesson that magnetic media has a shelf life of about five years. Likewise, a lot of the old game systems I had as a kid were showing signs of failure. The work my friends and I put into creating games over the years was now in jeopardy of disappearing forever, as was an entire generation of games by creators all over the world.

I remember a revelation I had in one of my college film classes. Our professor was talking about the hundreds of films lost at the dawn of cinema that we will never see, their impact only evidenced by written accounts of eyewitnesses. Films such as Fritz Lang's masterpiece *Metropolis*, which saw significant scenes lost to studio edits. There was a lesson to learn from cinema's early days, when movies weren't taken seriously as an art form, and even filmmakers treated their work as if it had no future value. I realized that we were still at the dawn of gaming and that the same was happening to this new medium. That's when I started to preserve games and educate others about the importance of digital preservation. It's a race against time, and the most critical aspect of it is getting others to recognize that games are worth preserving.

I am honored to be part of *The Art of Video Games* exhibition and to write the introduction to this book. I've waited a long time for this moment, and now that it's here, I don't feel the sense of closure I expected. It's more like that moment I had long ago when I first saw *Pong*. Get ready.

genres

TARGET

The target genre is one of the oldest in video games, and is a derivative of real world target shooting. From mechanical carnival games to pinball, these games are all about efficiently striking identified targets in order to amass points. The more you hit, the greater your score.

While seemingly limited by its nature, there are a wide variety of video games that fall neatly into this genre. Encompassing games based on the ability to change the laws of physics or to accurately represent them, featuring exotic locales or invaders from other worlds, or games with flying robots and impossible weapons, the target genre is nevertheless one of the most straightforward to understand, pick up, and play.

ADVENTURE

Since mankind learned to communicate, we have been passing stories and lore along from generation to generation. The adventure genre is similarly concerned with this tradition of storytelling, but through the flexibility of video games we can experience the details in ways never before possible.

From the earliest of text-based adventures to the fully-realized graphical world of a medieval kingdom, adventure games allow the player to participate in an unfolding story and encourage exploration and immersion above all else.

ACTION

An amalgam of other genres, action games have their focus on the surface. While there may be a deeper story to be told, the action genre relies primarily on testing the player's speed and skill. Typically the player is engaged in a series of activities that require a high degree of coordination and timing.

Standard in action games is a chapter-based structure, where the player only advances after clearing certain obstacles or objectives. Sub-genres in the action category include platform, maze, and fighting games.

TACTICS

Any game that deals with strategic planning or structured logic falls under the tactics genre. Tactical games feature direct action against an opponent, and often use the art of war to construct narratives that range from satirical to authentically historical.

From classic turn-based games such as chess to the advanced tactical environments of real-time strategy games, the genre engages with a wide variety of conflict as old as humanity itself.

the art of video games

There is beauty in the pixel. Beyond the game, in the crease of the scanline.
In these points of light, art is born.

— CHRIS MELISSINOS

START!

In the 1970s the world was being thrust, unknowingly, into the digital age. Miniaturization techniques allowed for increasingly smaller and more powerful radios, calculators, and televisions, making the leap to home computers inevitable, if not obvious. While the term *computer* had been primarily associated with massive machines used by corporations and the military, the public would soon become familiar with the personal application of these mysterious devices. In 1972, the introduction occurred with the launch of the Magnavox Odyssey. For the first time since the creation of the television, viewers had the ability to control what happened on their screens, and a revolution was quietly born.

By the beginning of the 1980s, the market for video games and personal computers had exploded. Companies like Atari, Mattel, Coleco, Commodore, and Apple were delivering personal computers and game consoles into American homes by the millions. This was also a period of immense imaginative growth as the first digital artists were working to bring all manner of games and experiences to these technological marvels. Kids in their family rooms, bedrooms, and dens across the country were learning to bend these machines to their will and bring stories and experiences from their books, tabletop games, and movies to the interactive frontier. It was a period of empowerment, where a child could control a digital world born of their imagination.

While this was a period of exceptional development, the limitations of the earliest systems proved to be a daunting obstacle to delivering the breadth of expression these early pioneers wanted to create. Ed Fries, a longtime game developer and former Microsoft executive, described programming for the Atari 2600 as similar to writing haiku. The limited palette meant that players were obligated to use their imaginations to fill in the blanks imposed on the artists' visual vocabulary.

Nevertheless, these experiences gripped the imagination of an entire generation and ignited a powerful new form of expression. It was the creative spark that inspired a renaissance of art and innovation.

START!

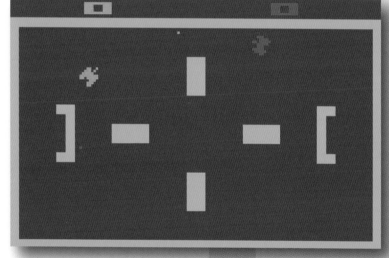

COMBAT

1977, Atari

The first game for the Atari Video Computer System, *Combat* was a successful port of the Key Games arcade game, *Tank*. With the VCS, developers were just starting to learn how to wring experiences from the new platform. As such, *Combat* was a two-player activity with no computer-controlled competitor in the game.

Designers had to distill war-based gaming down to its essentials. The players control three different kinds of military vehicles: tanks, jets, and biplanes. While the vehicles are different, the forms of gameplay are the same. Devoid of any narrative, the game ultimately pits players against each other in an unspecified place and time. This lack of detail has actually helped to make the game timeless and accessible years later.

Combat offered a variety of modes in an effort to add different dimensions to the gameplay—most of them cosmetic—but it also appropriated mechanics from another Atari hit game, *Pong*. The ability to ricochet your ballistics off of walls and partitions added a strategic element that is surprisingly strong.

To help fill out the narrative, the box art for the game depicted a battlefield alive with combat and realistic military machines.

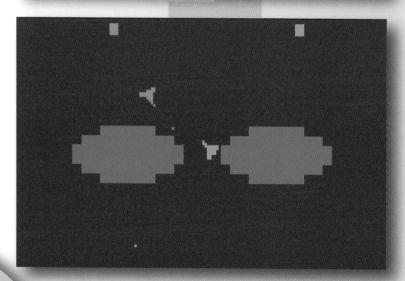

COMBAT

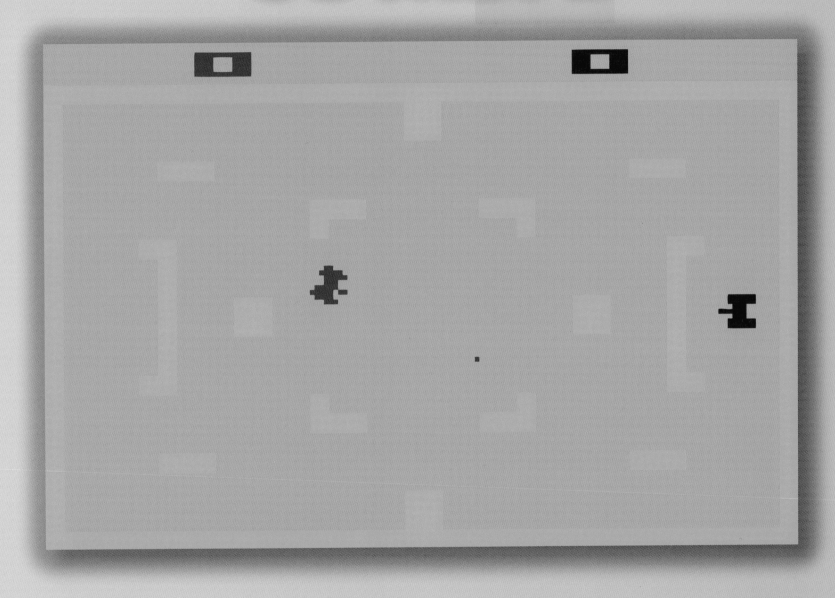

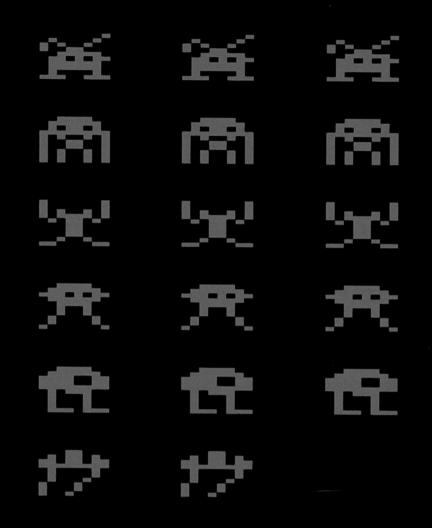

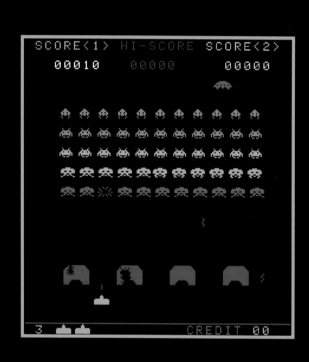

Start! | Atari VCS | Adventure **Start! | Atari VCS | Target** Start! | Atari VCS | Tacti

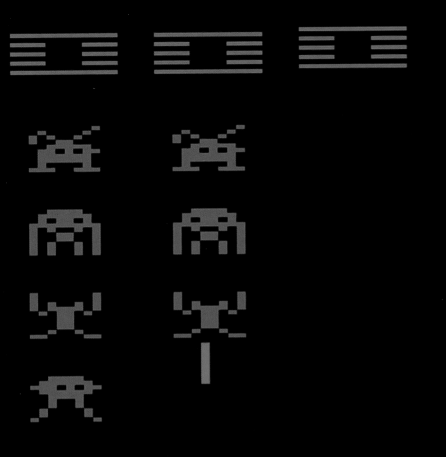

Space Invaders

1980, Taito

The arcade hit was converted for the home in 1978 and was an immediate success. The arcade game was built on more sophisticated hardware than was available in the anemic VCS, proving a challenge for the developer. However, while the game did not look like the arcade version, all of the gameplay was intact and the public received it favorably.

In *Space Invaders*, the player defends Earth from a nameless enemy hailing from the void of space. When it debuted, games where players attacked passive targets were the mainstream, and giving the enemies the ability to shoot back was one of *Space Invaders'* greatest innovations. The iconic design of the aliens was informed by H.G. Wells' *The War of the Worlds*. The book's tentacled tripods inspired *Space Invaders* creator Tomohiro Nishikado to base his aliens on sea creatures, resulting in the octopus-, squid-, and crab-shaped characters seen in the original arcade game.

Due to the limitations of the VCS, the player must fill in the gaps of the possible narrative with his or her imagination. The land you are defending is represented by an Earth-like green at the bottom of the screen, and the black expanse above is space, filled with alien enemies. Other mechanisms were employed to draw the player in to the gameplay, including the gradual increase of the invasion's pace coupled with the speeding up of the now ubiquitous *thump thump thump* soundtrack of the marching invaders.

PITFALL!

1982, Activision

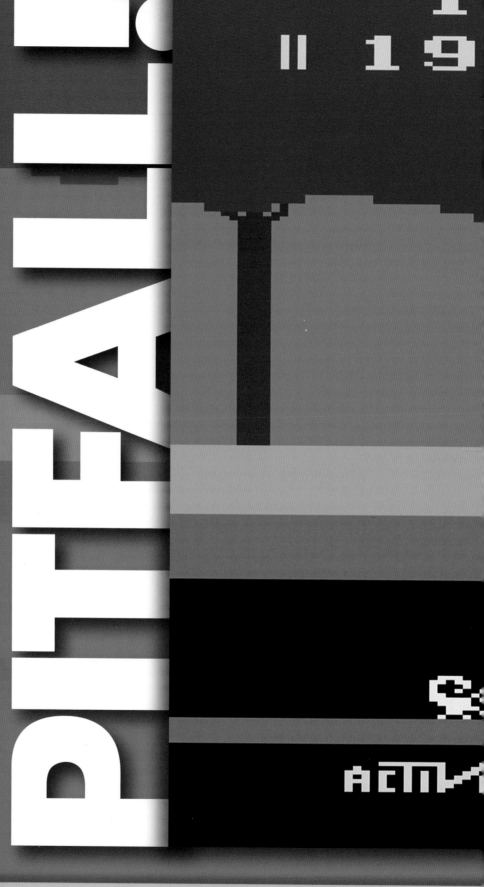

Pitfall! was the first action-adventure game to feature a realistically moving humanoid character. Developed by David Crane, the player controls the titular Pitfall Harry on a treasure hunt through a distant jungle, though the character's creation had a slightly more pedestrian start.

Crane was working on a system to animate a human character and, upon achieving this feat, realized that he had no game for him to exist in. So, he started asking questions: Why is he running? Where is he running to? What environment is he running in?

Within ten minutes of addressing these questions, Crane had developed the core narrative in which Pitfall Harry and the player would adventure. He also set the groundwork for a continuing host of games built on a similar footing. Adding alligators, swinging vines, scorpions, water, and quicksand traps helped flesh out the jungle setting and its inherent dangers.

One thousand hours of coding later, the action-adventure game was born and the echoes of its core mechanics can still be observed in modern examples of the genre.

Pac-Man

1981, Namco

In the early 1980s, a game about eating, running from candy-colored ghosts, and navigating mazes captivated the world. *Pac-Man* was a force of creativity when it hit the video game scene. It inspired a hit song, clothing, and changed what video games could be. Of the many mechanics it iterated upon, it also introduced the "cut scene," a story that played out in three acts, in between the completed levels.

Atari wanted to capitalize on the *Pac-Man* craze and assigned one of their programmers, Tod Frye, to create a version for their system. They gave him just six weeks to bring the game to the VCS in time for the holiday season.

Working with the extreme limitations of the VCS, coupled with the small game cartridge memory size and a system with one-sixteenth the memory of the arcade system, Frye had to make severe compromises with the implementation. Sharp corners instead of rounded ones, "dots" in the maze that used the same graphic for the walls, and having only one ghost appear at a time on screen were all necessary to bring *Pac-Man* to the home market.

Working under extreme pressure, on an extremely limited canvas, Frye delivered *Pac-Man* in time for the holiday season. However, the limitations of the system meant that the game was ultimately not well received and today it is held up as one of the games that contributed to the collapse of the video games industry in 1983.

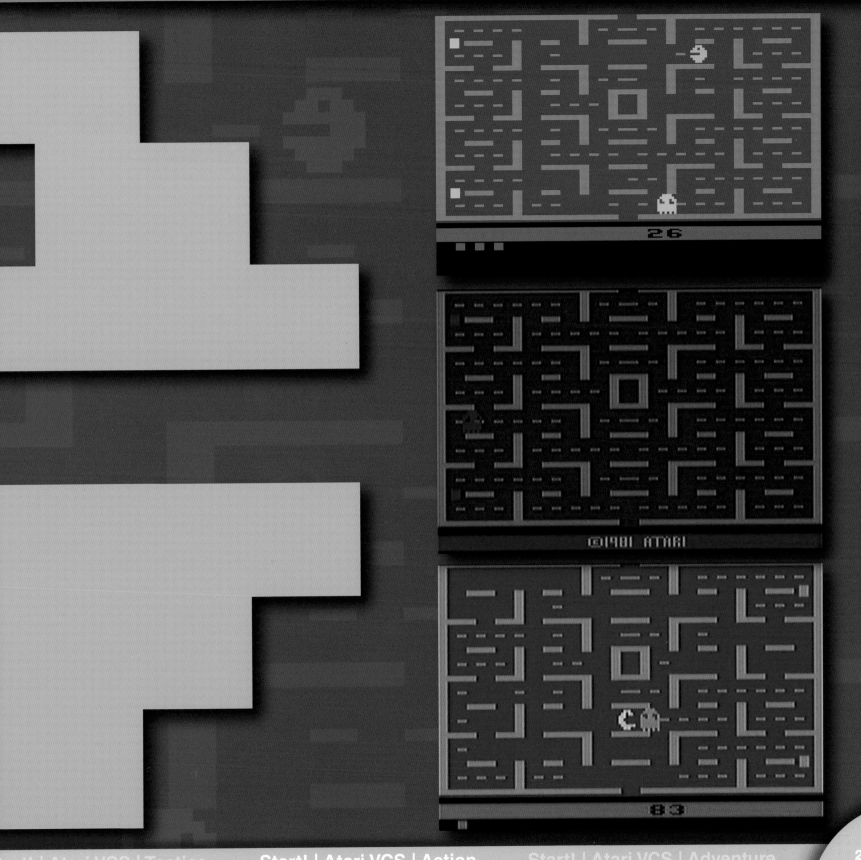

nolanbushnell

I have been involved with video games probably longer than anyone. I got involved because what I really wanted to do was emulate the things I was playing on the big computers at the University of Utah. Like so many others I started with Steve Russell's *Spacewar!*, which was just mesmerizing to me. I spent every minute that I could in the computer lab.

At that time I worked at an amusement park and knew the economics of the commercial arcade game business well. We had two arcades, and I knew the revenue of each game and what they cost to build or buy. I really knew the market side and asked myself, "Can I encapsulate this experience in a box?" I always knew that there was a home market if the cost could be brought down.

The first step into video games was with a company called Syzygy, though we thought of ourselves as an engineering company. We made a game called *Computer Space*, which was basically *Spacewar!*. It was hard to play. If you were a college student, you loved it. If you were a guy coming home from work just to play and have a beer, it was a little bit past

you. It was later on, with Atari's *Pong*, that suddenly we hit our stride commercially. We had something that could be played with one hand while holding a beer in the other. Since the game first appeared in bars, it exploded.

When we made the VCS, the Video Computer System, probably the biggest surprise was how flexible it was. The platform itself was actually quite stupid in that you had to keep track of what you were telling the television set to do with the software. You were writing code right on the metal, so to speak. That was the bad news. When you have a very fundamental system, it's like building games based on the rules of physics. It was really simple and yet extremely powerful if you were creative, interested, and very, very smart, because you had to keep track of so many things in your head. One guy told me that to write one line of code, he had to keep track of so much that if he got a telephone call in the middle of writing it would set him back half a day.

The good news was that it was very, very successful. When we released the VCS in 1977 we had a list of games we thought we could publish. It was around sixteen, and for some of the ones that followed we thought, No, they will never work on the console. Four hundred and eighty cartridges later—well, it was amazing.

We made some huge mistakes, which are funny in retrospect. We guessed that people would buy three cartridges with the first unit, so for every unit we shipped, we offered a selection on that ratio. Well, the first people to get the units bought every cartridge out there, and all of a sudden we had massive numbers of units sitting on the shelf with no cartridges available. It took us three months to refill the pipeline. I joked that the smartest thing Atari could do would be to airdrop VCSs all over major cities with little parachutes, and then the company would have positive cash flow that

night because of the number of cartridges people would buy.

The thing that is wonderful about games is that they're predictable; they respond the way you expect them to. It's like an island of sanity in a chaotic world. It's very seductive in some ways. We all like to master things, even if it is a game that you think is really silly but still love playing it. Getting better at things is part of the human condition. Games fill a very special niche of predictability, entertainment, and mastery. And at the same time you end up with a higher IQ.

The anti-aging games we are doing at Atari now are something that I feel very passionate about, particularly as I am getting older. I know for a fact that video games and game playing delays the onset of Alzheimer's. It's very good for people who are worried about dementia. It helps mental acuity. Like the body, your brain gets flabby if you don't exercise it. And I can assure you that watching television isn't doing it.

Something like doing crossword puzzles every day helps you for a little while, but in order to get the real effect you have to play different games, learn different rules. Even though the words vary in a crossword, you don't get nearly as much of an effect as playing *Asteroids* one day, *Donkey Kong* the next, and *Lunar Lander* the day after that, because they each have different metrics and require different mindsets that you have to climb into.

There are several studies that demonstrate an addition of ten IQ points for people who play games. They acquire better problem solving skills, faster critical thinking. And all of that is not limited to fourteen-year-old boys. It goes right up to one-hundred-year-old women. I know a woman who is one hundred and two and plays video games, and she is sharp as a tack.

My great hope is that video game methodology

has an ability to communicate with young minds in an amazing way. I believe that using video game technology in education has the potential of increasing kids' knowledge and learning by as much as a factor of ten. That's a huge gain. Are video games the be-all and end-all for everything? No. But for certain areas, people are learning stuff in games all the time when that's not necessarily their purpose.

There are so many creative and wonderful things going on right now in the industry that constantly surprise me and make me joyful. This business, this world, is constantly evolving and getting better, and as wonderful as some of the things in the past have been, the future just looks extraordinary. Everything from teaching languages to mathematics and physics to experiencing Mars or crazy imaginary worlds is possible. The next big wave of competition in the world is going to be about creativity. I believe the video game, more than anything else, fosters a mindset that allows creativity to grow.

Games have constantly tracked how technology has evolved, from using the knucklebones of animals and things carved of wood, to things made of stone, to counters with a rule. Then you get into cast iron and plastic games and then, God forbid, we actually put a battery and lights on things. And it keeps moving forward.

People love to play, and technology is an arbiter, an umpire, a scorekeeper, and a dungeon master all in a really great way. What better way to have fun and learn a lot at the same time? I'm not a Calvinist; I don't believe that all wonderful things have to be suffered for. Suffering is not necessarily good in and of itself. Games and computer technology can bridge the gap between doing things that are fun and doing things that are good for you.

1UP 00000

03600

Donkey Kong

1982, Nintendo

In 1981, a little-known company from Japan, Nintendo, launched a game that had a profound impact on the industry and laid the foundation for two of gaming's most enduring personalities. *Donkey Kong* was a type of game that had never before been experienced by the American public, and it helped establish several game staples, including narrative- and action-based platforming.

Designed by newcomer Shigeru Miyamoto, *Donkey Kong* was the first arcade game that had a complete narrative arc within its framework: an ape kidnaps a girl named Pauline, the protagonist works to defeat the enemy and save Pauline. This arc is punctuated by animations of the defeated ape exiting each stage with Pauline until you defeat him on the last level, where he falls to the ground. The protagonist, Jumpman—Mario's original name before becoming famous in his current guise—and Pauline are then reunited under a pink heart.

OIL

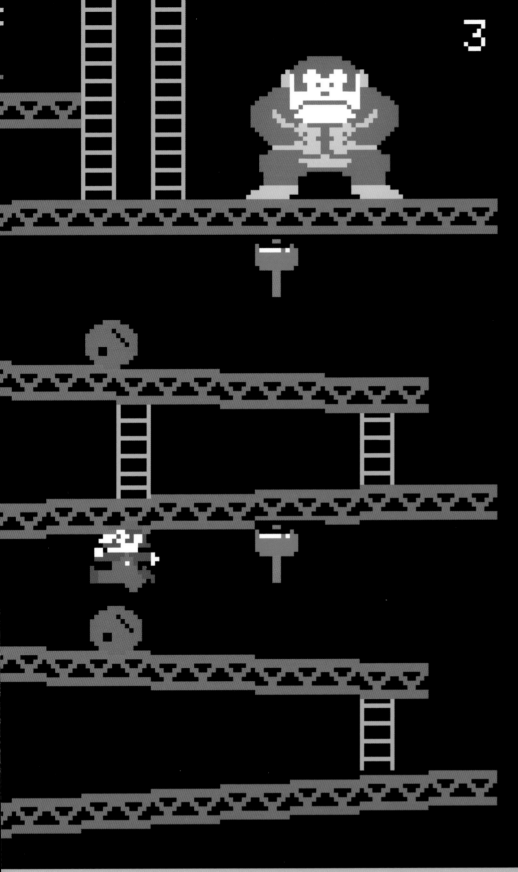

Donkey Kong is an excellent example of art made in spite of significant constraints. The limited display technology at the time forced design choices to convey characters using their essential elements. The designers could not animate hair, so Jumpman sports the now iconic red cap. There was not enough technical detail to represent a mouth, so he gained a mustache that defined his nose. Limited used of colors, sixteen in all, meant that overalls would allow the convincing contrast for an arm to be seen. All of these features are still present in this globally beloved character known as Mario, though he was a carpenter in *Donkey Kong*, not a plumber.

The game takes narrative cues from classic romance/rescue conventions and specifically from *King Kong*. The ColecoVision was propelled to the forefront of the game-playing public due to its ability to closely recreate arcade games' look and feel, an astonishing feat at the time. While there were several compromises, namely the omission of a whole level, a reverse position of the playfield, and lack of interstitial narration screens, the spirit and art of the original was kept intact and made it a must-have game.

ZAXXON

1982, SEGA

Since affordable computers were incapable of producing true 3D graphics, designers turned to different styles to mimic three dimensions. Known as isometric—or 2.5D—graphics, designers would go on to build 2D games with a skewed perspective that appeared to have three planes of movement.

Zaxxon became the first game to use this art style to great effect. A straightforward space shooter, *Zaxxon* had the player navigating through several stages while avoiding obstacles and destroying enemy fighters. Employing an altitude meter, players could determine how high or low they were flying relative to the oncoming objects.

Another faithful conversion, *Zaxxon* helped cement ColecoVision as the best console for arcade-to-home translations. In addition, *Zaxxon*'s popularity was bolstered by events happening in the world at the time. The public was under the spell of the *Star Wars* franchise and the awe of NASA's space program—the *Zaxxon* ship resembled the space shuttle—and the designers were able to tap into the national conversation about space exploration using art and design. Bringing this experience into living rooms provided a relevant, personal connection with the players.

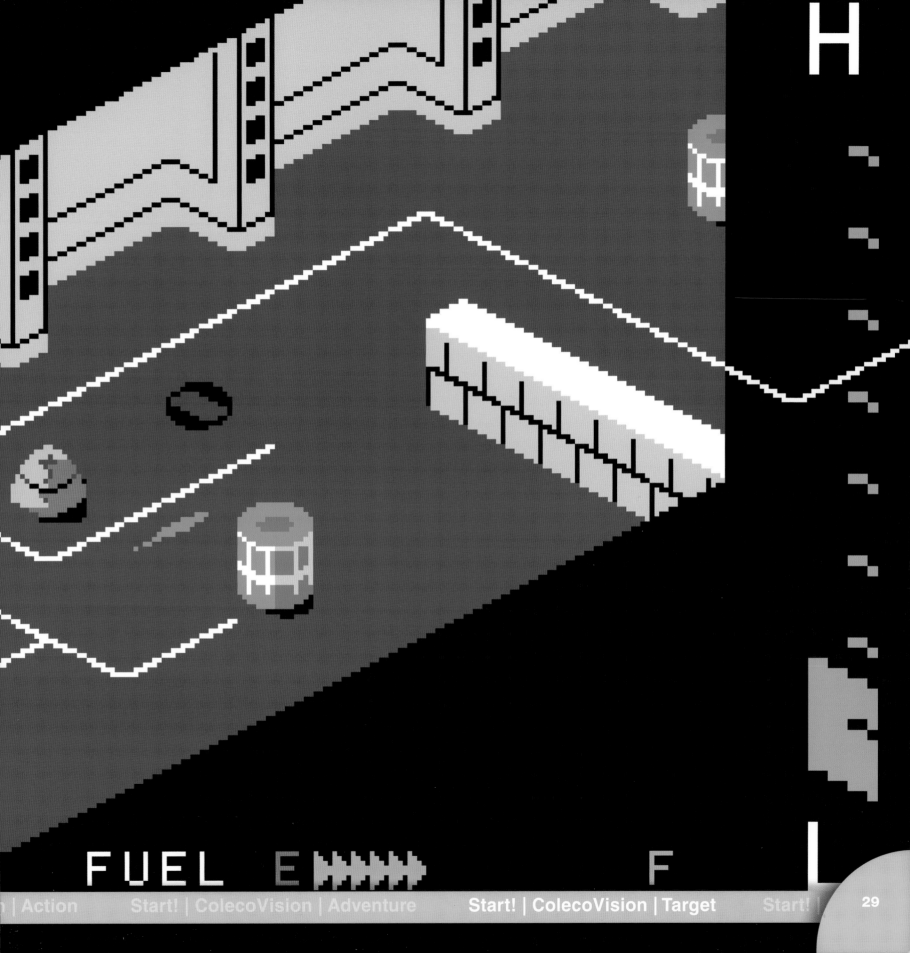

FUEL E ▶▶▶▶▶ F I

PLAYER1
000000

SHIELD

PHOTON

WARP

With the imagination of a generation growing up in the age of the first home computers and the context of both real and fictional space exploration in mainstream culture, space-themed games were an obvious outgrowth from that collective storm. While *Star Wars* held the minds of the press, venerable space series *Star Trek* was, in equal measure, part of the social dialogue.

Leveraging this appeal, and influenced by older iterations such as the PDP-10 mainframe version written by Don Daglow, *Star Trek: Strategic Operations Simulator* attempts to create a strategic battle scenario set in the world created by Gene Roddenberry. A port of the arcade game of the same name, the ColecoVision was able to closely recreate the arcade version's sophistication, including a gamefield split into three sections that allowed the player to monitor the ship's health, its strategic display, and a tactical display that provided a first-person perspective of the battle as it ensued.

While a seemingly generic space combat game, the use of ship design from the Star Trek universe, including the *Enterprise* and Klingon warships, coupled with a manual that outlined the objectives for would-be captains, helped bring the player inside the flight deck of the *Enterprise*.

As in many games of this era, the player was called upon to help fill in the details, through the use of a narrative contained in the manual, his or her personal experience with the source materials, and imagination. The players themselves created the details the designers were unable to present through these limited systems.

Storytellers and artists of this era were trying to bring experiences they dreamed of, having grown up on a diet of literature, science fiction, comics, and computers, but that desire was tempered by systems that were simply not capable of delivering the breadth of detail they reached for.

Star Trek: Strategic Operations Simulator

1984, SEGA

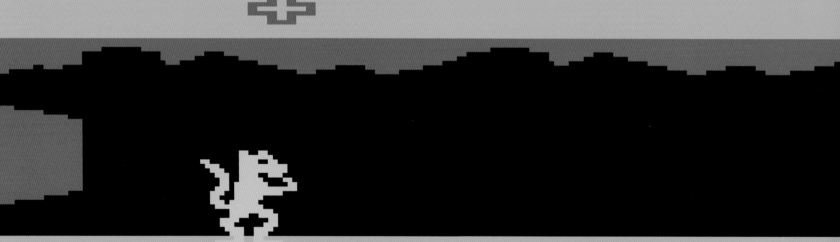

4000

ACTIVISION

Action Start! | ColecoVision | Adventure Start! | ColecoVision | Target Start!

PITFALL II:
Lost Caverns
1984, Activision

Pitfall II: Lost Caverns further evolved the platforming adventure mechanics that its predecessor popularized and took full advantage of the increased power of the console. Expanding from the horizontal playfield of *Pitfall!*, the sequel adds additional dynamics, such as vertical scrolling to create more variation in the playfields as well as new enemies, checkpoints, environments, and an in-game soundtrack, including a chorus of the song "Sobre las Olas," a first for its generation.

Additionally, *Pitfall II* introduced new characters—Harry's pet lion Quickclaw and his niece, Rhonda—which expanded the universe for Harry and the player to explore. The new characters and South America setting were further examined in materials that accompanied the Atari 2600 version of the game, which included a copy of Harry's handwritten, coffee-stained diary. Sadly, the artifact was not included in the ColecoVision edition.

Game sequels were not as prevalent then as they are today. However, *Pitfall!*'s environment, mechanics, and malleability afforded designer David Crane the ability to extend the world that Pitfall Harry inhabited successfully, and the sequel cemented one of the first icons of the action-adventure subgenre, one whose influence is still felt to this day.

steve cartwright

Unlike kids growing up today, when I was in high school and college there was no such thing as a video game. My first job out of college was designing integrated circuits. It was a fascinating job, actually, but not something that made you come home at night and say, "Gee, honey, look what I did today." Who cares? Most of the work was under a microscope.

I happened to go to school with a guy named David Crane, who worked at a little start-up called Atari, in the early days when the 2600 was just coming out. After a year or two, it was clear that most of Atari's revenue had been created or produced by four guys: Al Miller, David Crane, Bob Whitehead, and Larry Kaplan. The four of them quit and started their own company, though they weren't sure what they wanted to do. They said, "Until we figure it out, let's make some video games"—and they founded Activision. Having worked with a lot of programmers, engineers, and video game designers, those guys knew that there was something the four of them had that was unique and allowed them to make games. One day Dave told them, "I know a guy that I used to play games with in college. Let's hire him!" And that's how I got into video games.

Coming out of college, I was an engineer. The world of entertainment had never crossed my mind, but video games seemed like an interesting blend of entertainment and technology. I got into it because I had the technical skills, not the artistic skills. It just so happened that back in the early days, the graphics were crude enough that we could do our own graphics. The sounds were crude enough that we did our own sounds. So we became the designers, the directors, the musicians. We even wrote the manual and designed the box. Back in those days, it was more about the technology than it was about the game design. We had 4K of code for programming, for graphics, for sound—I think we had 128 bytes total of RAM. That was everything that went into the making of a game.

In terms of a story, a lot of people will tell you that it's key. I think what's more important is the situation you set up to allow the player to create his or her own story. One of the most popular games today is *Angry Birds*. People don't play it and say, "Wow, what a great story." I'm sure they're imagining all kinds of things as they play, but it's a situation that allows the players' imaginations to run wild. I've seen good games fall apart because too much of a bad story was injected into it. If the makers had scaled back and said, "We'll just set up a situation and let the player's imagination fill in the gaps," then everyone wins.

When I first joined Activision, Dave Crane was working on trying to depict a little running man in 8 bits. It was really tough to do, but he finally came up with something that looked decent and said, "Well, now what? Where might he be running? I'll make him run in a jungle. That's as good a place as any." What else

could he do? Maybe he can jump over logs. Then what? There might be some treasure in the jungle that he finds. And so the game—*Pitfall*—evolved out of a lot of trial and error. It was just about trying things, and we built upon the things that worked. We didn't start with a fifty-page design document. We started with, "Let me try to make a man run on the screen and see where it goes." Today, they call it Agile Development. There are high-paid consultants that try to teach companies how to develop things by trial and error, and that's just how we did things in the early days. I learned that all you need is the faintest kernel of an idea; you work on perfecting that little nugget until it feels fun, and you build upon that.

One of the biggest challenges in making these games is the attention to detail that's necessary. You can look at other forms of entertainment. One of my favorite movies is *Taxi Driver*. Through the early part of the movie, every time you see De Niro's eyes, they have a little twinkle. Toward the end of the movie, when he's gone kind of crazy, his eyes look dead and flat. I'm sure that was a conscious decision by the director—to light it in such a way to provide a detail that many don't notice but one that adds to the overall effectiveness of the scene. So when you're making games, the smallest detail has to be perfect, and you tune it for hours to make sure it feels right. I don't know if there's any magic formula, but if you look at the games that have been successful throughout history, they are all tuned in a way that feels right. It's easy to make a man jump on a screen; it's really difficult to make it feel fun.

I don't know if video games play a larger role culturally. I think they're for fun—a way to pass the time. There have been some monster-hit franchises that have been turned into movies. Some of them have been successful; others have not. At its core the video game is interactive, so its concept sometimes falls flat when you turn it into a film. This is about entertainment. Way

before video games, people played pinball and cards and poker. In fact, poker is still one of the most popular video games. You look at Facebook, and there is an explosion of Facebook games. A lot of old-school designers look at them and say, "Well, that's not really a game because there's no challenge to it." I look at it and say, "Games aren't supposed to be hard. They're supposed to be fun." My mom used to play a lot of dice games and card games, and today she would have loved Facebook games. It's a form of entertainment; a diversion. I just try to make something that's fun.

A few years ago I worked for a company that was trying to inject stealth education into games and puzzles. My primary realization there was that you're not going to educate the child if he doesn't play and know the game first. So the idea was to create something fun, get him hooked on it, and later sneak in a little education when he wasn't paying attention. And it actually worked. If you tried to hit them over the head in the beginning with a tough math problem, the kids are just going to tune out. So this whole thing about making education fun—you can actually do it through a game, but you must focus on the fun first. If they're not into playing it, they're not going to learn.

Someone might take a look at the early games and realize that a lot of technology went into the creation of those games. It was more about engineering back then than it was about game design. Nowadays, it's both: it's about engineering and game design. We were trying to build things that were fun out of very limited tools, and sometimes it's actually best to go back to those roots: I made something fun thirty years ago using almost no technology, and I should be able to do it again today with all the technology at my disposal.

Star Strike

1981, Mattel Electronics

Star Strike was another game that was heavily influenced by popular culture of the time, including the fascination of further domination in space exploration, the advance of computers into the home, and the global love affair with the *Star Wars* franchise.

Borrowing heavily from *A New Hope*, *Star Strike* is an homage to the trench run scene in which Luke Skywalker destroys the Death Star with a torpedo after maneuvering down a trench carved in the face of the space station. *Star Strike* has the player traversing a familiar trench, with the Earth slowly coming into view. The goal is to drop bombs on exhaust ports in the trench, ultimately disabling the space station and saving the earth from destruction.

6120

The power of the Intellivision console gave the designers an opportunity to convey a greater sense of speed and perspective than was possible on the Atari VCS, another console on the market at this time. The use of a pseudo-3D perspective and alternating color bars (light and dark green), conveyed the sense of speed, while a realistic depiction of Earth slowly entered firing range, heightening the tension for the player.

Without a full narrative for the game, the player was left to imagine the backstory, working from the familiar cues of both the imagery of Earth being under attack and the popularity of *Star Wars* in contemporary society.

Advanced Dungeons & Dragons

1982, Mattel Electronics

In 1982, *Advanced Dungeons & Dragons* for the Intellivision was introduced to the public as the first console adaptation of the storytelling game franchise that started captivating players just eight years earlier. For a franchise so focused on story, characters, and deep interactive mechanics, the Intellivision entry was the most basic of adventure games, marginally tied into its namesake's deep reservoir of lore and storytelling.

In spite of the shallow nature of the game, it still proved to be an engaging experience, due in part to the included player manual that helped broaden the story elements and because the player could use his imagination to construct his own representation of the game's world.

The core of the game revolves around a party of three adventurers who are seeking the pieces of the enchanted Crown of Kings that, when assembled, forces a sleeping dragon to leave its den on Cloudy Mountain. The game employed a variety of mechanics that, borrowed from the *Dungeons & Dragons* narrative, persist to this day in other games with an adventure component: caves shrouded by darkness that reveal themselves only when approached, a limited supply of arrows that the player needs to defend themselves with, environments such as forests, mountains and caves that need to be traversed in pursuit of the Crown of Kings.

Due to the limited computing power of the Intellivision, the designers used colors to denote the type of creatures one would encounter in the various caves, in lieu of more descriptive gameplay elements. Sound, however, was used to good effect. Players would receive audio cues, like the hissing of snakes, before the contents of a room were discovered, indicating what foes may be awaiting them in the darkness.

While simple by today's standards, *AD&D* was a great example of designers using the capabilities of a system, with supplemental materials, and the imagination of the player, to bring the first computerized *Dungeons & Dragons* adventure to life.

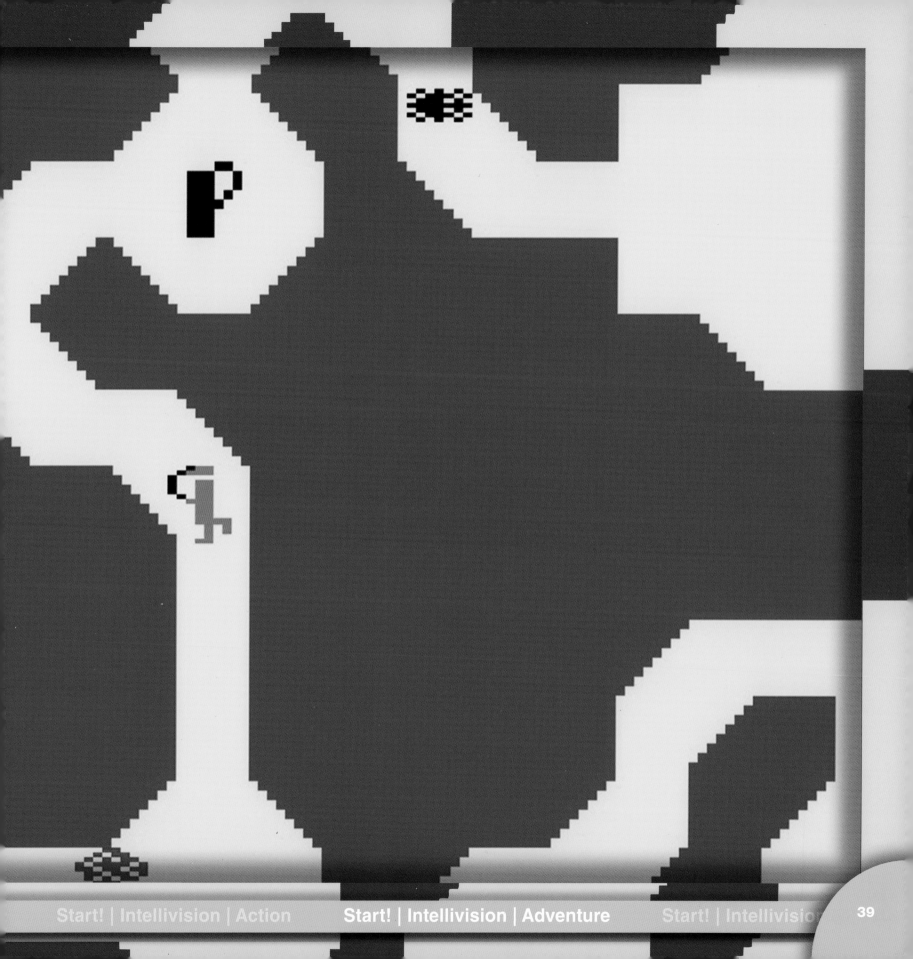

TRON: Maze-a-Tron

1982, Mattel Electronics

A movie tie-in, *TRON: Maze-A-Tron* would seek to take advantage of several innovations that were occurring in popular culture at the time. On the heels of the first major motion picture to utilize computer graphics, the introduction of home computers to the market, and the vernacular of programming metaphors becoming mainstream, *Maze-A-Tron* tapped into the world as it was moving into the digital age.

A unique adventure set in the world of *TRON*, the player controlled the actions of its protagonist, who had been zapped into the circuits of a computer operated by the Master Control Program (MCP). The playfield is in constant motion, forcing the player to navigate the environment while collecting energy and bits in order to clear the Random Access Memory (RAM) of the MCP.

The designers repurposed art assets from earlier *TRON* games, which also used animation techniques from the Intellivision sports games such as a "running man" cycle and the crude sprites of the enemy ships from the movie. The game was typical of other overly ambitious games of the era. It controlled poorly, was overly complicated, and presented only the loosest of a storyline.

However, the game is notable for examining the frustration that developers and artists had for designing games and stories for a world that was rapidly progressing, with tools that were not fully formed. Anemic systems that could not meet the ambitions of the artist with the technology at hand resulted in games like *Maze-A-Tron*, and hundreds like it.

Start! | Intellivision | Action Start! | Intellivision | Adventure Start! | Intellivision

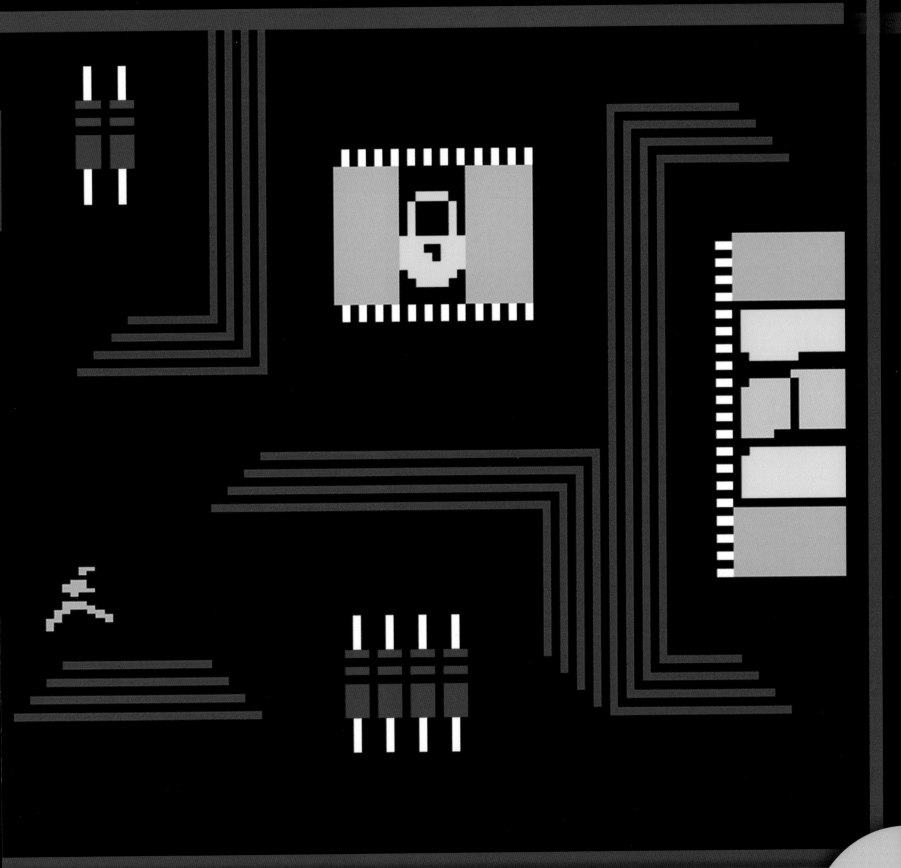

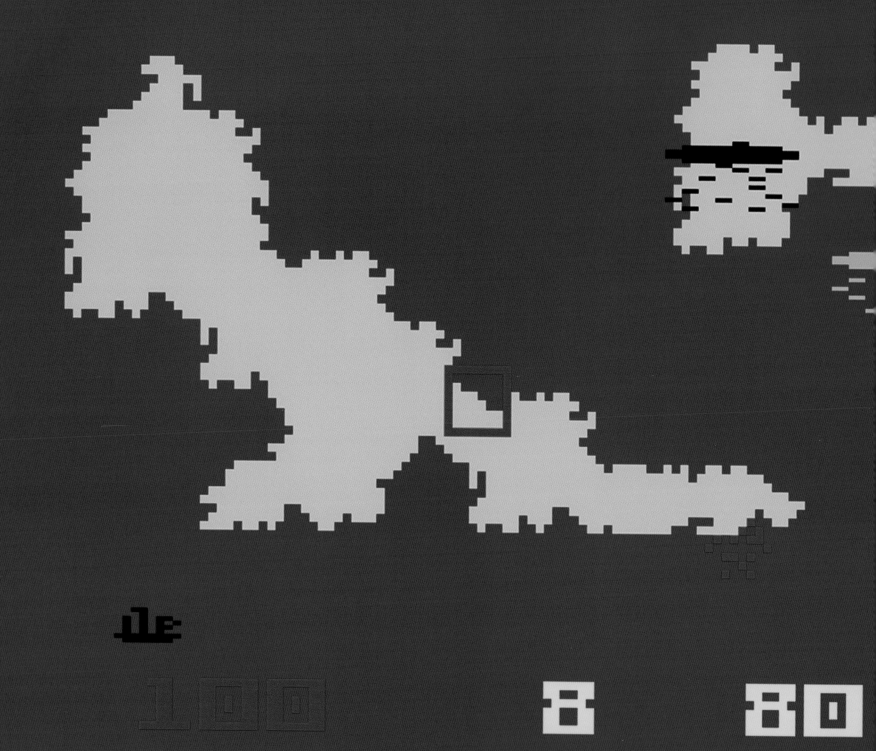

Intellivision | Target **Start! | Intellivision | Tactics** Start! | Intellivision | Action

Utopia

1981, Mattel Electronics

Created by Don Daglow, *Utopia* is considered to be the first real simulation game, or "God game," for a home console. A two-player affair, *Utopia* pits players against one another to achieve the highest score by the game's end. Each player rules his own island that he or she needs to develop with buildings, boats, and farms while also funding rebel attacks on an opponent's island. As each player's island population grows, they must be kept happy or risk a rebel attack.

Players earn income by having rain fall on growing crops or positioning ships to capture schools of fish. The game's system would generate various acts of nature that could wreak havoc on an island's resources and remove points from the players affected.

Simple graphics that were representative of natural events conveyed what could affect the island: swirling hurricanes, tropical storms, rain clouds, and pirate ships were controlled by the computer and could cause devastation and loss of points during gameplay.

Inspiration for the game came from Daglow's days as a middle school teacher, wherein he developed a geography game. He had constructed a 2,500 square-foot map of the world outlined in electrical tape in the school's cafeteria, and had his students stand on various parts of the map and represent their respective nations. *Utopia* was the evolution and refinement of that system. While rudimentary by contemporary standards, *Utopia* proved engaging enough to give life to the simulation game genre that remains prevalent in video game design today.

don daglow

I think games chose me rather than the other way around. When I was a college sophomore I was walking down the hall of my dormitory and heard this *clickity-click-click* sound. It was from a terminal that had been set up as a result of a grant from the Alfred P. Sloan Foundation, so liberal arts students would have access to a computer, which previously had been the sole domain of the math and science students. I walked in and they showed me little text games as a way of getting students interested in the computer, and my whole life changed at that moment. I was a playwriting major. To show me text that prints out on a page and varies based on how you interact with it . . . My eyes went wide and it was love at first sight. And here I am forty years later.

I don't see games as more important than any other medium. I was trained to be a playwright and then was subverted by a weird process into becoming a game designer. I see each medium as crafts. Every art has its own strengths and weaknesses, methods by which it can most directly connect to your feelings as well as your brain. Each one is different, and the minute we get into words such as better, we're losing the point.

In any new situation you bring what you know to it. Playwriting was my foothold clinging to the cliffs of this new world. In those days games were all text anyway, so it facilitated an entry point. Two artists I looked to for inspiration were Edward Albee and Shakespeare. Albee could make you feel exceptionally uncomfortable in two hours, and you would keep asking yourself questions he posed well after leaving the theater. What I liked about Shakespeare was his ability to transcend the centuries—this corresponds to transcending platforms in our business today—in that if you look at modern productions of Shakespeare, you can see the same play presented in a completely different way. Whenever or wherever you might be, those adaptations still work. That sense of timeliness, variability, and access to emotions across time periods was my entry point.

In the early days of games, we relied heavily on the users' willing suspension of disbelief. Because of the limited technology, we really did ask players to use their imagination. We would say that this block represents the city of Cincinnati, or these eight pixels are General Patton. Because using computer graphics to tell a story was so fresh, they were ready to do it. They'd say, I can see Patton marching across the battlefield even if he's just a few pixels and looks like cauliflower leaves at the bottom of a sink. As things have become more sophisticated we think technology will do everything for us. But there's a problem with that because now we actually have to tell the stories; there is no excuse to ask the audience to do the work for us. Now we resemble other media, and the audience is not used to having to do the work. They expect us to give them an experience that they relate to. So while telling a story seems much easier, in reality it's become much harder.

I think that providing narrative in a game is an obligation of last resort. It's like we're breaking the fourth wall, turning to the audience and saying "Oh, by the way, you can't simply interact with this game by itself. We have to give you some background for it, we have to set some context. Let me help you." That's the author coming through the work and speaking to the audience instead of the work speaking directly to the audience. In some games you simply have to do it because of the nature of the medium and the nature of interaction—that feeling of "What do I do?" And we always want to answer that question for the player; we don't want to leave him wondering. Narrative sometimes does help with that, but I believe it is a necessary evil we are trying to avoid rather than an opportunity to exercise our inner muse and display our great ability as storytellers.

Before the games industry began I was a middle school social studies teacher. I made a game for my kids in which we took black electrical tape and made a map of the world on the cafeteria floor. Some of them had never been out of a five-square-block area, and in trying to find a way to give them a sense of the world, I made the map. When it came time to make my game on Intellivision, we had been doing so many action and sports games. I was thinking about how to counter-program that. We had been writing simulations all the time for 1970s mainframe games. You would watch a terrible movie like *The Killer Shrews* and spend a weekend writing a game about being on an island with radioactive killer shrews. So using my roots as a teacher making up games for my students on the floor—that's *Utopia*. It was a combination of all those things and the system, because Intellivision was all about tiles. The metaphor underneath was that of a board game come to life in which the pieces moved for you, so you designed in tiles. That's where the hardware comes in.

The most challenging aspect of our work—which is also the best—is that whatever way in which you are practicing your craft now, take a few notes, because you won't be doing it the same way in a few years. You have to continually reinvent yourself, reinvent your process, reinvent who you think your audience is, and reinvent the technology, the languages, and the methodologies. Everything changes. New technology appears at your doorstep, suitcase in hand, and says, "Here's what I can do." And if the technology doesn't change, you now have to reach out to a new audience. You have to pack up your suitcase and go out and try to understand them, the way you do by moving to Paris and living on the Left Bank for two years. If you don't spend enough time to actually get it, you won't get it.

Every game is different, but one of the things I learned is that you cannot summon yourself to care. You can't go out and think, "Oh, somebody's going to pay me a whole lot of money to design this game, so suddenly I'm very passionate about simulating hot dog stands." It doesn't work that way. You can't summon that passion. Very few great games were born out of a sterile opportunity to make money.

Now the momentum is there to take games where I first wanted to go, when I thought I was going to be a playwright with my delusions of grandeur in high school and college. It's the idea that we don't just entertain, we reach out. We create an experience in which the audience might get enjoyment out of it, but maybe they're also thinking in a different way about something as a result. It's the old idea that art holds a mirror to life, and life considers what it is about as a result of seeing itself there. That's why I'm hopeful for the work we do.

8-BIT

nture | Target | Tactics Action | Adventure | Target | Tactics Action | Adventure | Target

What goes up must come down. This held true for the home video game industry as well. By 1983, the market had become oversaturated with games coming not only from the console manufacturers, but seemingly any company that wanted to get into the business. This period saw video games being released by dog food, soft drink, and toothpaste companies among others, all eager to cash in on what was believed to be a fad.

Hollywood was also drawn to the video game tie-in, and games based on movies came fast and furious. While some were respectable, many more—including the notorious *E.T.* video game— were not, and are considered a significant factor in the collapse of the home console market. And collapse it did.

During this same period, arcades flourished by providing an experience that could not be equaled at home. Personal computers were shipping record numbers, driven in large part by the sale of video games for the systems. By all outward appearances, the home console market appeared to have died out, destined to be replaced by the personal computer.

That is, until 1985, when the seventy-six-year-old Japanese corporation Nintendo Company, Ltd. released its console in the United States. The Nintendo Entertainment System was deliberately designed and marketed as an alternative to the failing consoles that retailers were avoiding, and parents all over the country brought them into their dens and living rooms. The console's success is widely recognized as bringing the market back from the brink, and it has only grown since then.

The reboot of the console industry marked a turning point of creativity for video game artists. The systems released by Nintendo, Sega, and Commodore during this era allowed for more complex games, environments of increasing size, and adventures with more depth than ever before. It is the era where video games would be recognized the world over, from the cover of *Time* magazine, to the radio hit "Pac-Man Fever," and in the form of a plumber who takes on wild adventures to rescue a princess.

More than just returning to home video game consoles, the public began to better understand how to classify computer technology. The consoles of this era were all based on 8-bit microprocessors, and the overall aesthetic—now referred to as pixel art—had a distinctly blocky, hand-drawn look.

This is the 8-bit revolution.

Jumpman

1983, Epyx

Jumpman was a deceptively simple platform game that was surprisingly deep, requiring a significant amount of strategy to complete each of the levels with the highest possible score. What helped to set *Jumpman* apart from its competition was the character's fluidity of motion and a descriptive, distinct personality for each stage.

The decision to render *Jumpman* as a stick figure seems inspired in hindsight. This design direction served several purposes, including the ability to render fluid, human-like movements. As the computer did not have to draw details on the character, all of the processing could be dedicated to the animation. Having virtually no features meant that each player projected himself on to the character, drawing the player further into the game through personal identification.

Each level of the game was imbued with humor and personality via the titles. Names such as "Easy Does It" and "Roll Me Over" conveyed what the level may have in store for the player or even a hint for how to complete it.

PROGRAM LOAD IN PROGRESS. PLEASE WAIT.

JUMPMEN
SCORE

07 LEVEL 12 RUN SPEED 04

0 PLAYER 1 BONUS 1500

Attack of the Mutant Camels

1983, Llamasoft

Created by eccentric British designer, Jeff Minter, *Attack of the Mutant Camels* mixed several different artistic perspectives in the final game. Minter's fascination and love for all things pachyderm and llama—his company was named Llamasoft—and his ability to tap into the global phenomenon of *Star Wars*, resulted in a playful take on what is now a classic scene from the space opera.

In *The Empire Strikes Back*, the rebel forces are evacuating the ice planet of Hoth while under attack from the evil Empire. The Empire's forces attack the hidden rebel base through a variety of means, including a four-legged robotic transport that resembled a mechanical camel. This connection was an obvious one for Minter.

In the game, giant mutant camels are slowly approaching the player's base and must be destroyed before they reach the outpost. Players could instantly understand the reference and the joke allowed them to connect to the material in a personal way. Humor and reflection made Minter's game an underground hit in the Commodore 64 library.

JETS 5

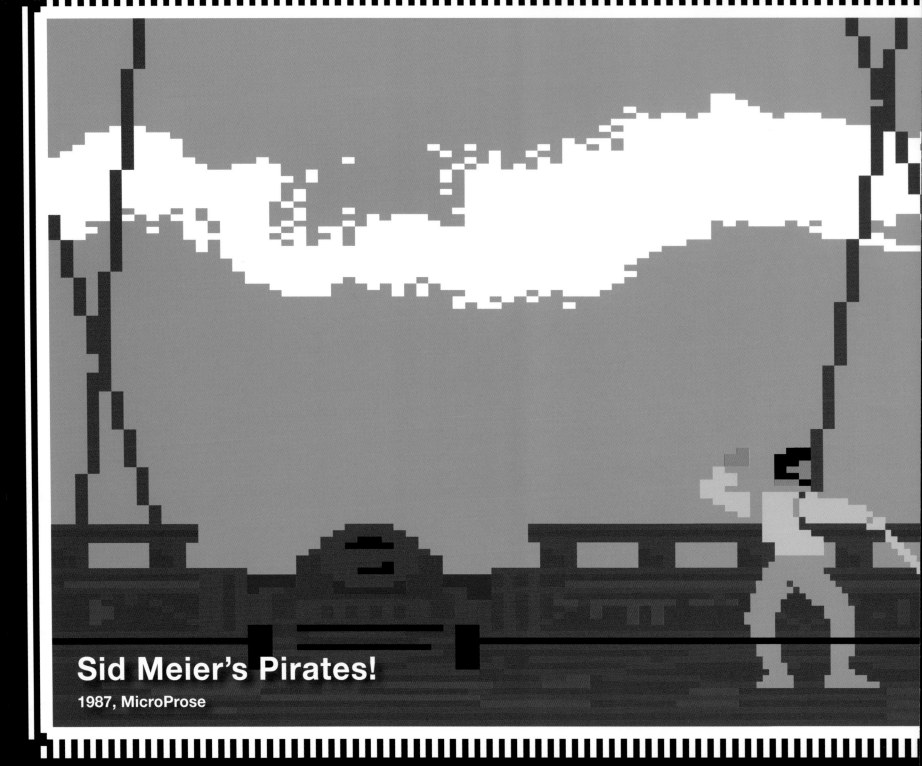

Sid Meier's Pirates!
1987, MicroProse

In *Sid Meier's Pirates!* the player takes the role of a swashbuckling privateer, seeking out fortune and reward in one of six time periods. The player selects a historically accurate era to inhabit, entering that world while developing an alternate, fictitious narrative. Detailed artwork and characters helped breathe life into the worlds crafted by Sid Meier and gave a sense of reality to a fictional storyscape. While the player sailed from location to location charted by a map at the top of the screen—complete with details of storms, sea life, and weather—it's in the on-the-ground action that the player

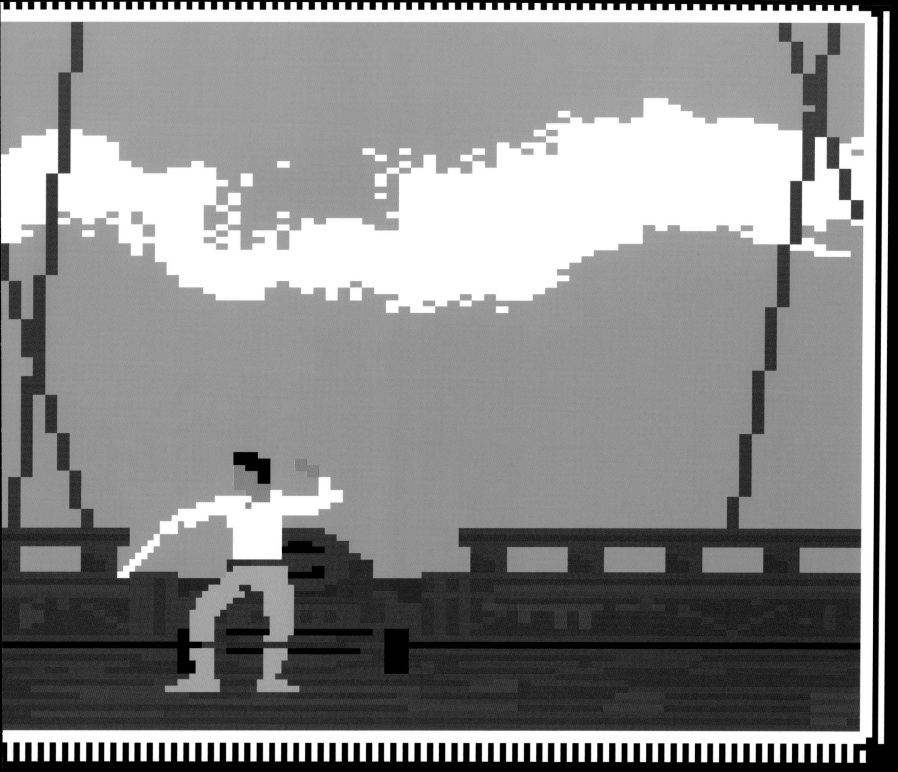

witnesses a unique method of narration. During the gameplay, each action or encounter pops up as a separate window, almost like a comic or flip-book, layering window upon window. This allowed the player to partially see several "scenes" back, giving weight to the player's choices as his past actions would remain on screen. Adding to the experience are moments of trade, swordplay, recruiting for the ship's crew, and making moral decisions throughout the game. These combine to create a unique story for each player while accurately depicting pirating in particular historical periods.

Ironpants ha
options this
round:

Attack foes
Defend
Party attack
Use an item

Select an op

Hookfangs

	Character	AC	Hits	Co
1	Ironpants	2	88	
2	Greenbolt	3	41	
3	Gwendolyn	1	44	
4	Shadow	5	27	
5	Morganna	8	32	
6	Runeflinger	9	30	
7				

The Bards Tale III: Thief of Fate

1987, Interplay

The Bard's Tale III was an adventure game that stood out among its peers for a variety of decisions by the creators. While the series was known for its clever writing and tongue-in-cheek in-jokes, it was this iteration that established many conventions that would be appropriated by other games in the genre.

Utilizing a first-person perspective, the game established a sense of presence that distanced itself from games that utilized a top-down map while remaining highly intuitive and navigable. The artwork for the towns, shops, and enemy encounters were highly detailed for the time and paid homage to other popular games in the genre.

Appropriately, music played a big part of the game experience and would break the fourth wall by incorporating songs from popular movies and other games. One such example is the incorporation of the song "The Ballad of Sir Robin," from the movie *Monty Python and the Holy Grail*, popular among game players of the time. This mashup of popular culture and familiar fantasy tropes, combined with advancements in graphic techniques and witty writing sets *The Bard's Tale III* apart from its contemporaries.

rongilbert

I got started in video games through programming. My father was a physicist and he would bring these programmable calculators home. This was in the seventies—a long time ago. He'd bring the calculators home and I was just fascinated with them. When you're fourteen years old, games are the most interesting thing you can do. So I started programming them, making games on these calculators. Later, I got a computer and a Commodore 64 and just grew from there.

I became fascinated with a very early game on the Commodore 64 called *Jumpman*. It was a little platform game; the character would jump around on different platforms. I started to hack into it and try to see how they were doing the things that they were doing. The game was kind of an inspiration because I got to peek behind the curtain. I saw that it wasn't just something I was playing on the screen—there was something going on behind it. That really triggered something for me.

The first game I made was *Maniac Mansion*. The reason that game is so special to me is that it's horribly flawed. There are a lot of problems with it—a lot of dead ends, a lot of weird puzzle solutions. There's just a lot of stuff that doesn't make sense. But the reason it's so special is because of *The Secret of Monkey Island*. That game was the culmination of everything I had learned from *Maniac Mansion*, having fixed all of the earlier game's issues from a design perspective. It was my proof that all that stuff could be fixed, and fixed well.

When I'm designing a game, my influences come from a lot of places. At the very beginning of the process I read a lot of books, go to a lot of movies, and listen to a lot of music. Anything that can flood me with interesting ideas, get my mind to jump from one place to another. A lot of my influences are definitely comedic. I watched a lot of Monty Python when I was a kid as well as *Saturday Night Live* with Dan Aykroyd, Bill Murray, and all those guys. So that really informed my nature and the things I wanted to do with humor and writing. *Monkey Island* is obviously a comedic game but its inspiration came from a variety of creative sources.

Monkey Island resulted from my desire to create a game that was based in fantasy. It was a very popular genre, much like it is today. I didn't really like it, but including pirates made a nice melding. I could understand that fantasy. I could get sword fighting. I could get all those things that people seem to like about fantasy but I could set it in a non-fantasy environment—which is where the pirates came from.

One of the things I really enjoyed at Disneyland was the Pirates of the Caribbean ride. I loved the mood it set at the beginning with the bayou section, with the lighting and the blue haze over the ocean. A lot of the visual inspiration and the feel of *Monkey Island* came from that ride. The rest was just me sitting around, writing a lot of little short stories. I wrote these one-page stories over and over again, trying to pull out what was going to be interesting about that world. To me, the main character in an adventure game is the world itself. It's not Guybrush Threepwood. Guybrush is just the lens we use to look at that whole world. You have to make sure the environment you create makes a lot of sense.

Story is incredibly important, and it's not just important in games. The story is important to us as human beings. We've been telling stories since we were sitting around fires ten thousand years ago. People love

stories. People find stories where there are no stories. If you go to a baseball game, the announcers will describe an epic dual between a pitcher and a batter. They're turning that into a story because we just crave them inside. Games have a unique ability not only to give us stories but to allow us to participate in them. We can go into those stories, start playing around and pull things out of them that are personal to us. That's why games can be an amazingly powerful medium, and I think they will be in the future. They will dwarf movies and the way people experience stories today.

In an ideal world, the designers and people making a game should have a creative vision for it, and the technology should serve that. But that's not always the case. A lot of times there will be some very interesting effects that a programmer has done or a really interesting way that the team has done the lighting. You'll see them going, "Oh, that's really neat, we could really use that here," and you draw on that. I don't think technology drives design. I don't think design drives technology. They just work very, very closely together.

One of the biggest challenges of being a game designer is that we're very young in this industry. We're not like the movie business, which has been around for a hundred years. We don't have a unified way of expressing our designs. Every designer has a different way that he does his design documents. Every company has a different way that they do these things. In contrast, the movie industry has a standard script format. I can write a script, give it to anybody in the movie business, and they can read and understand it. But if I give someone else my design documents, they will have no idea how to go through them. That's a really challenging thing, because you need to get an entire team of people to understand what you're making. You need to get external companies to understand what you're making. And until we have a unified form like the movie business has the screenplay, it will be very difficult.

My hope for games is that at some point they really get taken as a serious art form. People view film as art; there's no question about that. Games are still viewed as toys for kids. However, if you look at the people playing games, they are mostly adults. But if you ask the average person, they're going to say kids play games. So my hope is that down the road, when the kids today have grown up and they have kids, games are just as accepted as a form of entertainment as movies or television or books. It is a very powerful medium.

The most important thing to learn about games is that we have a very rich history with them. They didn't come from nowhere. A lot of the earlier games built upon basic things, and the games that followed were built from the earlier generations. It really is a form of artistic expression for us. As a game designer, I'm not just making a gameplay mechanic. I am doing something very personal to me. *Monkey Island* is a very personal game to me. To me, that is a work of art. Hopefully, people will be able to look at these games, see how they progress, and try to understand the people behind them—because we put our souls into these things.

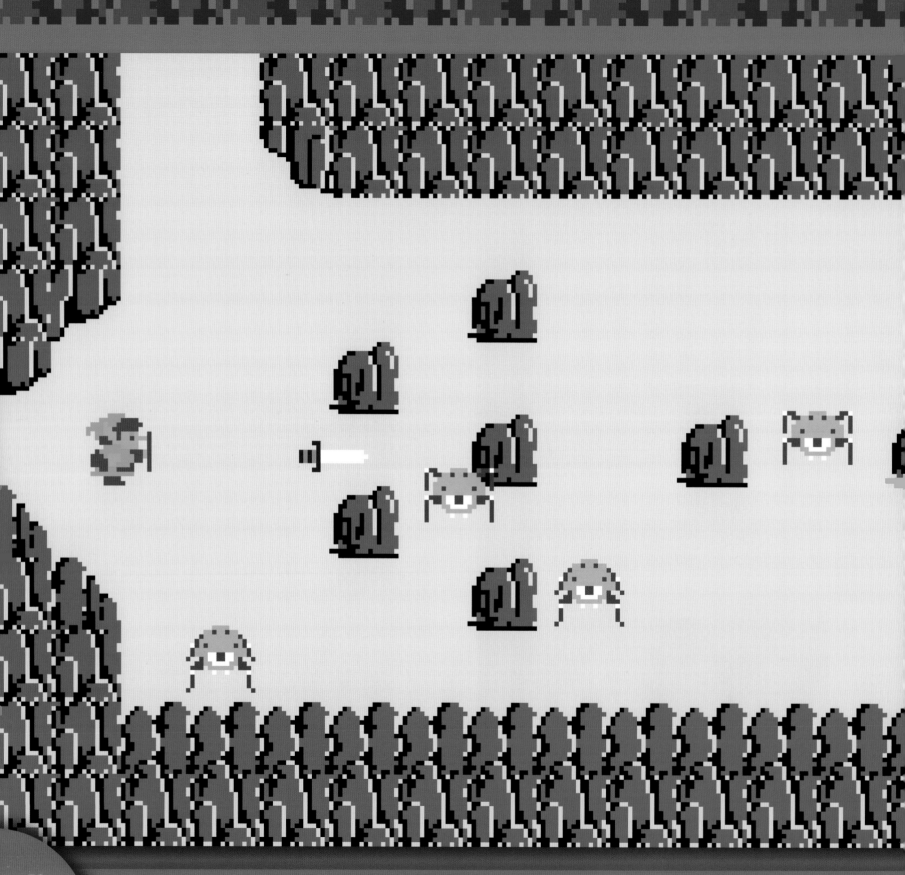

8-Bit | NES | Action **8-Bit | NES | Adventure** 8-Bit | NES | Target 8-Bit | NES | Tact

The Legend of Zelda

1987, Nintendo

Much of the inspiration for the *The Legend of Zelda* stems from designer Shigeru Miyamoto's childhood. Specifically, he would explore caves, forests, lakes, and villages near his childhood home in Sonobe, Japan. A particularly delightful surprise occurred when Miyamoto found a hidden entrance to a cave in the middle of the woods and, after building his courage, explored it with the help of a lantern.

These experiences are mirrored in the gameplay that embodies *The Legend of Zelda*, and Miyamoto's design principle of building a believable environment where things are not always what they seem. The core elements of the action-adventure genre find their foundation in this game. Similarly, the fictional land of Hyrule, its backstory, and its rich history have been further explored and refined over the course of the many games in the series that followed.

The first massive exploration adventure for the Nintendo Entertainment System, the player controls the hero Link as he sets out to save Princess Zelda—named after F. Scott Fitzgerald's wife—from the clutches of an evil wizard, Ganon, who is seeking the mystical Triforce of Wisdom. It is up to the player to save Zelda, recover the Triforce, and free the land of Hyrule from Ganon.

Miyamoto's intent was to create a world that players would inhabit as a "miniature garden that they can put inside their drawer." Designed as a coming-of-age story, with the childlike Link gradually developing strength and courage in order to ultimately overcome evil, the game borrows from Japanese folklore (as well as some nods to J.R.R. Tolkien's *The Lord of the Rings*) to resemble a fantasy that children playing the game for the first time could readily identify with.

1943: The Battle of Midway

1988, Capcom

1943: The Battle of Midway is a classic "shoot-em-up" released in 1988. A follow-up to the arcade game *1942*, it references a particular period in American history—the player pilots a P38 Lightning against Japanese forces over the Pacific—but the setting has little bearing on the gameplay beyond the World War II designs of the games' fighter planes.

1943 employed a few novel graphical tricks, including water and clouds moving at different speeds and boss enemies that fill up half of the playfield. The game boasted an exciting musical score and offered some strategic elements by allowing the player to upgrade the plane in between levels.

The graphics highlight the issue that designers in general had at the time. Building bigger and more detailed experiences in games were out of balance with the capabilities of the home systems for which they were developing. This meant having to sacrifice certain features to achieve the experience they desired. For example, during boss levels there is no texture on the water over which you fly, appearing simply as a flat, blue expanse. This was necessary to save system memory used for the much larger enemy encounters.

As was the case for many home games in this era, there was a constant balancing act between desired experience and limited system capabilities, a trade-off that would continue to play out over time.

Desert Commander

1989, Kemco

Desert Commander is one of the more complex turn-based strategy games for the Nintendo Entertainment System. Set in North Africa during World War II, the player chooses between commanding either the Allied Forces of George S. Patton and Bernard Montgomery, or the Axis Powers of Erwin Rommel. Similar to *1943*, using this point in history informed the visual aesthetic of the game and simplified the vehicle design, a necessary compromise for the underpowered NES.

The game uses a top-down view for strategically placing vehicles and assets against the opponent, much like a board game. The player manages resources, helping to simulate the decisions that go into deployment of a military force. When an encounter between opposing sides ensues, the game switches to a close-up view of the battles. While it was a rudimentary view with limited animations, it created a design aesthetic that remains to this day, even with systems that are capable of sophisticated animation and photorealism. The abstracted landscape keeps a focus on the numbers engaged in combat instead of the surrounding visuals. Animated sequences were used to depict special actions, such as refueling or the gathering of supplies.

Operating on a limited platform and dependent on utilitarian visuals, *Desert Commander* managed to build a sophisticated tactics game.

Super Mario Brothers 3

1990, Nintendo

The third installment of the Super Mario Brothers series saw the final iteration of the famous Mario on the NES, and it was a refinement of the mechanics that designer Shigeru Miyamoto had introduced with his first Super Mario Brothers game. Adhering to the original's tried and true gameplay and sense of discovery, *Super Mario Brothers 3* expanded upon these aspects and formed the basis for many of the mechanics that exist in today's action platformers.

Super Mario Brothers has always been about the joy and wonder of discovery in places where you least expect it. While the goal is to defeat the evil Bowser, it is the journey, not the destination, that counts in *SMB3*. While the core gameplay remains familiar, the inclusion of an overworld map conveys a sense of scale and allows the player to choose his or her own path.

Colorful and bright, the game allows players to escape into a world worth discovering. Large, hand-drawn sprites and massive, sprawling environments are both inviting and full of possibility. The addition of suits that Mario can don—such as one that allows him to fly and another that turns him into a rock-like statue—adds a variety of strategy and surprise. The music is inspired and has a full orchestral sound that ranges from plucky minuets to more brooding pieces which help to set the tone for the particular level a player is traversing.

Miyamoto's personal philosophy is apparent in the Mario games, which is to say that he believes that our world is full of potential and wonder; we just have to be receptive to the discoveries when we find them. Full of "what if?" scenarios, *SMB3* invites players to explore the familiar, while expecting the fantastical. Miyamoto imbues his worlds with exaggerated caricatures from his childhood which, when discovered in the game, strike a familiar chord with the player. One such example is the Chain Chomp, modeled after a chained-up dog that would bark at Miyamoto when he would walk to school as a child.

There is a reason that the Mario games have a special place in popular culture. They bring light to a world in which it is needed and allow the mind of the observer to expand. The game reflects a child's wonder, and exploring its bright world allows us, for a moment, to join in that joy of discovery.

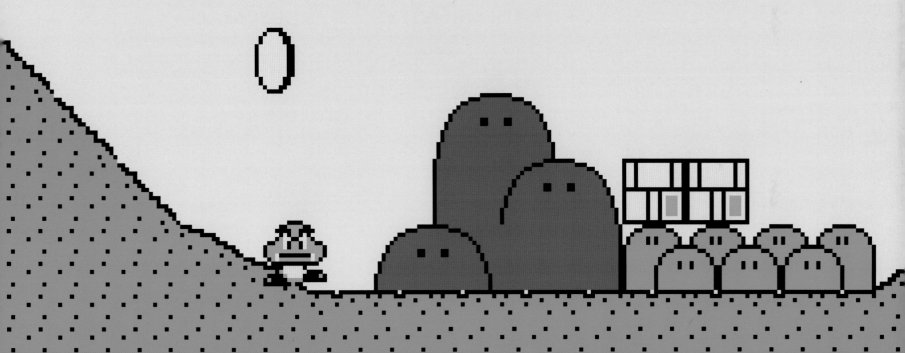

kevinbachus

My path to video games was a little different from a lot of people at the time. I started writing games in my bedroom in high school, much like many people who came into the field, but I soon got a reputation in the small city in Kansas where I grew up for being into high tech. Being a rebellious teenager, I didn't want that label. I said, forget it, I'm going in the opposite direction. So I went to film school, where I learned a tremendous amount about story and character and other things that would later serve me well in video game production.

Something about the work that I'd done with games previously drew me back into the game industry. The funny thing was that a lot of my friends in film school were like, "Oh, what a waste of an education." But now that same film school has a very prestigious video game program. It's funny how things come full circle.

The interesting thing about the game industry is that even though it's a really young industry, there already are a lot of people that I look up to. On the business side there are obvious people such as Nolan Bushnell who more or less created this industry along with a few other people that I really admire. There are great creative lights that really have set the direction. But I'm most inspired by the audience. We're constantly being driven by the demands of gamers everywhere to come up with something no one has seen before. It's exciting. What other industry has this kind of close interaction with the people that consume their products?

Most media draws from some predecessor. Stage plays, which have been around for thousands of years, came from the oral tradition of storytelling. And films clearly started off by taking the medium of the stage play and basically putting it on-screen. It was only later, when filmmakers discovered the ability to move the camera and to edit film, that it really came into its own as a medium. I think that it's possible to draw inspiration not only from film—to do things that look like a movie in a video game—but also poetry, drama, music, and art. One of the really great things about video games is that they take advantage of every piece of every other media. They take advantage of music. They take advantage of storytelling. They take advantage of interactivity and real life experiences. That's certainly where I draw inspiration from and probably most of my peers as well.

I think that the Xbox, which I co-created, caused the game industry to step back and think more about the nature of making games and the role of tools in making games. Prior to that we had heard a lot of criticism of various game consoles because they were so hard to learn how to develop. You had to specialize and spend years getting to know the hardware intimately. Because the Xbox built upon all the work that Microsoft had done previously, you as a game developer didn't have to learn anything terribly new. You could take concepts you're already familiar with and translate them directly. For the first time, creators didn't have to think about the console itself. They could think more about the gameplay, about the characters, about the story lines, about the interactivity. That's the thing I'm most proud of with the Xbox.

The single most challenging part of the work that I do is trying to balance the desire to delight the audience with the desire to actually run a business. The fact is, as much as we hate to admit it, at the end of the day bills have to be paid. People have to get salaries. And the product has to work. So as with any type of commercial media such as films or books or records, you have to walk the balance between trying to push the envelope to do something great and being able to pay for those advancements.

The other challenge that drives me is the balance between technology and art. Delivering new experiences expressed using the tools available to us is something that's a constant struggle and probably always will be. At the same time, I believe that tension makes games better. There are things that had to happen in the 8-bit era that could not have happened without those kinds of constraints. People had to be clever. So while it can be frustrating it makes you a stronger designer because you have to learn to work with the limitations.

It's really important not to lay blame on the limitations of the technology. It's always possible to invent new techniques or to come up with more clever solutions. If you look at what painters have done over the years, they've created so many different types of expression. As game designers we do the same thing. Whenever something new comes out, you have to say, "Well, what can I do with that?" You can't appreciate the technology without also thinking, "It would be really great if I could use it to evoke this emotion or to allow the user to express this thing."

I honestly believe that we're only at the beginning of the development of video games as an artistic medium. You can see an evolution in other types of media, particularly in film, which has only been around three or four times longer than video games. I think that over the next few years the people who have played games all their lives, who truly understand interactivity, will make the leap forward. It's going to take someone who didn't grow up with preconceptions about what video games are, someone who has been inspired by his experiences of the later versions within the evolution of video games.

When we were launching Xbox in Japan, I met with a very famous video game designer. He was trying to decide whether his next game would be developed for the Xbox, PlayStation 2, or the Nintendo GameCube.

He said to me, "Nintendo says that games are toys. Sony says that games are entertainment. What do you say?" Without even thinking, we said, "Well, games are art." Because we believe that you can express things and actually evoke an emotional experience in someone using the media available in video games.

Part of the reason why people get into arguments about violence in video games, for example, is that our culture has an intrinsic denial of the fact that adults might find enjoyment in playing video games—at least stable, well-meaning adults. The most interesting thing that I've found in the last several years is that everybody is a gamer whether he or she knows it or not. They may not identify as gamers. They say, "Well, I don't really play games." You don't play *BrickBreaker* on your BlackBerry? You don't play sudoku? Those are games. As we embrace games and understand what makes them so interesting, so useful, and so attractive, it will actually propel us as an industry to invest more in those kinds of experiences.

Marble Madness

1992, Atari Games

Created by seventeen-year-old programmer Mark Cerny, *Marble Madness* is an isometric game where the player must navigate a marble through a pseudo-3D, M.C. Escheresque world to a goal at the end of the playfield. The original game took advantage of a new controller mechanism, the trackball, with which the player would control the marble by maneuvering a

marble-shaped controller. The home version did not have this control system, however, and defaulted to using the directional pad instead.

Marble Madness was one of the first games to employ physics-based mechanics, properly conveying momentum, trajectory, and velocity. This made traversing the playfields treacherous but exciting. Learning the control system—i.e., understanding how to move the controller against the movement of the marble—required

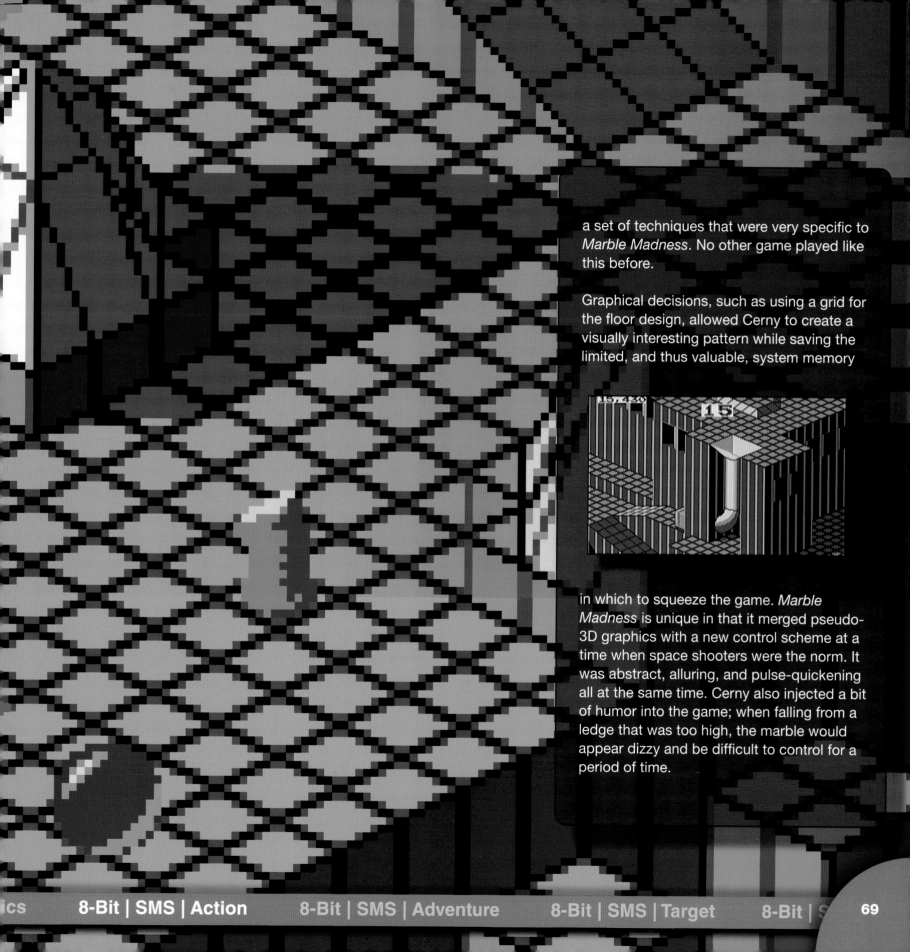

a set of techniques that were very specific to *Marble Madness*. No other game played like this before.

Graphical decisions, such as using a grid for the floor design, allowed Cerny to create a visually interesting pattern while saving the limited, and thus valuable, system memory

in which to squeeze the game. *Marble Madness* is unique in that it merged pseudo-3D graphics with a new control scheme at a time when space shooters were the norm. It was abstract, alluring, and pulse-quickening all at the same time. Cerny also injected a bit of humor into the game; when falling from a ledge that was too high, the marble would appear dizzy and be difficult to control for a period of time.

Phantasy Star

1988, SEGA

Phantasy Star is one of the most beloved role-playing games from this era. The game was sophisticated both technically and narratively, which set it apart from its contemporaries. It is a story about betrayal, vengeance, and redemption.

The plot follows the story of Alis Landale, the player-guided female protagonist—quite uncommon at the time—who intends to exact revenge on King Lassic, the ruler of the Algol solar system, for the death of her brother Nero. As she travels between the planets of Algol, she witnesses the oppression of others under Lassic's rule. Eventually, Alis' mission turns from personal revenge to the liberation of the people of Algol.

Phantasy Star was a technical tour-de-force for its time. The game featured detailed overhead maps while the player traversed through Algol, allowing a macro view of each local environment. The map included towns and caves that Alis could explore; unique for the time, when the player entered a dungeon, the perspective shifted from a top-down 2D view to a 3D, or first-person view, which gave weight and immediacy to the dungeon she explored.

Additionally, the animations of the enemies were much more sophisticated than other contemporary games. Typical of the era, battles in role-playing games would take place on a generic background, while in *Phantasy Star* the battle environments reflected where the conflict took place in the game world, further connecting the player's actions with the environments.

The mature technical presentation was matched by the complexity of the story. *Phantasy Star* dealt with questions of oppression, religion, and redemption in a way that was sophisticated yet accessible to a wide audience.

SCORPION HP 12
 HP 12

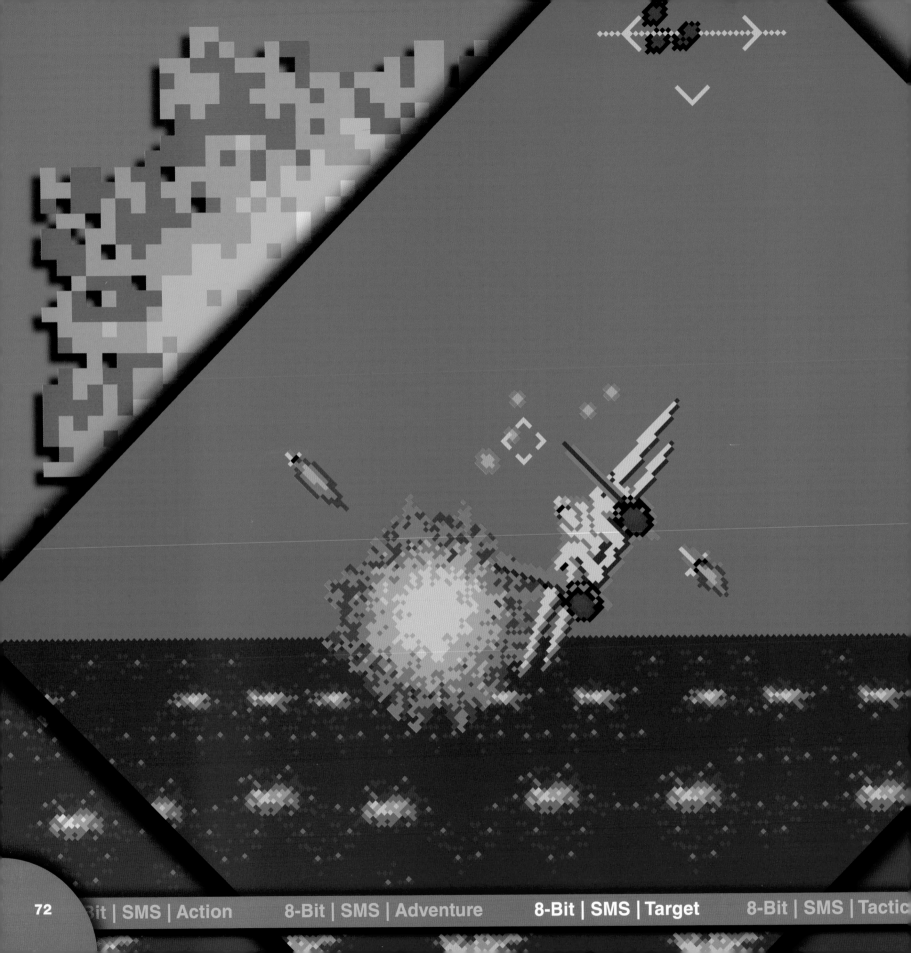

After Burner

1988, SEGA

Developed in the late 1980s, *After Burner* became popular along with the rise of movies such as *Top Gun*. It was a time of American patriotism, and *After Burner* tapped into that public sentiment. Like the pilots in the movie, the player piloted an F-14, and the name of the aircraft carrier (the *Sega Enterprise*) bore a name similar to the aircraft carrier in *Top Gun* as well.

The game makes use of a variety of techniques that allow sprites to be scaled quickly and at a variety of angles, giving the feeling of them flying about. The game stacks the sprites, scaling them together to give the illusion that the objects coming at the player are in 3D.

While simple from a graphical standpoint, and lacking any narrative or dialogue, the game was widely popular, to the point that the *After Burner* franchise became an identifier of the period. Its presence was a touchstone in other popular media, with the game making appearances in films like *Terminator 2: Judgment Day* and the television series *Red Dwarf*.

WHITE

BLACK

SPY vs. SPY

1988, First Star

Spy vs. Spy was a tactical game that followed the antics of *MAD Magazine*'s Black and White Spies. Set within an embassy, the object of the game is to set traps in the various rooms for your counterpart, who is damaged upon setting them off. When time expires, the player with the most damage loses.

The characters, created in 1961 by Cuban artist and political satirist Antonio Prohias, came about in the wake of Fidel Castro's revolution. For Prohias, it became clear that if you disagreed with the party line you were considered a spy. Prohias did not support the newly installed leader, and fled to the US just days before Castro took control of the country's newspapers. Today, *Spy vs. Spy* stands as a cutting send-up of the persistent hostilities that characterized the Cold War and its accompanying international intrigue.

The game managed to successfully capture the irreverence, slapstick, and artistic style of the source material; the characters moved like a comic strip come to life. *Spy vs. Spy* breathed life into the static world the Spies inhabited for readers of *MAD*, as well as exposing Prohias' creation to a whole new audience unfamiliar with the source material.

BIT WARS!

nture | Target | Tactics Action | Adventure | Target | Tactics Action | Adventure | Targe

The age of the personal computer was in full swing by the early 1990s. As more people in the United States brought personal computers into their homes, they became more familiar with industry terms, and measurements such as processing speed became differentiators between competing platforms. The technological education of the public similarly impacted video games, and companies soon began touting not only the gameplay they offered, but the power and size of their consoles versus those of their competitors.

Along with descriptions of their games, developers would often talk about how many colors were on display, at what resolution their games ran, how many "voices" their musical scores were comprised of, and how much Random Access Memory (RAM) their games took up. This was the era of bigger equals better, and video game companies came up with all sorts of creative ways to explain just how powerful their games and systems were. From Sega's marketing campaign trumpeting the "Blast Processing" of its Genesis console (without explaining what it meant), to the sprite manipulation technique of the Super Nintendo's "Mode 7," companies were adjusting to an audience that was more computer savvy and acclimating them to the technological progression that pushed video games forward.

While this era placed a heavy focus on technology, it was not done in lieu of inspired game creation. While technological leapfrogging was more apparent than ever before, it also opened up exciting new possibilities for developers. Higher resolution images meant there were more detailed environments to engage with; more colors on-screen meant more complex artwork and better detailed characters; and more memory meant the inclusion of additional dialogue, more musical scores, and even realistic voices.

This was the golden age of 2D gaming, where hand-drawn characters and environments ruled the day. Role-playing games flourished and became more mainstream, side-scrolling action games hit their peak, arcade conversions more closely resembled their arcade counterparts, and we started dipping our collective toes in the water of online gaming with consoles.

This was the new battleground. These were the Bit Wars!

Dune II:
The Battle for Arrakis

1993, Westwood Studios

Most modern
real-time strategy
games owe their most
enduring mechanics to
Dune II: The Battle for Arrakis.
Released in 1992 by Westwood
Studios on the PC, and in 1993 on
the Genesis, *Dune II* would establish
the RTS nomenclature that others would
follow. Design elements such as a "fog of
war" that would obscure portions of the map
until explored by the player, tile-based placement
of buildings and structures, and the progressive wear
on facilities over time would become standard fare for
future games in the genre to appropriate.

Working off the highly popular Dune lore, including the book
series by Frank Herbert and subsequent 1984 film adaptation,
the designers did not expend much time or energy having to explain
the backstory about the continual war for the spice known as mélange.
To begin, the player chooses one of three warring houses to command, and
the conflict that surrounds harvesting this valuable commodity unfolds.

The top-down style of gameplay that would become standard for RTS games
affords some advantages to the artist. The bird's-eye view reduces the need for
detailed graphic elements; one can discern that a small, pixelated blob in motion is a
human while a more complex tile depicts a building. Similarly, animation does not need to
be as detailed as the nuance is lost from such a high vantage point. This gave the designers
more freedom to focus on better Artificial Intelligence algorithms and wider variety of
gameplay elements.

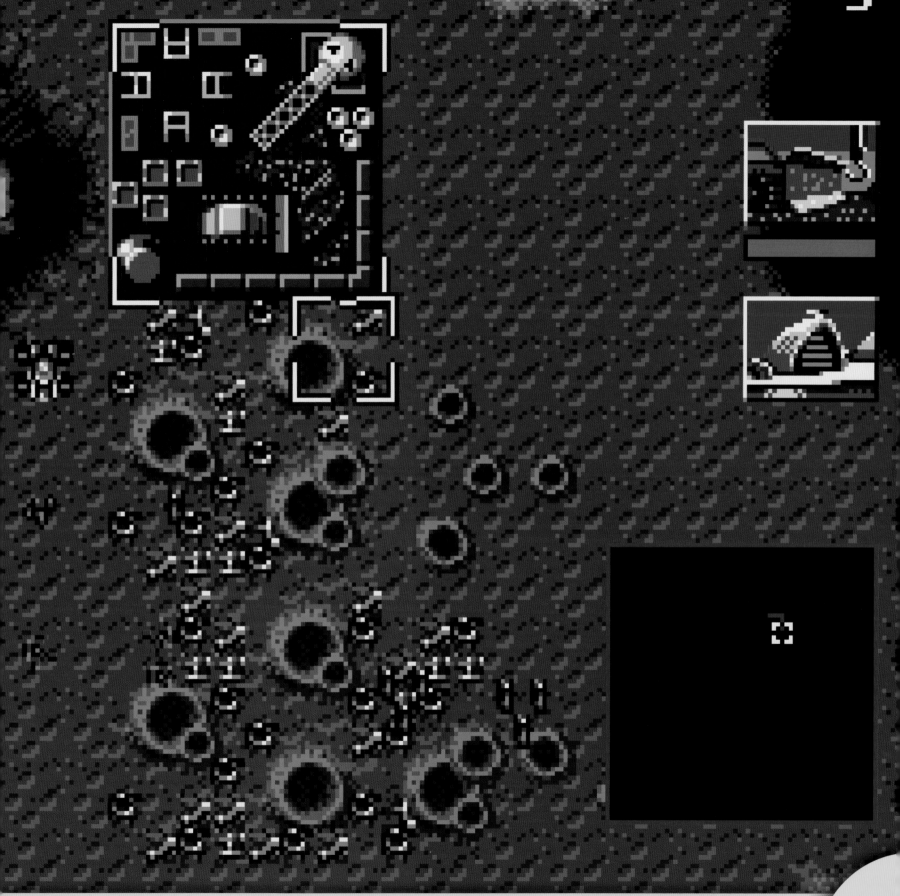

Phantasy Star IV

1994, SEGA

Originating on the Sega Master System, *Phantasy Star IV* expands on the foundation built by the first three games in the series. Advances in both console technology and in programming and artistic techniques helped draw the player deeper into the worlds that make up the Algol solar system, and the history therein.

As with the preceding games, the designers set forth to build a grand, sweeping adventure, replete with artwork that matched the depth of the narrative. Once again, battles with alien creatures took place in a variety of settings, from deserts to dungeons, and the environments reflected the geography of the conflict.

The animation of the characters and monsters were highly detailed for the Genesis and were more convincingly animated. During battle scenarios, characters from the player's party could be seen advancing toward the enemy to perform their attack, a rare occurrence in role-playing games of the time. Their progress added a sense of spatial awareness and scale to the battles.

A more advanced system, with greater power and storage capabilities, the Genesis provided the platform for an improved experience. With comic book-style storyboards, sophisticated character design, detailed buildings and environments, and a massive script that unfolded over the course of the game, *Phantasy Star IV* drew players into a much larger, living, breathing world than any of the series games before it.

Finally, the musical score was one of the most advanced on the Genesis at the time. Sound effects mimicked the environments for which they were scored, the music changed along with the player's action, whether speeding up for battle or using somber cues during dramatic scenes. The grand scope of *Phantasy Star IV*'s sound design is reflective of the game at large, and helps it stand among the best in the role-playing genre.

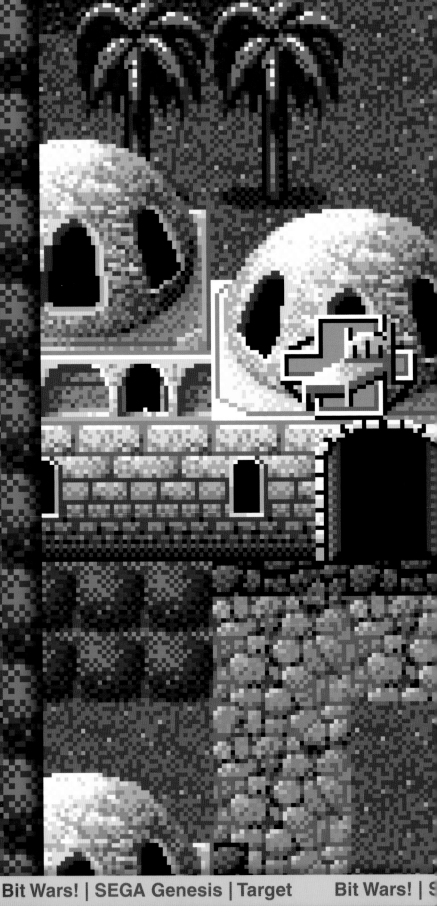

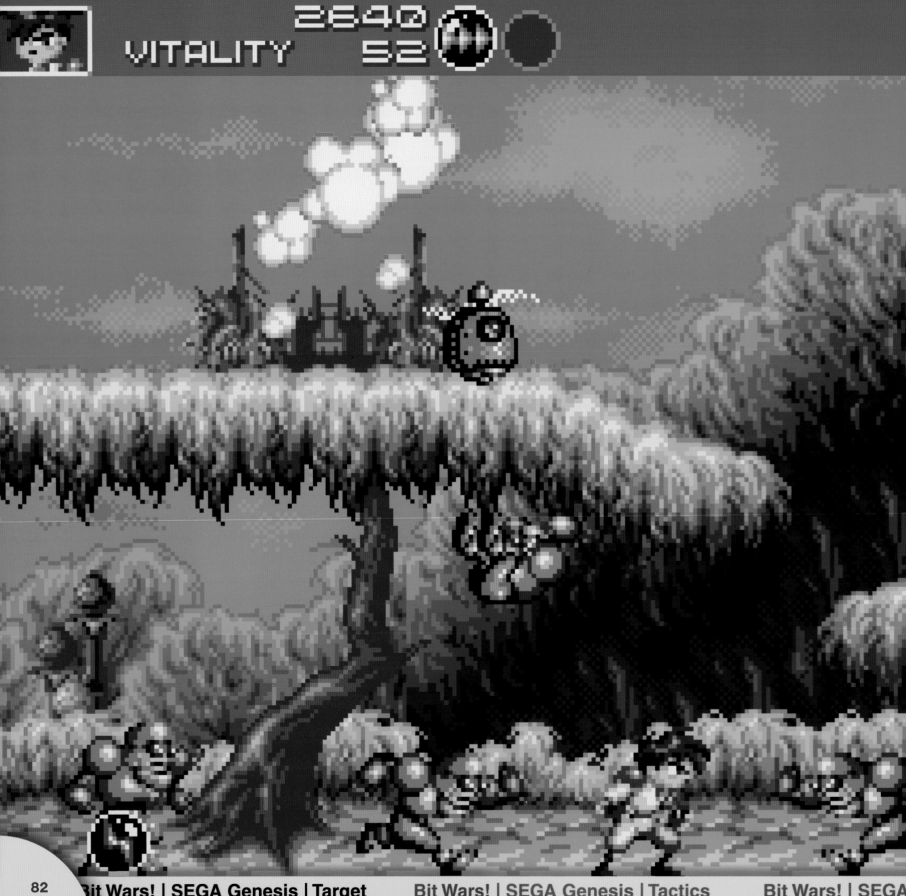

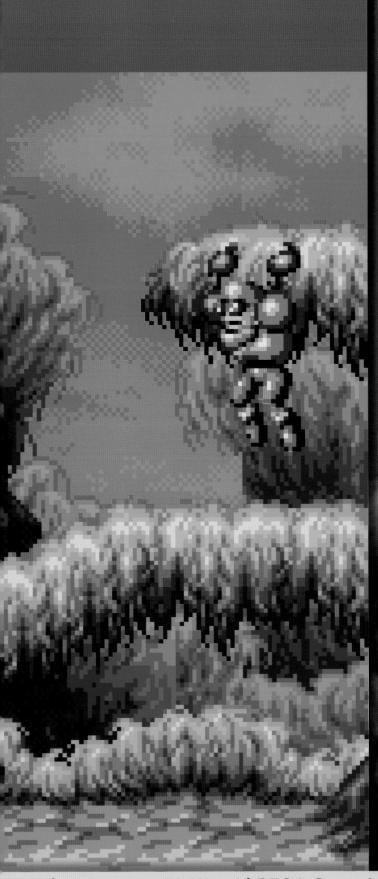

Gunstar Heroes

1993, Treasure

The debut title from game developer Treasure presented Sega Genesis players a game with a familiar backstory: a world on the edge of destruction, and the heroes needed to return balance. However, what *Gunstar Heroes* delivered was an expansive, frenetic game that successfully meshed a variety of target-based and side-scrolling games into a cohesive experience. In addition, the artwork and animation masterfully blended Eastern and Western styles, and the act-based structure resulted in a game that had players feeling as if they were interacting with a Saturday morning cartoon and not just a video game.

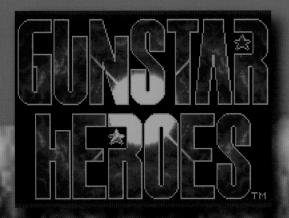

Building on the mechanics of traditional side-scrolling and action-adventure based gaming, *Gunstar Heroes* takes design cues from multiple genres. A core mechanic, however, is borrowed from traditional target-based games. An example can be seen in the telegraphing of projectiles that serve as a guideline for aiming. Another instance is found in enemy behavior, appearing in waves with predictable patterns, regardless of the type of gameplay currently being employed onscreen.

Leveraging a variety of storytelling mechanics—from breaking the fourth wall to plays-within–plays—*Gunstar Heroes* demonstrated that multiple art styles, genres, and modes of storytelling could be coherently delivered in a compelling and enduring game. Fans across the world recognize *Gunstar Heroes* as one of the top gameplay experiences on the Genesis for all of these reasons.

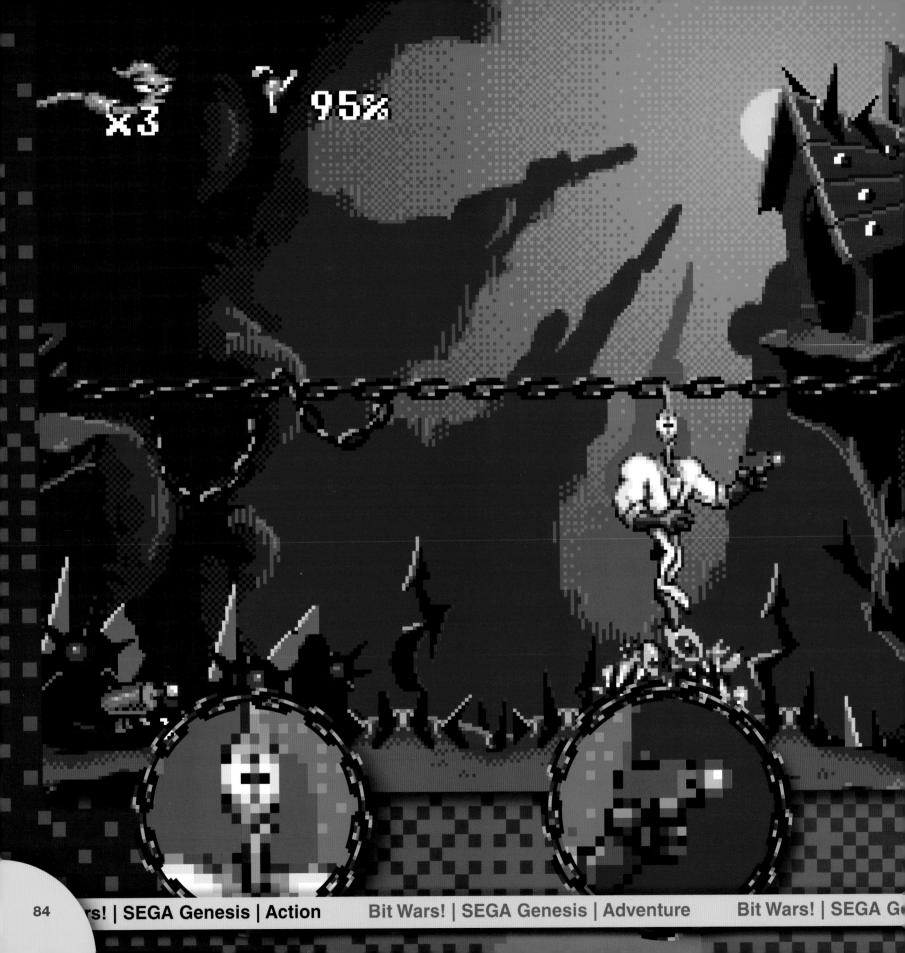

x3

95%

Earthworm Jim

1994, Shiny Entertainment/Playmates Interactive

Created by Doug TenNapel, with gameplay design by David Perry, *Earthworm Jim* played out as a live-action cartoon with a fidelity that had not been experienced by the game playing population at that time.

The game begins with an absurd premise: a worm crawls into a space suit that was dropped by a demented villain—a crow named Psy-Crow—and is transformed into the intergalactic hero known as Earthworm Jim, who sets out to rescue Princess What's-Her-Name. The player joins Jim on his adventures, which include launching a cow into the air, riding on the back of a giant hamster, and careening down an interstellar half-pipe.

While the adventures Jim has are exciting, what transports the player is the rich and colorful world of the game. Drawing inspiration from Tex Avery's animation, which imbued the Warner Brothers cartoons with their distinct style, the artists managed to create a new expression of art and animation that blended the aesthetic of the past with the interactivity of the present.

Equally important, the soundscape created by Tommy Tallarico and his team brought the world to life through the combination of effects, the score, and voice samples—another relatively new innovation for the time. The complete experience allows the player to peel back the celluloid veil of their Saturday morning childhoods and step into a world previously restricted by glass and phosphor.

The aesthetic of the game pulls from several classic cartoon styles rooted in traditional cell animation, and employs the same nonverbal cues such as the bulging eyes, side-to-side swipes, animating with motion, and painting with sound. In an era that was seeing a transition to 3D experiences, the game world was presented with a work that represented the pinnacle of 2D animation. It was a gift that marked the twilight of one era and ushered in a new period of artistic expression.

tommy tallarico

My two greatest loves growing up were video games and music. But growing up in the seventies, there was no such thing as a video game composer. When I turned twenty-one, I decided to leave my parents crying on the doorstep and head out to California, because that's what you did if you wanted to be a musician. I had no job, no place to stay, no money, no friends—nothing. I just drove out there. I was homeless for the first three weeks, sleeping under a pier in Huntington Beach. I went down to a music store and got a job selling keyboards.

On the first day of work I was wearing one of the few articles of clothing I brought with me, a TurboGrafx-16 shirt, the name of a new game system. The very first person who walked into the store that day was a producer at a company called Virgin Mastertronic. He saw my shirt and asked if I was into video games. I proceeded to unload twenty-one years of information on the poor guy. He told me they were starting a company down the street, and that he'd hire me as a games tester. I thought, "You're going to pay me $5 an hour to play video games? This California place is all right." So I was the first tester hired at Virgin, and every day I would bug the vice president of the company to let me do music. I didn't know what I was doing when I said, "Look, I'll do it for free. If you don't want it, you don't have to use it. Just give me the opportunity." And he did. The first game I worked on was the original *Prince of Persia*. I did the music, won some awards, and they decided to make me the music guy.

Pop culture got me interested in pursuing the arts, pursuing composition, pursuing my dream. We're seeing the same thing happen thirty years later with video games. Every time we perform *Video Games Live!* I get letters and e-mails from parents saying they went to our show last night, took the whole family, and they loved it. They didn't know anything about video game music, but they were writing because their eight–year-old daughter wants to take violin lessons so she can learn the music for *Zelda* or *Kingdom Hearts* or *Final Fantasy*.

Even the symphony musicians we play with will become moved. I played a show once and the oboe player, a woman in her fifties, tells me, "I've been playing in the orchestra now for over twenty years, and I've wanted my son to see me play for so long. He's never come to see a performance before tonight. And not only is he here tonight, but he brought all his friends along. He's so proud of his mom playing the music to *Halo* and *Metal Gear Solid* tonight." And she had tears in her eyes. The other thing she said was that over the past couple of years, she thought there was something kind of wrong with her son sitting in the basement playing games. As if she was losing him. But she said, "I see these thousands of people tonight just like my son, screaming, clapping for this music and for these games. And I realize that my son's not different at all. This is the culture. He's part of this community, and you guys are bringing it all together." Those are stories that you don't hear about on the news.

When I'm working on scores for games and composing music, I focus on emotion. A lot of times people get trapped in the "Oh, we're in the ice level; we must play some high tinkly bits." It's the same with the lava level or jungle level. I don't want to know what level we're in. That's secondary to me. Melody is the most important thing, but I also want to know the emotion. You remember games like *Mario*, *Tetris*, *Zelda*, and *Halo* because of the hook. Once you create the melody line, which can be five or six notes, you can then emote anything through music and through

composition. You can make the Mario melody sound scary or sad. You can make it sound happy and bluesy. Once you have that motif, you can mix it all together. After that's taken care of, if we happen to be in the jungle, maybe I'll bring in a bongo.

Games have become so massive now; there are so many things you can do. In the old days you had ten levels, and I'd write you ten one-minute songs that would loop. Add another song for the menu, another one for the credit screen, about fifty sound effects, and you're there. Now you have a hundred hours of game play, twenty-five thousand lines of dialogue, and seven thousand sound effects. The work has become so huge. When you add interactivity, we're doing things now that Beethoven and Mozart never dreamed would be possible. We're able to branch out interactively: If the player stops here, then we need to keep this riff going; if he goes in that direction, then bring in a percussion track. If a monster comes, we need the battle tune. There are so many considerations based on what's happening on the screen. When you record, you're not just recording one piece of music anymore but songs of different tempos, different orchestrations, different layers; it can be overwhelming.

What makes video game music different from film or television music is that interactive element. Film and television scores are often considered background music or incidental. They are telling linear stories. So the acting, the dialogue—those are the focus. In video games, it's those things, but it's also about interactivity. I call our compositions "foreground music." It drives the action. Take a big movie, for example, in which you have a two-hour score. For eighty percent of the movie, somebody's talking over it. So you've heard pieces of it, and then maybe six months later, you watch the DVD, so maybe you heard a total of three hours of the film's music.

Compare that to video games. People will play *World of Warcraft* twenty or thirty hours a week, and the music is there, pounding along. That's the equivalent of putting your favorite album on repeat for twenty hours every week. No other time in the history of the world has more music been played for more time than in video games today. It's for all these reasons that I've always said if Beethoven were alive today, he'd be a video game composer. No doubt in my mind. He wouldn't be a film composer. He wouldn't want people talking over his music.

Super Mario World

1991, Nintendo

The follow-up to *Super Mario Brothers 3*, *Super Mario World* was Mario's first appearance on the Super Nintendo System. The game retained some of the mechanics from the previous game, including the overworld map, multiple paths to choose from, and abilities like flying, and introduced a multi-player capability allowing for two players to engage in the same adventure.

Shigeru Miyamoto introduced a new character to the series, a pet dinosaur named Yoshi, that Mario could ride and who provided new ways for the player to engage with the environment and enemies. Miyamoto had wanted Mario to have a dinosaur as a sidekick from the very first Super Mario Brothers but, due to the limitations of the original NES platform, was unable to include him. Advancements in hardware, memory, and processing power allowed him to deliver another new aspect to the established world of his creation.

Additional capabilities such as advanced sound processing and scaling technologies in the SNES meant that the world Mario and the player inhabited could be larger and much more ambient than ever before. Scenes seemed to be dripping with color, landscapes had a life of their own, and sprites were larger, more abundant, and more detailed. It was during this period that the modern form of Mario's design would start to take shape. All these advancements, as well as the addition of environmental elements such as fog,

helped to expand the world that poured from Miyamoto's mind and into the living room.

The musical score, composed by Koji Kondo, is present throughout the game but played in different styles depending on the environment Mario is in. While underwater, the music slowed to a three-four signature and took on an dreamy, aquatic tone. In the caves, the music slowed down even more, and an echo was added. While riding Yoshi, bongos could be heard as an accompaniment. The technology had reached a point where music could play an interactive part of the narration and inform the environment.

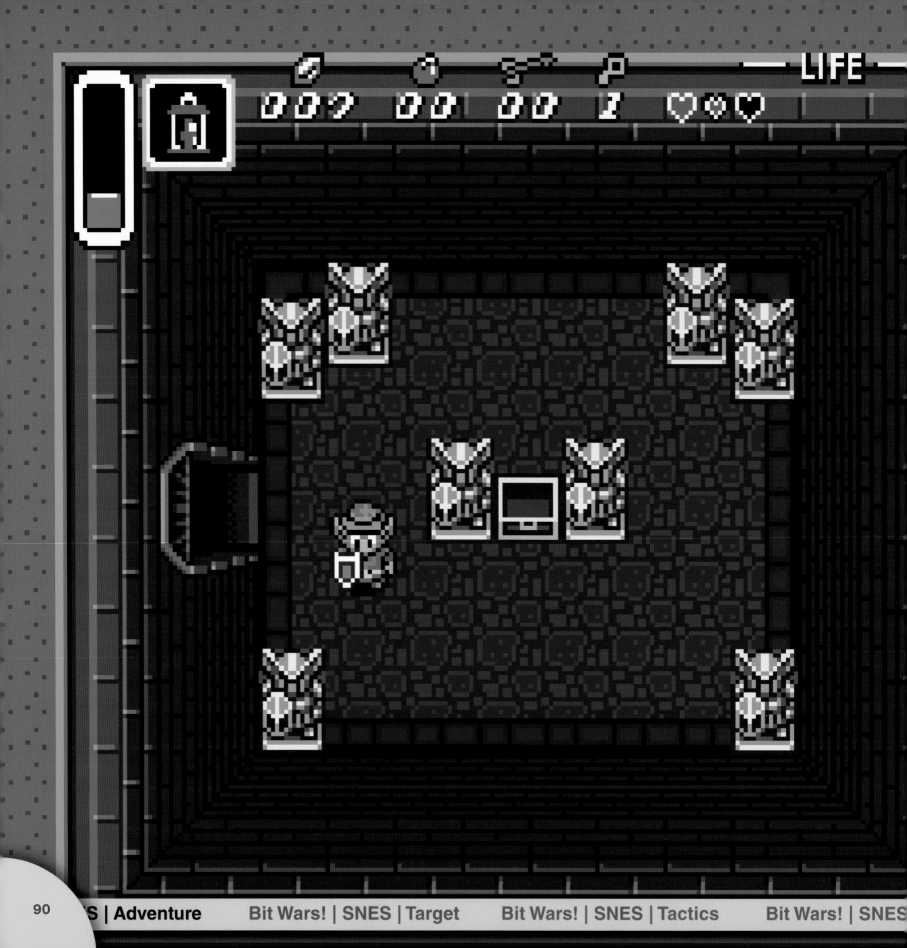

The Legend of Zelda: A Link to the Past

1992, Nintendo

A Link to the Past is a continuation of the Zelda canon and a return to a top-down viewpoint after a brief detour into a side-scrolling perspective implemented in *The Legend of Zelda II* on the NES. While the refinement of the gameplay first established in the original Zelda game is apparent, *A Link to the Past* established the iconic form that the protagonist Link would assume moving forward, in much the same way that *Super Mario World* established the modern form of Mario. It is the advancement of technology that allowed the artists to define, in much greater detail, the look and feel of the characters and environments.

The story follows the same basic structure as its predecessors, with slight variations. While Link must save Princess Zelda again, he must also rescue the seven descendants of the Seven Sages, in order to use their power to help defeat the evil Ganon.

A new gameplay element was added to *A Link to the Past* that would become a recurring theme for the series moving forward—the ability for Link to traverse both a "light" world and a "dark" world. The Light World is where the player finds Link living with his uncle; the Dark World is a mirror image of the light realm with some geographical changes. This mechanic of mirror worlds allowed Shigeru Miyamoto to create a variety of geographic puzzles and narrative conventions that would not happen in a single realm.

In establishing the lore of the game, various religious symbols and references were employed in the Japanese version but removed in the English translation, as Nintendo believed that they might be offensive to Western cultures. For instance, a fictitious language called Hylian included symbols inspired by Egyptian hieroglyphics, such as an ankh or vulture. The symbols were removed due to their religious meaning. As they did not directly impact the story the designers wanted to tell, these changes could be made in order to reach the broadest audience possible.

Star Fox

1993, Nintendo/Argonaut

Released in 1993, *Star Fox* marked a change in video game evolution as developers started to further experiment with 3D games and environments. New technologies were emerging in the PC world that allowed for polygon graphics, and Nintendo saw this as potential threat to their company's system. The SNES, while having some superior capabilities over its predecessor, unfortunately did not have the capability of rendering 3D models of sufficient speed for gameplay.

Jez San of Argonaut Software, developer of *Star Fox* and a company that worked closely with Nintendo, told Shigeru Miyamoto that it was impossible to deliver on the vision that Miyamoto had for this game unless they were able to create custom hardware. A new processor was developed which turned out to be significantly more powerful than the processor in the SNES itself; it was included in each *Star Fox* cartridge and allowed a 3D world to emerge from imagination to digital reality.

The ability to revise and include new technology in cartridges meant that as new techniques and solutions presented themselves to the artists, they could leverage that technology to immediately expand the breadth of their design and immersion.

Star Fox chronicles the adventure of the Corneria defense force in their battle to defeat Emperor Andross and save the people and the planets of the Lylat system. General Pepper brings in the elite Star Fox team to travel to planet Venom, battling Andross' forces on various planets along the way. The game offers multiple, branching paths that essentially allow the player to tailor the difficulty level, as some planets are harder to conquer than others.

Apart from 3D graphics, the game also boasted a few other environmental delights, such as digitized voices and interstitial animations, as well as dialogue between Fox and his team. These aspects reinforced the backstory while also presenting mission objectives that would change en route, requiring quick decision making by the player, and thus heightening the game's tension.

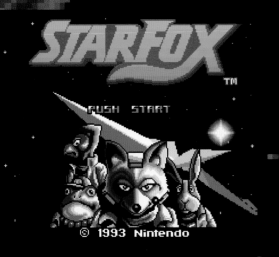

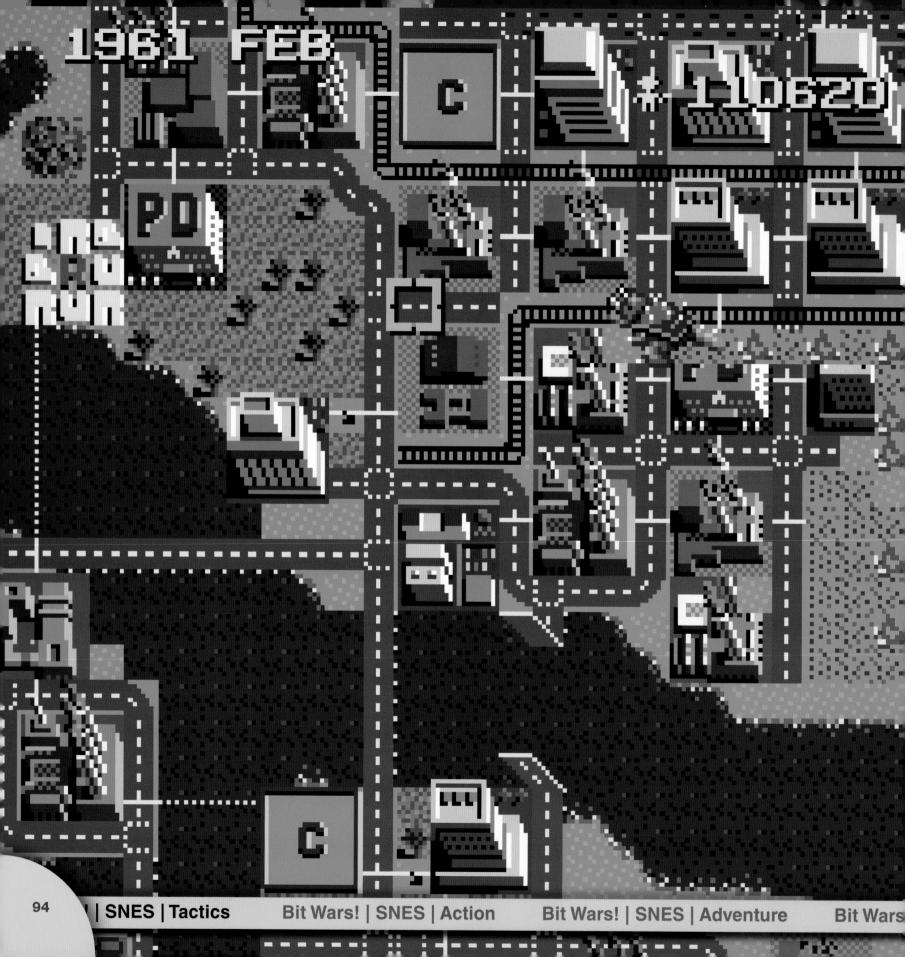

SimCity

1991, Maxis/Nintendo

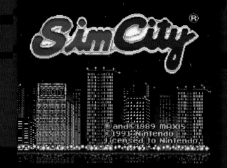

The inspiration for *SimCity*, a game focused on urban planning and construction originally designed by Will Wright, was found in a most unusual way. Wright had been designing a target-based game several years earlier called *Raid on Bungeling Bay*. He had developed a tool that allowed him to quickly build the island formations on which the combat would take place, and he quickly became fascinated by the construction, not the action, components of the game.

During the development of the game, Wright's influences ranged from his emerging love of urban planning theory, the book *System Dynamics* that helped him understand the fundamentals for his simulation, and a short story by Stanislaw Lem, called "The Seventh Sally," in which an engineer creates a miniature city with artificial citizens for a tyrant to control.

The game was meant to be an open-ended simulation, with no conclusion or accomplishments to achieve other than growth. Eventually, different scenarios were created to provide the player goals to work towards and to inject some connection with real world events. Scenarios that take place in Boston in 2010, Detroit in 1972, and Rio de Janeiro in 2047 made the environments relatable to the player.

As the cities develop, populations of "sims" emerge. These tiny residents are too small to see, but they inhabit the newly constructed cities and affect the way they grow and evolve. The player must also contend with natural disasters such as earthquakes, flooding, tornadoes, and attacks by monsters. In the SNES version of the game, one of the monsters is Bowser, a cameo from the Super Mario Brothers series villain.

The psychology of the game emerges as players learn how to best care for their cities and their sims. The game also set the groundwork for The Sims series of games, which are among the best-selling of all time.

TRANSITION

There comes a time in the life cycle of any technology, from the printing press to music recording equipment, when new advancements push the possibility of what could be far enough that the dreamers of dreams can see, but not fulfill, its promise. In a time when computer technology was seeing massive leaps and bounds on a seemingly monthly basis, game developers were compelled to tap into that promise and bring deeper and richer experiences to their players. More often than not, what emerged were game experiences that straddled two eras.

The possibility of moving games from 2D to 3D environments was imminent in the late 1990s. New advances in processor technology provided developers with inexpensive, rudimentary platforms that they were eager to take advantage of. CD-ROM technology, utilized by Sega in its Dreamcast and Saturn consoles, and by newcomer Sony in the PlayStation, provided a seemingly endless amount of space that could encompass massive game worlds. While the excitement of being able to express oneself in this new 3D medium washed over the development community, the techniques and practices—along with hardware not fully capable of meeting those expectations—were still being learned and understood.

However, resourceful game developers learned how to meld the methods of the past with the promise of the future, and they helped to create new and lasting experiences not possible in previous eras. It is at this point that we can see the evolutionary process of the move from 2D to 3D take form, stand erect, and lead the way into a new era of creativity and potential.

This was the dawn of a new voice for expression. This was the era of Transition.

DOOM II

1994, id Software

DOOM II was a refinement of the ground breaking experience of its predecessor, *DOOM*, and helped move the fledgling first-person genre forward.

Inspiration for the games's story—saving a future Earth from an invasion by creatures that escaped from Hell—came from a variety of sources. Nods to *Dungeons & Dragons*, heavy metal culture, and science fiction all play a part in establishing the tone and aesthetic of the game. A highly detailed account of the narrative, including the characters' backstories, missions, and environments, are all captured in a canonical design document, affectionately known as the DOOM Bible.

Principal developer John Carmack created a set of tools that enabled his designers, including American McGee, to craft the visual architecture of the world with very little programming needed. This also marked a shift to the utilization of game "engines" for developing multiple titles, and afforded the designers the freedom to focus their attention on crafting the experience and not programming code.

Featuring highly detailed environments, including sprawling military stations and urban landscapes, a rocking musical score, and the ability for up to four people to play across a local area network, *DOOM II* was a force of creativity, design elegance, and a social flashpoint, which cemented its place in history as a milestone in game development.

Transition | DOS/Windows | Action Transition | DOS/Windows | Adventure

Fallout

1997, Interplay

When *Fallout* was released on the PC in 1997, it immediately distanced itself from other role-playing games of the time with its gripping storyline, complex character development, and dark humor. Taking place in Southern California in 2161, the game uses its fictionalized future setting to touch on serious political and social issues. A struggle over the control of nonrenewable resources like oil and uranium sets the stage for a global conflict that results in nuclear armageddon, and mankind retreats into several government-controlled underground vaults. The player's story starts one hundred years after this event.

The game's retrofuturistic art style takes design cues from the 1950s and 1960s era of technology, pulp magazines, and pop culture. The stylization is reflected in the many detailed props found in the game, including computers that use vacuum tubes, art deco-designed space weapons, antique costumes, and a new world currency consisting of bottle caps.

The plot follows the protagonist's attempt to retrieve a computer chip that regulates his vault's water supply within 150 days. Traversing the world, the player meets mutant creatures and explores new towns and subterranean areas. Cut scenes and interactive dialogue shape the branching storyline, the outcome of which depends on how the player resolves various conflicts.

Fallout provides players an opportunity to explore potential world events, Pop Art, politics, and science fiction in one fully realized and engaging fictional experience.

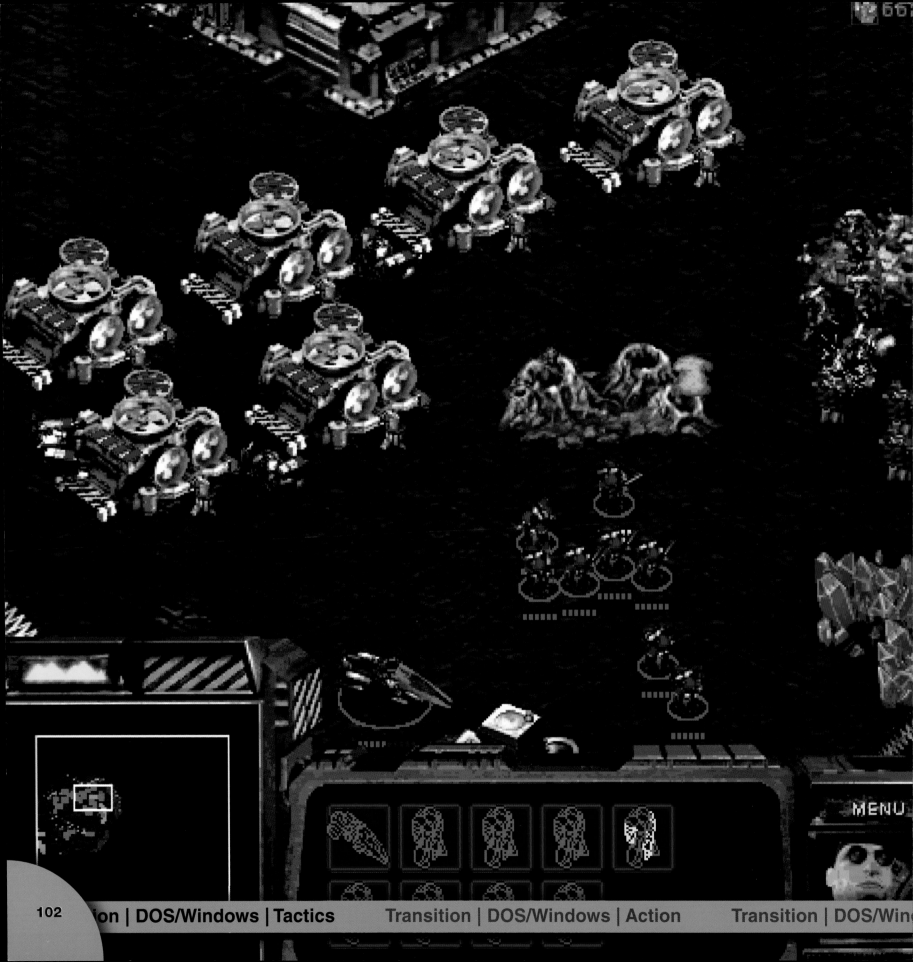

StarCraft

1998, Blizzard Entertainment

StarCraft takes the concept of the armchair general overseeing a strategic battlefield, and merges it with a science fiction narrative that finds humanity at odds with two distinct alien races. As in *Dune II*, *StarCraft* tasks the player with managing nonrenewable resources, building fortifications, researching new technologies, and amassing an army to defeat foes.

The art direction for each of the races is distinct and thorough, reflected in the designs of their respective weapons, buildings, and troops. The insectlike Zerg operate as a hive mind and their weapons are entirely organic; the technologically advanced Protoss are more typically alien, characterized by sleek designs and energy-based weapons; the humans have more readily identifiable and predictable assets at their disposal. The art style straddles both the fantastical and the familiar. Unlike *Dune II*, the power of the PC and more advanced graphics techniques meant that the characters, buildings, and environments were more detailed and expressive than those in older games in the genre.

While a strategy game at its core, *StarCraft* exists in a fully realized fictional world created by Chris Metzen and James Phinney, and is explained in detail in the game's manual. The storyline deals with themes of overpopulation, colonization, government suppression, and genocide. While these primarily serve as plot devices for the combat, the narrative plays out across three distinct acts, which are propelled along by cutscenes and dialogue during the mission briefings. *StarCraft* is widely considered one of the greatest real-time strategy games ever made, and remains the benchmark for which all others in the genre are judged.

Diablo II

2000, Blizzard Entertainment

Diablo II presented many design innovations in the dungeon-crawling/action role-playing game genre, including a strong narrative that plays out in four distinct acts, solid character development, a complex musical score, and an advanced graphics engine that allowed for realistic lighting and shadows, enhancing the mood of the experience.

In many dungeon-crawling games, the player typically has complete control of the protagonist. In *Diablo II*, however, the player leads the on-screen protagonist to his destination or conflict by clicking, or targeting, a location or enemy and never directly controlling the character. This appropriation of a target game mechanic in an RPG had been tried in other games, but *Diablo II* is widely recognized as the game that perfected its use.

Copyright 2000 Blizzard Entertainment. All Rights Reserved.

This mode of controlling the on-screen character affords several advantages for games that utilize an isometric perspective: it allows the player to see more of the playfield and strategize accordingly; it's easier to maneuver in an environment where the depth of 3D objects are difficult to discern; and without direct control, the dramatic tension of battles is heightened.

With the added ability to play online with remote players in a time when the world was just beginning to understand the power of the Internet, *Diablo II* stands as a pinnacle of the era, bringing a fresh experience to a well-worn game type.

FALLEN SHAMAN
Demon Raises Fallen

warrenspector

I fell into the video game world. I had been working in tabletop games, but originally I thought I was going to be a filmmaker or a film critic. I've been lucky enough to work in a variety of media, however. I've published a novel and have written *Dungeons & Dragons* adventures, as well as other role-playing and board games. One day when I was working on a new game system, I remember thinking that if the biggest decision I had to make was whether to use twenty-sided dice or percentile dice, I really needed to find something more fulfilling. This was in 1988. At the time I was totally obsessed with computer games and console games, and I believed that they were the future. Luckily, I got a job at Origin as an associate producer, even though I made almost no money. And that was my start.

When I look back on my life now, it's not like I had a clear plan, but when I was introduced to the work of Ray Harryhausen, a great filmmaker and special effects guy, that certainly set me on the road I'm still on today. The *7th Voyage of Sinbad* was the first movie I ever saw. I saw it in a theater in 1958, when I was two years old. I remember it vividly—the dragons and the cyclops. Reading *Famous Monsters of Filmland* magazine, edited by Forry Ackerman, was a huge influence on me. All of a sudden, I've got fantasy and horror and movies running in my blood. And I'll never forget the second issue of *The Amazing Spider-Man*, and a month later, issue thirteen of the *Fantastic Four*. Stan Lee became my hero, and I knew I had to tell stories with super heroes and monsters and fantasy elements. Those influences are still with me today. Even if you're going to do something special in a specific medium, your inspirations will be varied and come from everywhere.

I once walked into a party at a friend's house, all of us adults in our mid- to late-twenties. The lights were out in the living room and the entire room was lit by the glow of phosphor dots. One of my friends was sitting on the floor surrounded by everybody else, playing *Star Raiders* on the Atari 800. And it wasn't just Nancy on the floor playing a game; it was someone actually inhabiting another place. She was piloting a starship. When I got my hands on the joystick, that was the first time I felt transported. It was an experience that I could not have in any other way, in any other medium. Later, I realized through Richard Garriott's work that games could be something more than just beating up a monster and grabbing the treasure, or defeating an alien invasion. *Ultima IV* was the first game that made me stop and say, "How do I feel about what I'm doing? There's something special here." It made me stop and think about who I am as a person in the real world.

I try not to use other games for inspiration. Mostly the inspiration I take is critical: "I need to do this better," or "I need to do that differently." I draw much more inspiration from life. One of the most amazing experiences I've had since I started making games was when people started writing master's theses about my work. There's at least two out there that I know of. One of the authors pointed out something in the games I've produced or designed that I hadn't recognized: Every game I've worked on tells the story of a dysfunctional family becoming functional, and they ask what it means to be a family. And it's true; they all tell that story.

People have been telling stories for as long as there have been people. Why anybody thinks that our medium should be any different, I don't understand. In games, however, the critical element is player interaction, which is more important than story. A story provides a context for the player's choices and actions. In essence, whether you're playing *Deus Ex*, *Disney Epic Mickey*, or any other game—all you're

really doing is moving a green pixel over a brown pixel, then pressing a button at the right millisecond that causes a red pixel to appear. That's all. There's nothing significant or interesting about that. But when that first pixel is a bullet, the second pixel is a bad guy threatening your brother, and the red pixel is blood, all of a sudden it's significant. That's what story can do. Players are really good at the mechanical interactions of gaming. I jump, I run, I do all this stuff. They can recount experiences saying, "I did this and then I did this and then I did that." Anybody who listens to that story is going to fall asleep. We provide context to make it significant.

Even though we are an entertainment medium, a medium of communication, and a medium of self-expression for the player, we always have to remember that we're still making software. That's one of the things people—especially media people—don't always understand. We're not just making movies or writing novels. We are in the software business. So you always have to be thinking about the limitations of the hardware and the capabilities of the people writing the software for you.

But all art happens within constraints—all art. John Ford made some of the best western films of all time.

He never felt compelled to have an airplane land in the middle of Monument Valley. That's a limitation. In the early days of print, they couldn't do full-color photographs. It's a limitation. So creativity really is independent of, and I think superior to, technological limitations. You just have to work within them and try to bust out and do something really spectacular.

I think we've proved pretty conclusively that games are more than a way to waste a couple of hours. Video games are a serious medium of expression. The creators of these games—speaking not just for myself but for all of my friends and colleagues—we think about the creative process in the same way that a filmmaker does, in the same way that a novelist does, in the same way that a musician or a painter does.

I believe we can get people to think about their lives in new ways. We're an entirely new medium, still trying to figure out what we can do and what we can't, how we work and how we don't. But in terms of cultural relevance, I think we're good to go. I think we've done it.

I really hope that there's someone out there in a garage or sitting in her parents' house doing something with games that I can't even imagine. We're too young of a medium to say, "Well, we're done. We've figured it all out." Many mysteries remain, which means that there's going to be some young punk out there who's going to knock me off my pedestal and do something totally unimaginable. That's the great thing about being a gamer right now.

Super Mario 64

1996, Nintendo

Super Mario 64 was a declaration that the era of three-dimensional games was upon us, and it promised experiences unlike any game before it.

While the plot was familiar to players who grew up on the adventures of Mario, designer Shigeru Miyamoto presented Mario in a world of such solidity that gamers were awestruck. For the first time, players were not observing the adventures of Mario from a distance but were instead thrust into the detailed, vibrant world of Princess Peach's castle in the Mushroom Kingdom, with all of its wonders to explore. Colorful, expressive, whimsical, enduring—the world of Mario had never seemed so alive.

The Nintendo 64's new controller afforded players a surprising degree of precision over Mario's actions. Players could have him tiptoe past sleeping enemies, run at full tilt to avoid obstacles, grapple and climb, and even control the viewpoint they observed the game from. The new freedom to thoroughly explore a familiar world entranced a generation who had grown up on the side-scrolling antics of the stout plumber.

Players guide Mario through a variety of environments with their own unique challenges, in whatever order they choose. Though the goal remains the rescue of Princess Peach, *Super Mario 64* allowed the player the opportunity to explore the world on their own terms.

Interactive audio, sound effects, and a brilliant musical score from Koji Kondo perfectly match not only the environments, but the player's actions within each stage. Depth of control, level design, art, and audio all conspired to create one of the most beloved Super Mario games of all time and marked the viability and transition to full 3D worlds in game design.

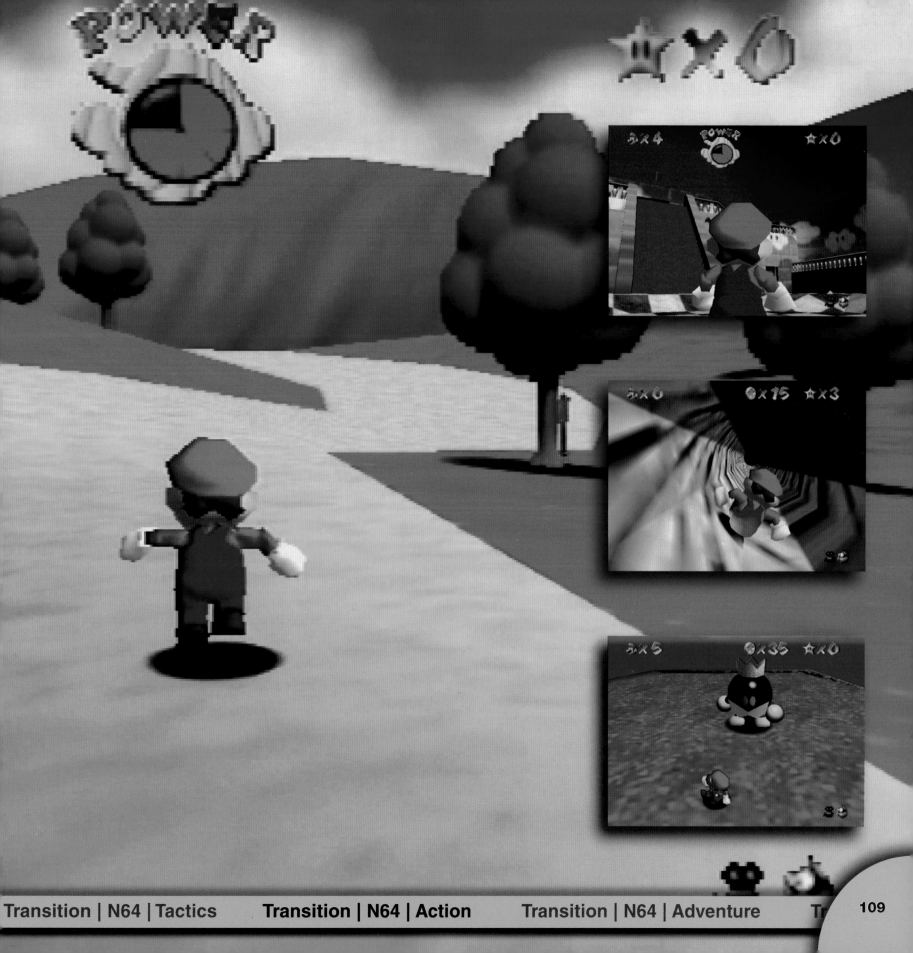

GoldenEye 007

1997, Rare

Based on the James Bond movie of the same name, *GoldenEye 007* helped demonstrate the viability of first-person perspective games on home consoles. While there is a history of poor movie-to-video-game conversions, *GoldenEye* remains the best-selling game on the Nintendo 64, ahead of both *Super Mario 64* and *The Legend of Zelda: The Ocarina of Time*.

The Bond universe is an internationally beloved franchise, spanning more than fifty years of books, movies, and music. In bringing the world of *GoldenEye* to life, director Martin Hollis tapped the rich history and widespread appeal of MI6's most infamous agent.

In developing for the Nintendo 64, Hollis and his team sought inspiration not only from the Bond lore itself, but also from gameplay elements in Sega's *Virtua Cop*, Nintendo's *Super Mario 64*, and id Software's *DOOM*. Enemy interaction, open 3D environments, and camera movements were all inspired by these groundbreaking games.

In bringing the movie franchise to the realm of video games, designers built levels and objectives that centered on thematic elements from the films, while showcasing the fantastic and wonderful gadgets that are a staple of every Bond adventure. Many of the game's cinematic effects and kinetic moments were influenced by a variety of action movies from contemporary directors like John Woo.

Janus Control Center, Cuba

While the adventures of James Bond are rife with daring escapes, breakneck chases, and scenes of seduction, violence plays an undeniable part in Bond's repertoire. Hollis made the decision to use a stylized depiction of violence that frames the game in the fictitious world of the movies and distances the player from the real-world consequences of his actions. Most notable is the overly dramatic way in which enemies fall after being hit. This hyper-animated, melodramatic movement clearly cements the action in a fictitious world.

With large-scale set pieces, Hollywood-style explosions, and action-packed pacing, *GoldenEye 007* allowed up to four players to step into James Bond's suit and save the world. *GoldenEye* is widely regarded as the best multiplayer first-person shooter for home consoles of its generation and helped pave the way for future games that would attempt the same multiplayer experience.

Converted Missile Train, heading east

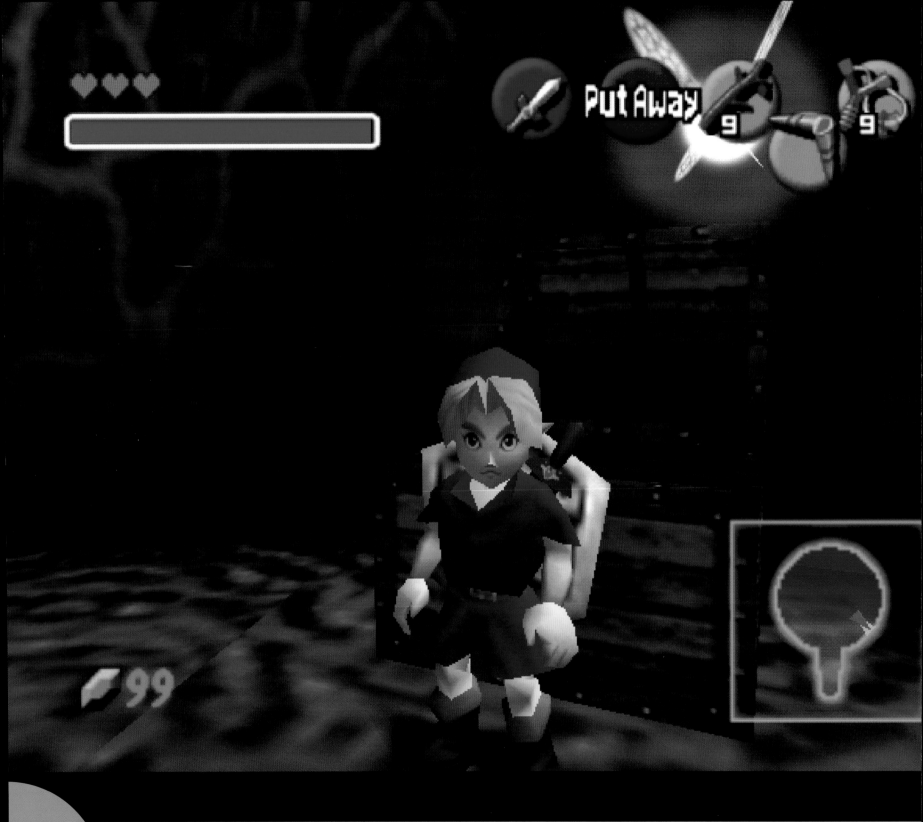

The Ocarina of Time

1998, Nintendo

The Legend of Zelda: The Ocarina of Time was the first leap into 3D for the Zelda franchise. The Zelda titles have always had a strong backstory and a lush, hand-drawn aesthetic married to an iconic musical score. While *Ocarina* stayed true to the Zelda universe and boasted a familiar orchestral soundtrack, the jump to 3D was a test for die-hard Zelda fans.

Building on the successful design of *Super Mario 64*, Shigeru Miyamoto and his team took the lessons learned and created a new, open-world adventure game that incorporated a few new and radical game mechanics, such as being able to lock on to targets and context-sensitive buttons whose function would change depending on the item the main character, Link, was interacting with. However, the major innovation was the ability for Link to jump without the player's input.

This was a foreign concept to players and one that they needed to be eased into. The rationale for the change was that maneuvering in a 3D environment is difficult, and Miyamoto felt it was better to not frustrate the player by having to control the jump in 3D. This delicate balance between design and control is where superior game design becomes apparent.

Apart from the innovative control mechanics, *Ocarina* is different from other games in the series due to Miyamoto's intent for an emphasis to be placed on the game's world, not the protagonist himself. The goal was to create an "interactive experience," not necessarily like a movie, but something more than a game. Central to creating this feeling was the computer-controlled camera that would adjust its position relative to the player to provide grand, cinema-like shots of the environment, while the player retained control of the game.

The Legend of Zelda: The Ocarina of Time stands today as a groundbreaking title that laid the mechanics for other games to mimic in this era of transition.

Worms Armageddon

2000, Team 17

Worms Armageddon, developed by Team 17, was the fifth iteration in the series, with each new release building upon its predecessor. Utilizing a turn-based combat system, the roots of which can be traced back to versions played on mainframe computers with Teletype output, *Worms Armageddon* is a game of contradictions. Warm, colorful, and whimsical, the game's art direction is welcoming and stands in stark contrast to the violent weapons that the worms wield in battle against each other.

Each player commands a team of worms; the goal is to eliminate the opponent's worms before they eliminate you. Environments such as kitchen sinks, piles of toys, and caverns serve as the battlegrounds. Taking turns, the player moves a selected worm into position, then fires a selected weapon at his opponent, hoping to remove them from play. There are an enormous variety of weapons at the player's disposal, each affected by elements such as gravity, trajectory, and wind.

Sound effects are put to excellent use and further disjoint the combat scenarios from the charming graphical presentation. The worms speak in high-pitched, squeaky voices while hurling their war cries and battle taunts, adding a comical tone to the game and lending the worms distinct personalities.

r.j.mical

I graduated from college with a degree in computer science. I got a great job right out of school in my field, but it was not satisfying for me because it was only a mechanical job. And for me, computer science was only partly about logic and math. So much of it was about the art that I was creating, and computer science for me was always a blend of art and scientific undertaking. When I got out of that first job, I decided to take a trip around the world. I traveled for about a year.

The most valuable thing I got out of that trip happened when I got back, when I was contemplating what to do next with my life. What I realized from my trip is that the world is big, and there's so many interesting things you can do. You don't have to stay in a rut; you can go off and invent things for yourself. I always loved to create music, to write, to draw—a lot of artistic undertakings in addition to science. At the end of this trip I decided I should try to find a way to blend all of these things together in one space.

Computer games, of course, were the place to go. At the time arcades were really popular, and there were a lot of really brilliant arcade systems. I discovered that not only were there a lot of brilliant games, but Williams Electronics made the best games of all. So I marched over to get a job with them and thus change my career—my life, really. And indeed I did, because that job and the friendships I made there led to a job working on the Omega, which led to the Lynx, which led to the 3DO, which led to Sony and everything else that I've done in between.

I'm working on some puzzles that I love to publish and have been thinking about 3D models a lot, enjoying the exquisite beauty of those kinds of shapes. Part of it is the logic, but part of it is the human nature of comprehending objects and the beauty of a physical object itself. It's sort of profound to realize that you want to create something beautiful and satisfying. For me, a well-written program is not only as good as a well-written short story, but it usually is a well-written short story for me. When I go to write a program, I first write it using comments, and then I fill out the code around them. The comments tell the story first, and I keep them updated throughout the code so that you can read through them and understand what my programs do. I write my comments like I write a good book; I make sure that the sentences and the ideas are clear and well-formed. When I write code that executes well it satisfies me in a really profound way. I'm not sure what it is, but it's beautiful in the same way as when you realize how a three-dimensional object works.

In the beginning, the hardware designers would create platforms that the software guys would then go off with and figure out how to use and how to deploy. Clever guys that they were, the software guys would not only learn how to use a platform but know how to drive it to its limits. One of my favorite examples of that was with the Atari 2600. They would create hardware and write games that would drive the system

faster than it was supposed to go, increase the access rates more than they were ever intended. So they took the console's basic design and evolved it into a more powerful system.

Slowly over time the dynamic flipped. There was a sweet spot right in the middle in which the hardware guys, the software guys, the game designers, and the system people all worked together to create systems that would satisfy everyone. But what's happening more often now is that the software developers—the game developers—are in control now. They are basically pushing the direction of the industry by their demands. For instance, take the pixel shaders in our graphics hardware. I don't believe they came from some graphics guy who wanted to represent graphics better but rather from the software developer's desire to have more realistic-looking scenes.

Look at the Microsoft Kinect and the Sony Move controllers—these three-dimensional-space controllers people have started using. The demand comes from the increasing need to create experiences that are more than just sitting on the couch, ones in which you actively get involved, which I think is going to last for a number of years. This idea of active involvement rises and falls over time, just like 3D rises and falls over time, and both technologies are really hot right now. But this too shall fade, and we'll revert to other ways in the future.

The single most challenging aspect of my job is the fact that I have to deal with a lot of stupidity infused in the tools I have to use to develop the technology. It's with both the hardware and the software, but less with hardware. Those guys seem to have their act together pretty well. The software tools, however, are often incomprehensible and unnecessarily complex. Instead of having one solution, you have to use three or four solutions—a part from this and a piece from that. It

seems no one can create a clean, easy-to-use development environment that doesn't have a lot of baloney that gets in your way.

I strive to make people happy with game development, to create experiences that give them joy, because I feel that the best thing I can do for people is to lift them up a little bit, raise their spirits. But much more important than that is the great way that games bring people together. We're seeing it accelerate in games from the Xbox 360 and the PlayStation 3, since these systems have online presences to connect people. PC games have been offering this for years now, and it allows for the creation of bigger communities, people to get to know more people, to understand one another better, and to get more comfortable with one another. You may not feel an immediate connection just because you're shooting at a guy from your trench and he's shooting at you, but in a real way it is furthering communication, furthering the development of society and community.

Sonic Adventure

1999, Sonic Team

Sonic Adventure was the first foray of Sonic the Hedgehog into a fully realized 3D world. Once again battling Dr. Eggman, Sonic must recover the seven Chaos Emeralds, save the animals under Dr. Eggman's control, and stop the doctor from taking over the world.

Set against a lush and diverse set of levels, Sonic is free to explore the environment, while the main objective is to traverse the level in as little time as possible, rescuing animals along the way.

The power of the Dreamcast allowed producer Yuji Naka to create an experience that was both recognizable and new to the player who grew up on a diet of Sonic games. The ability to build solid 3D environments—using advanced graphic techniques and implementing realistic physics—allowed Naka and Sonic Team to bring a much more believable world to life.

The Dreamcast was capable of rendering fully 3D scenes which meant that the entirety of player interaction rested in a fully modeled world. An inspired soundtrack that mixed a variety of music genres such as world, pop, jazz, rock, and electronica into the soundscape, helped sculpt an audiovisual experience the public had never before experienced on a home console.

Due to the 3D nature of the game, platforming levels could be varied in ways that a 2D environment could not. Sweeping ramps and jumps, platforming pads, and hidden passageways were unveiled for players to explore the world of Sonic in a way they hadn't experienced before.

Challenging yet accessible, nostalgic but new, *Sonic Adventure* offered an experience that crossed and united generations. The gamers were growing up, and the end of this era saw the emergence of a multigenerational gaming household that would shape the opportunities for game designers moving forward.

Shenmue

2000, SEGA

Shenmue is equal parts virtual life experience and role-playing game. Created by legendary game designer Yu Suzuki, the player follows the story of a young man named Ryo, who is out to find a man named Lan Di and avenge the death of his father, Iwao Hazuki. A story plot that is familiar throughout literature, *Shenmue* approaches this with a level of detail that had never before been experienced in a video game.

In an effort to draw the player into the game, set in Yokosuka, Japan, Suzuki focused on creating a mirror world, one that mimics our real world in a virtual space. To achieve this, the player can interact with almost anything in the game world, from opening drawers to using vending machines.

Layered on top of this interactive world was a weather system based on actual, real world weather information from 1986–1987 Yokosuka and that affected how the world looked to the player. If it was raining, characters in the game would be walking around with umbrellas; if it was snowing, everything was covered in white. A day/night system would change the look from dusk to dawn and directly impact the gameplay: shops would be closed at night, streets deserted. The freedom to explore and the

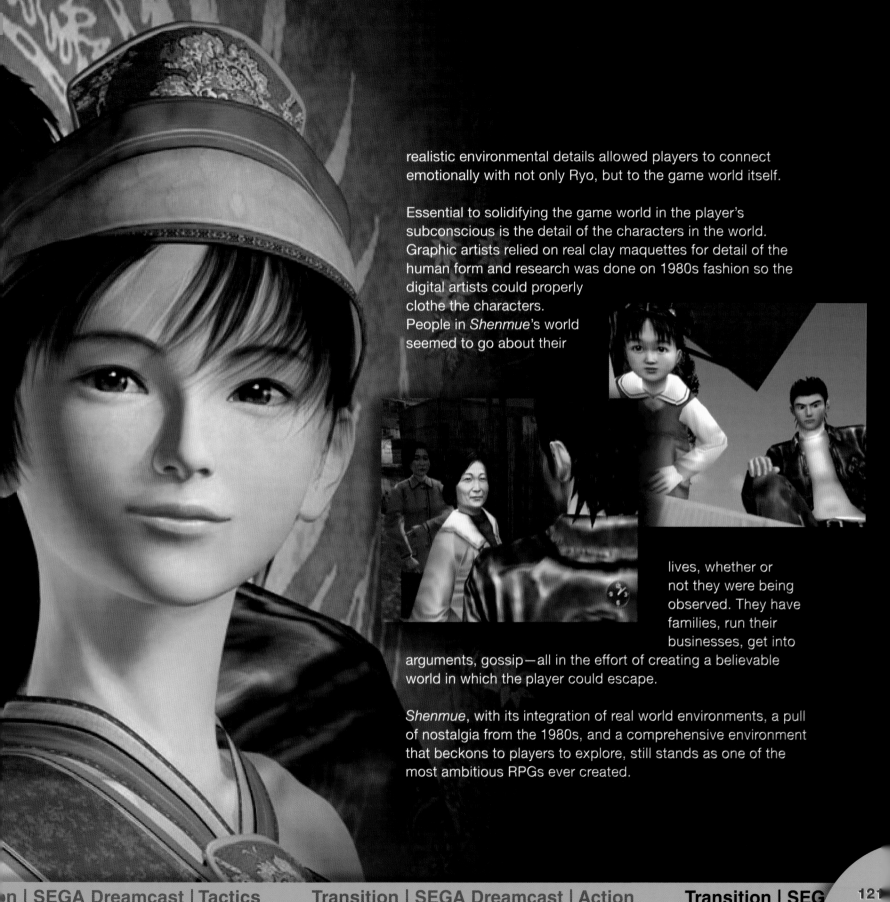

realistic environmental details allowed players to connect emotionally with not only Ryo, but to the game world itself.

Essential to solidifying the game world in the player's subconscious is the detail of the characters in the world. Graphic artists relied on real clay maquettes for detail of the human form and research was done on 1980s fashion so the digital artists could properly clothe the characters. People in *Shenmue*'s world seemed to go about their

lives, whether or not they were being observed. They have families, run their businesses, get into arguments, gossip—all in the effort of creating a believable world in which the player could escape.

Shenmue, with its integration of real world environments, a pull of nostalgia from the 1980s, and a comprehensive environment that beckons to players to explore, still stands as one of the most ambitious RPGs ever created.

ChuChu Rocket!

2000, Sonic Team

ChuChu Rocket!, while having no real storyline or societal meaning, stands as one of the great puzzle-based party games ever made. The hook to a great tactical game is the ability to understand the mechanics while in the throes of conflict. And *ChuChu Rocket!* throws the player directly in to the conflict: not only must the player guide little mice to a rocket ship to evade cats that are bent on eating them, he or she must compete with three other players trying to get there first.

The art direction makes the game highly approachable. Using cats and mice as a formula for conflict is well established—the cartoon *Tom and Jerry*, for example—but it is the art that makes the game feel familiar and foreign at the same time.

The game is decidedly Japanese in its art direction, and placing that aesthetic within a rapid-fire puzzle game gave many casual players a glimpse into the stylistic influences that were making their way into Western popular culture.

One could try to draw out all kinds of metaphors about life as the mice are threatened by the hungry cats, but the game offers no such message. As it stands, *ChuChu Rocket!*—with its whimsical design, approachable gameplay, and the ability to bring friends and loved ones of all ages around the same television to engage in its colorful world—needs nothing deeper.

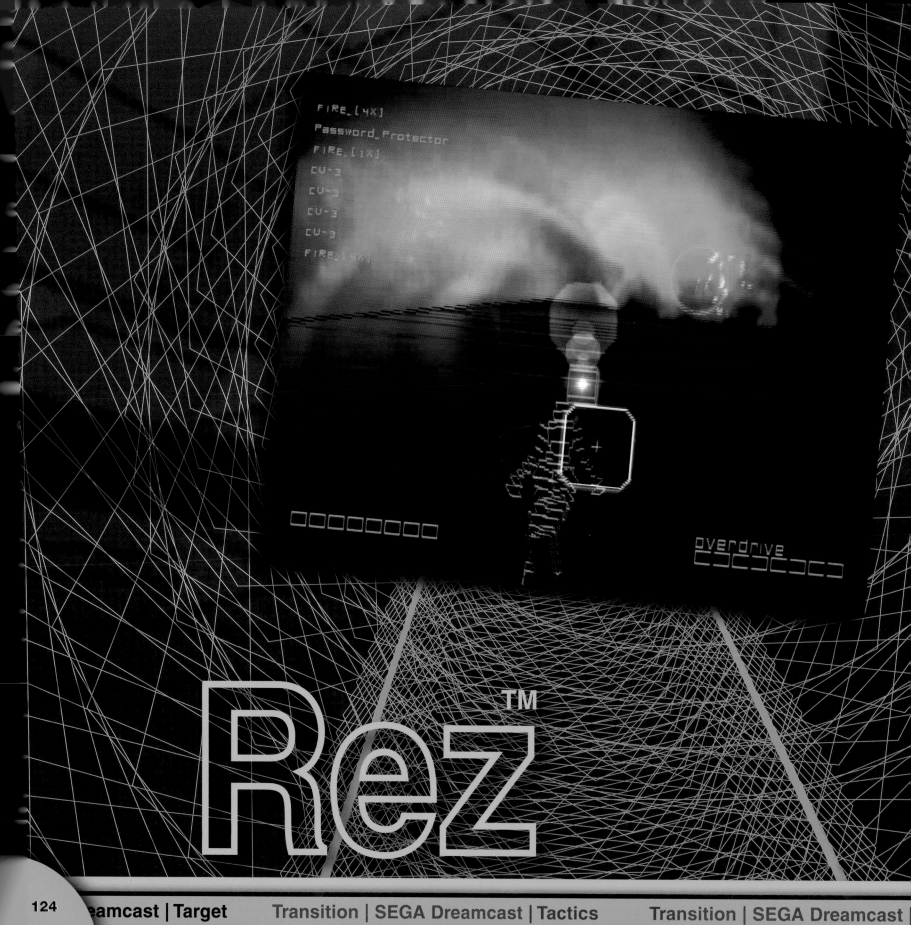

Rez

2001, United Game Artists

Rez emerged in an era when computer technology and the Internet were exploding into the social consciousness. With the broadening popularity of the cyberpunk aesthetic, demonstrated in the novels of William Gibson, Neil Stephenson, and Bruce Sterling and depicted in movies such as *Blade Runner*, *The Matrix*, and *TRON*, *Rez* pulls the player into an experience that illustrates the world inside a computer network.

Computer "K-project" is a global interconnected network system, driven by an AI known as Eden that becomes self-aware and is attempting to shut itself down. The player assumes the role of an avatar, injected into the system by a hacker to rid Eden of viruses and reboot the system before it causes a global information meltdown. Essentially an on-rails target game, using the same mechanics from games in the Panzer Dragoon series, *Rez* manages to become something wholly unique and stands apart from other games in its genre.

Inspired by the works of Wassily Kandinsky, *Rez* paints an abstract visualization of what life in a computer system may resemble. Points of light, manifestations of elegant mathematical formulas, digital representations of ethereal forms, and an environment that becomes increasingly detailed as the player progresses, *Rez* brings to life the abstract concept of digital existence and grounds it in the familiar, particularly with the humanlike form of the player's avatar.

Of particular note is the soundscape for *Rez*. The game is devoid of sound effects, mimicking the empty void of cyberspace. Rather, the game features a musical score that is revealed, in real time, based on the viruses you eliminate. The more proficient you are, the deeper into the system you progress, and the more complex the audio becomes. The external vibration of the player's controller, impacted by gameplay and providing physical feedback from the game, blends into an experience that achieves the goal of synesthesia—the combination of visuals and audio to merge two senses and overpower the user.

To date, *Rez* stands as an extraordinary example of the dawn of a new digital age and the expression of an abstract world linked to our existence.

janepinckard

The first video game that changed the way I felt about gaming was *Lode Runner*, which came out on the Commodore 64. The game came with a level editor, which I had never experienced before. The idea that you could play a single-player game and also go in and edit the levels—it completely transformed my understanding of what my participation in the medium could be. It was as if I got a book that came with room to add my own chapters, or a CD that also came with music mixing software. Early on, games allowed users to remix them, and that was a really transformative moment.

My work now revolves around experimental games and research. Our goal is a bit ambitious, but it's in order to make games better—whatever that means. There are a lot of definitions for this. What I try to think about when I approach my job is not necessarily which games are going to be popular, or which games are going to sell, because I think other people have that covered already. Instead, I think about the new genres we could invent. What are some new ways of crafting player experiences? Do we need to invent new technologies to do that? How does that inform game design? So it's this loop of thinking about player experience, then game design, then new technology, which then informs player experience, and so on. It's a positive feedback cycle. If we're able to concentrate on that, some of the lessons that we learn might translate into the larger game space. A rising tide lifts all boats.

The way our lab approaches game design is that we're most interested in narrative technologies. This is heavily influenced by experiments such as *Façade*, which was a narrative-driven text adventure in which you could interact with couples by entering natural dialogue. The game would then recognize the words and respond accordingly, and this obviously comes out of a long tradition of storytelling.

I know that there's some debate over whether storytelling should be the backbone of a game or something that you overlay to make the mechanics sensible. I believe in the former. Storytelling is such an important means of self-expression culturally, and it makes sense that it shows up in every art form that we have, including games. Narrative remains extremely important because it gives you the opportunity to hook in emotionally. Otherwise, a game's mechanics might be interesting but without that engagement, it feels a little cold or without purpose. The love story might be one of the strongest narrative arcs we can explore in a game system because there are so many emotional hooks to be had.

There's a healthy and interesting tension between the idea of games as art and games as technology, meeting somewhere in the area of design. Game designers and game programmers have a variety of approaches as to how to deal with that tension. There are a lot of challenges technologically, because commercial games are necessarily constrained by economics, which often plays out in technological constraints as well. Maybe you don't have the time to develop the tools that you'd like, or you don't have time to do the research that you need. In that area, hopefully places like my lab or MIT may help, because we can do free-form research into new technology. That said, I think games are most effective when the design goals are made articulate by technology; so if there is indeed a central design thesis, the technology supports that. Still, I think a lot of new ideas come out of technological innovation.

For instance, we wouldn't have multiplayer games unless we were able to solve latency issues and

network issues. In that particular case, I don't know which drove what—whether someone said, "Look what we can do with this tech," or someone said, "We must have multiplayer." It's probably a mix of both. So I think there exists a very good, healthy tension that hopefully supports and continues to evolve both sides.

There are so many different directions that the game industry could go and that games could go as an art form. Right now we're experiencing extremely seismic shifts. There are a lot of disruptive new technologies, a lot of disruptive new genres and designs, social gains, changing distribution systems, maturing console cycles. I'm sure everyone can sort these out. But they have coalesced into a perfect storm of "What's going to happen next?" It's really exciting. Right now it seems that there are so many possibilities.

One day I hope that there will be a literary review; a *Cahiers du video game*, is what we called it in our pretentious way, modeled after *Cahiers du cinéma*, which had been part of the new wave film movement. It chronicled the movement and drove it forward because you had all these people writing essays about what film should be, writing manifestos about where to take film next, and so on.

There are people interested in doing that, but there aren't many places for them to have conversations. There are some blogs and magazines such as *Kill Screen*, which I think is a great art-driven publication. But I would like to see the conversation come together around movements. It's really useful to define and articulate what is important about a movement. "Indie" is a bit vague, but if we assigned a term like *new wave*, it would offer a built-in identity and shared aesthetic that everyone can comprehend. So I would love to see things like that come around—game genres identified and an influx of ideas about where games should go. Then let them percolate up into the rest of the world.

One time I was in an elevator in Tokyo and this couple asked what I did for a living. I said that I work in video games, and they responded, "They're so violent." I hope people will come to understand the vast territory that games cover and that games are a form of artistic expression as diverse as cinema, as literature—or that it can be. I admit that we're not quite there yet. But I hope that people can see the progression of where we're going.

SimCity 2000

1995, Maxis

SimCity 2000 builds on the wild popularity of its predecessor, whose roots reach all the way back to a level editor for a game on the Commodore 64. Expanding on the notion of a construction playground for city planning, *SimCity 2000* adds a variety of new facilities, transportation utilities, and an intricate monetary system.

Using a system with more powerful rendering capabilities, *SimCity 2000* eschews the traditional top-down view of past SimCity games and offers players a diametric view of their city, providing the ability for a more diverse topography, including higher elevations and underground layers for utilities, such as pipes and subways. New graphic features were added to show buildings under construction or decay, and other animations were enhanced.

One of the staples of the SimCity series is the natural disasters that the player must deal with and rebuild from to meet a victory condition for his or her city. Many times, these scenarios would be a nod towards real world events. In addition, some pop culture references are included in the game, including town names lifted from the science fiction sitcom *Red Dwarf*, a hidden document that is an essay by author Neil Gaiman, and humorous newspaper articles that appear in the game, populated with the real world's tabloids.

The magic of *SimCity 2000* is the ability for the player to construct and control an environment of his own making. At its heart, it is a sandbox of expression and aspiration that provides a better understanding of the world we inhabit.

Panzer Dragoon II: Zwei

1996, Team Andromeda

Panzer Dragoon II: Zwei stands as a fantastic example of elegance within limitations. The game is an "on-rails shooter," which means that a player's course through the game is set on a predetermined path. While the player can control left to right and up and down movements, the character is always moving forward along the path. To supplement this limitation, the player may shift the viewpoint to look around the dragon on which he rides, providing the ability to fight enemies from all sides. As with most target games, the enemies attack in predictable patterns. With multiple play-throughs, players can easily learn these patterns to maximize their score.

This type of gameplay proved useful to the designer, Yukio Futatsugi. Because the player does not have the ability to move just anywhere, there are no issues with camera placement as there are in free-roaming 3D games. Since the path is predetermined, the graphics can be loaded progressively, or streamed, from the CD-ROM, which decreased unpredictable rendering that could negatively impact the experience. This enabled Futatsugi to craft an illustrative environment with huge caverns, sweeping vistas, and other moments of grandeur in a game developed for a system that was principally designed for 2D games.

Mounted on a dragon, the player explores a world that is a mix of the old and the new; ancient yet also high tech. Influences in design, including French artist Jean Giraud and the Dune universe, are present throughout. By keeping the gameplay on rails and freeing up processing power for characters and animations, Futatsugi was able to create one of the Saturn's most visually striking games.

Panzer Dragoon Saga

1998, Team Andromeda

Panzer Dragoon Saga was the final role-playing game released on the Saturn console, and it remains one of the best and most sought-after RPGs released for the system. Taking place in the expanded world of the Panzer Dragoon universe, *Saga* was directed by Yukio Futatsugi and features the art of Katsumi Yokoto. The game differs from the others in the series, as it is principally a role-playing game and not a rail shooter.

The grand backstory for the Panzer Dragoon universe lent itself to a deep adventure and the game managed to incorporate the series' original gameplay elements, such as flight, reticule targeting, and branching paths, while offering a simplified RPG system that still provided an amazing depth of discovery for the player.

© SEGA ENTERPRISES, LTD., 1998

The game takes place in a post-apocalyptic world in which humans are competing for the remains of the devastated environment. The protagonist, Edge, is a soldier who is protecting an excavation site for the Empire when he discovers the body of a young woman entombed in a wall. The site is attacked by Imperial troops and they take the girl, in the process knocking Edge off a cliff where he is rescued by a flying dragon. The game sees Edge take revenge on the Imperials and uncover the mystery of the girl.

The game manages to convey a sense of permanence in the environments, due to the rich details and storyline that plays out in extensive cutscenes. In an era in which developers were still coming to grips with CD-ROM technology, full-motion video, and 3D game development and art direction, these cutscenes were intertwined with the gameplay, attempting to provide a seamless experience from one encounter to the next. But the Saturn's limited processing power meant that the pre-rendered cutscenes did not match the system generated graphics, and the contrasts in resolution and detail were often jarring. Most of the time, the engrossing gameplay, strategic leveling of the player and dragon, and the engaging story found the player quickly forgiving the inelegant transitions.

A design decision by Futatsugi was to have only one player, with a dragon, in one's party. Other RPGs at the time typically allowed the player to control up to three or four characters in combat. The decision to limit the number was intended to create a feeling of being small and alone in this vast world. System limitations would also mean that villages appeared crude and sparse, adding to the feeling of a world rebuilding itself from the ashes of nuclear war.

With its haunting soundtrack, in-depth storyline and emotional relationship with the dragon on which you ride, and its mix of shooter and RPG genres, *Panzer Dragoon Saga* remains a solitary work of art that is beloved by some, yet seldom remembered by the gaming audience at large.

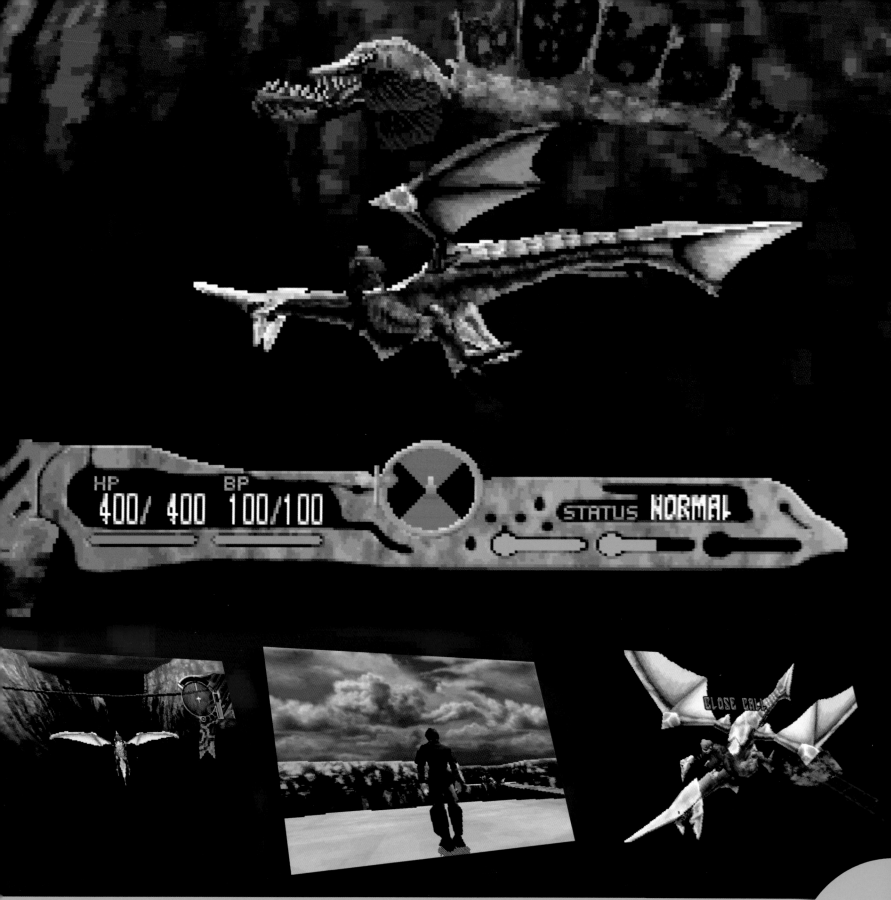

HP
400/ 400

BP
100/100

STATUS NORMAL

CLOSE CALL

Tomb Raider

1996, Core Design

Tomb Raider introduced the now-iconic Lara Croft to the video game world. In a genre dominated by strong male characters, Lara Croft stood as an empowered female on equal footing despite her controversial sex appeal. Likened to characters such as Indiana Jones, the player follows Lara on an adventurous ride, plundering caves in search of ancient artifacts.

Set in present-day Calcutta, Lara sets out to recover a relic called the Scion from the tomb of Qualopec in Peru. From there, the story has her traveling to uncover more artifacts from locations in Greece, Atlantis, and Egypt as the story unfolds. Each of the environments takes design cues from their real-world counterparts, or in the case of Atlantis, its lore.

Created by designer Toby Guard, Lara Croft started out as Laura Cruz but, as her backstory evolved, Guard decided that she needed to be of English descent, and changed her name. Guard wanted to reflect that there was more to Lara's life than what the player initially knows, and hints at her history during cutscenes and dialogue.

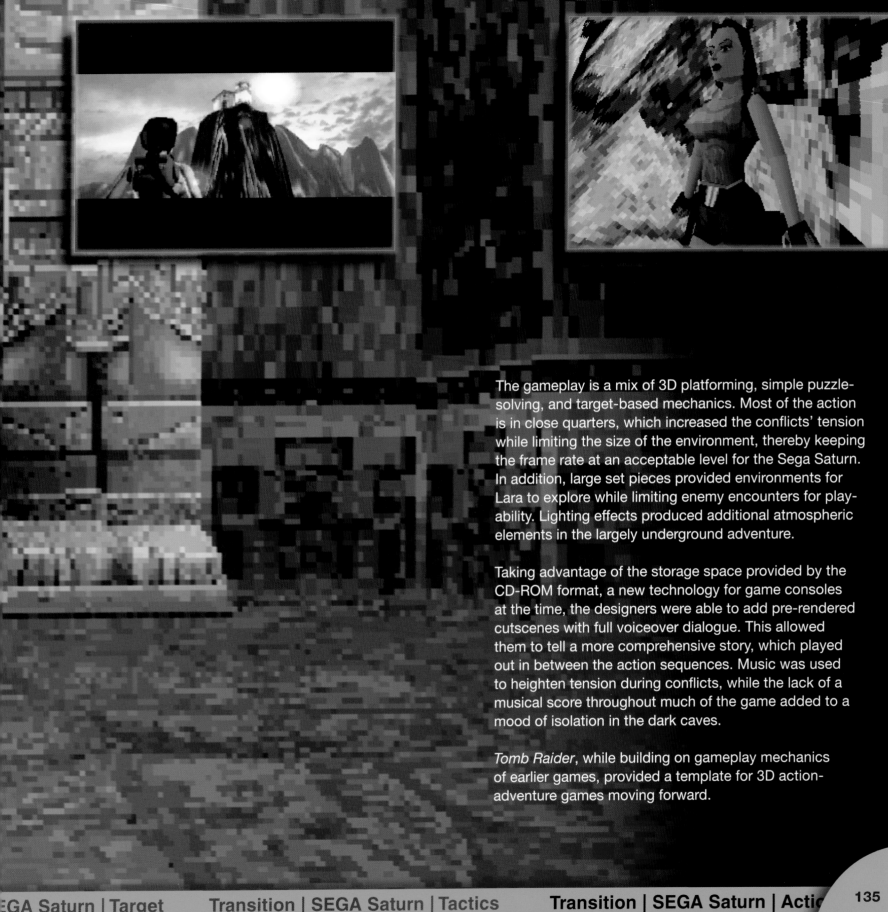

The gameplay is a mix of 3D platforming, simple puzzle-solving, and target-based mechanics. Most of the action is in close quarters, which increased the conflicts' tension while limiting the size of the environment, thereby keeping the frame rate at an acceptable level for the Sega Saturn. In addition, large set pieces provided environments for Lara to explore while limiting enemy encounters for playability. Lighting effects produced additional atmospheric elements in the largely underground adventure.

Taking advantage of the storage space provided by the CD-ROM format, a new technology for game consoles at the time, the designers were able to add pre-rendered cutscenes with full voiceover dialogue. This allowed them to tell a more comprehensive story, which played out in between the action sequences. Music was used to heighten tension during conflicts, while the lack of a musical score throughout much of the game added to a mood of isolation in the dark caves.

Tomb Raider, while building on gameplay mechanics of earlier games, provided a template for 3D action-adventure games moving forward.

jon-paul**dyson**

Video games are changing the way we play, the way we learn, the way we relate to one another, the nature of our interactions, and how we spend our time. They're having an impact on our lives far greater than any other medium in recent years. At the International Center for the History of Electronic Games at The Strong museum we're preserving the history of video games from the earliest to the most recent. We're doing that because they are being released in such massive numbers, having such a massive impact, and yet they're such a delicate medium. They're going away almost as quickly as they're being produced, whether it's because they're physical products that decay or digital products that never had a physical existence, so they are threatened to disappear if someone presses the wrong key.

At the museum itself we're all about play; we have the world's largest toy, doll, and game collection. As an institution it makes a lot of sense for us to study video games. We are attempting to preserve these materials so that people in the future will understand not only how the games themselves have changed, but what impact they're having on their lives.

For me, it's always been a passion. I remember when my parents brought home our first computer. They had an Osborne, which was the first portable computer. It weighed about thirty pounds and had a screen about eight inches across diagonally. My first actual experience with a game, though, was not by playing, but by watching my older brother. His high school had a DEC PDP-11, which was one of the first well-known minicomputers. It was a large, multiterminal system. My brother used to play a game called *Dungeon*—more commonly known as *Zork*—on a Teletype terminal.

The game would give him a scenario, and he would type in actions. You would have all these amazing adventures by entering words and being transported to worlds that fired your imagination. My brother would bring home reams of paper—probably broke the school's budget—and I would go through it with him and say "try this" or "you can solve the puzzle this way." So even before I had a chance to play on a computer, before my parents had brought home that first computer, I was playing with them through my brother's experience of playing them. And it was magic from then on.

Most of the artifacts of play are created for children. They're toys. It's a bit harder to collect the things that adults do for play, but computer and video games span the whole age spectrum. There is an amazing sophistication about games, both in their production and also in the imagination they generate in the user. So to preserve the art, designs, and schemes that people have used to create the games is key. From there we can see that the games don't appear magically; it's not like the Greek myth of Athena coming out of the head of Zeus fully armed and ready for battle. Sometimes it's the work of an individual, and sometimes it's the work of hundreds of people. But by marrying imagination to the brilliant use of code, the designers are able to create really compelling game systems that keep people playing no matter what their age is.

Games are also powerful learning engines. People have known this for hundreds of years. The philosopher John Locke, in his book *Some Thoughts Concerning Education*—which is now just over three hundred years old—made the point that children learn best when they're not compelled to do so, and when they do so voluntarily. He said never make learning a burden to them, which is one of the basic characteristics of play.

Video games can be great learning tools when they partake of that tradition. When they are able to teach people in a way that is voluntary and lets them have fun. Kids learn more about city planning by playing *SimCity* than they probably ever would sitting through a million lectures. They can learn more about the growth of civilization by playing a game like *Civilization* or *Age of Empires*. Games open worlds.

Maybe the most important thing is not only the facts that you might learn, but the way that games inspire imagination; the way that they force kids to make decisions, calculate what the best odds are, and foster the ability to work together. The social aspect of games is often neglected but it's key, especially these days since the games are highly connected. So that ability to imagine, to learn facts, and then to figure out how to make decisions and to work together are all great ways that games can teach.

We have paper going back thousands of years, with papyrus going back to ancient Egypt. Video games are much more fragile because of the nature of the medium. First of all, the magnetic information can disappear—think about those old five-and-a-quarter inch floppies. It will decay over time, and the content will disappear. Additionally, there is the whole issue of how you access the information. We're able to access ancient hieroglyphs because we had the Rosetta Stone to use for translation. How are you going to access ancient operating systems? We need a lot of

Rosetta stones to figure out Windows 1.0 or the old Commodore 64 system.

So you have this double danger, of the information itself decaying or not being able to access it. Now we add a third sort of threat. So many games now are being released purely in digital forms. They never exist in a physical medium, so how do you go about preserving something purely digital? On one hand we think someone will make a copy somewhere. But think about how easily we lose documents, or how our hard drive dies and everything is lost.

Play has, for millennia, been key to what makes us human and where we find joy in life. Video games liberate people to do this in new ways. I think video games will reach out to all audiences so that one day people won't say "I'm a gamer," or "I'm not a gamer"; everyone will be a gamer. And that may be because you play thirty hours a week or maybe because every once in a while you play something on your phone—or in some medium we can't even imagine yet.

It's easy to forget that video games are only half a century old. They're young. It would be like talking about the novel in 1789 and not being able to imagine the hundreds of years of amazing art that would come after that. Ten, twenty, one hundred years from now, we can't even predict where games are going. Personally, I think the best games are ones that build connections between people and in new ways, and thus make our lives more richly human than they were before, even though we're playing with a computer.

FINAL FANTASY VII

1997, Square

FINAL FANTASY VII's use of technology, art, and narrative, ushered in a new era of role-playing games in the West. It combined exquisitely detailed 2D drawings and backgrounds with a detailed and thought-provoking storyline and a musical score that stands as one of the most popular in the history of video games.

While a strategic role-playing game sits beneath its inspired art direction, it is the story that brings the focus of the game into sharp relief. Designer Hironobu Sakaguchi created a world that sheds light on ecological issues, the balance between progress and respect for the world, and appropriation of natural resources by corporations. While the game exists in a fictionalized universe, the comparison to our real world is evident.

Development of the game brought up compromises as Sakaguchi's team struggled to bring such a grand vision to the PlayStation platform. Due to the PlayStation's limitations, the 3D characters in the game are less detailed than character artist Tetsuya Nomura had originally designed. This, in turn, directed the manner in which the more than forty minutes of cutscenes in the game were crafted. The character design, physical models, and composition were simplified so that the transition from the gameplay to the cutscenes was not jarring.

FINAL FANTASY VII—with its complex narrative, beautifully rendered environments, lovingly crafted models, and dramatic musical score—stands as a pivotal demonstration of the medium's potential for evocative storytelling.

Metal Gear Solid

1998, Konami

Metal Gear Solid, building on the successful franchise created by Hideo Kojima in 1987, was met with awe when unveiled in 1998. Using the backstory established in the earlier games, *Metal Gear Solid* successfully brought protagonist Solid Snake into a 3D world filled with espionage, danger, and adventure. *Metal Gear Solid* is credited as one of a handful of games that firmly established Sony's first video game console, the PlayStation, as a dominant platform in the transition era.

In a scenario that could be ripped from the headlines of a real newspaper, the player follows the story of Snake, a Special Forces soldier who is brought out of retirement to stop the terrorist splinter cell FOXHOUND, who are planning to launch a nuclear weapon named Metal Gear REX. The composition of the game, the emphasis on stealth action versus firefights, and the over-the-top enemies and gadgets are all heavily influenced by Kojima's love of movies, evidenced by the cinematic quality of the narrative.

Kojima's intended goal was to create the best PlayStation game ever made, and in pursuit of this he wanted the world to be as realistic as possible. He employed the use of sculpted clay models for the principal characters as references for the digital artists, traditional brush art for concepts, and multiple camera placements for a dramatic, cinematic effect.

The pacing, story development, and attention to detail on display in *Metal Gear Solid*—from the opening underwater cinematic to the final encounter with Liquid Snake—had the player stepping into an interactive movie in which actions had real consequences. The design of the world allowed for multiple ways to address each situation, and it is left to the player to decide the level of force or stealth to apply. In fact, the player may complete the game without killing a single character. This offers the player the opportunity to see his own sense of morality reflected in his in-game actions.

Kojima's perspective on war is that it should not be used to solve problems; diplomacy is always the first course of action. Despite the content, all of Kojima's games contain an anti-war message as he believes war tends to develop a life of its own, even after a goal has been achieved.

What Kojima achieved with *Metal Gear Solid* was to set the standard for all stealth action games that followed.

ure **Transition | PlayStation | Target** Transition | PlayStation | Tactics Transition |

EINHÄNDER

1998, Square

EINHÄNDER was the first 3D shoot-em-up, or "shmup" to grace the PlayStation platform. Developed by SquareSoft, best known for its role-playing games, it was also the first side-scrolling shooter for the company. After learning how to bring 2D RPGs into the third dimension, SquareSoft here demonstrated how to evolve the target-based game.

During this transitional era of game development, SquareSoft managed to marry two different disciplines: 2D illustration for backdrops and 3D art for environments, ships, and characters. Using a fixed camera, the game will shift the point of view from 2D to an isometric position, rounding out its environment and allowing the producer of the game to script how the player moves through the playfield.

In the era of transition, developers struggled to balance their designs with the capabilities of their platforms: overly ambitious, the art and gameplay would sometimes break down; not ambitious enough and the experience is quickly dated. By layering simplified 3D models over 2D backgrounds, the visuals appeared to be more detailed than they actually were, and *EINHÄNDER* became a breakout game that redefined the 2D side-scrolling shooter.

FINAL FANTASY TACTICS

1998, Square

FINAL FANTASY TACTICS is a tactical role-playing game that takes place in a fictionalized world not in the official Final Fantasy canon. Leveraging the creative design of Hironobu Sakaguchi and art direction of Hiroshi Minagawa, *TACTICS* exhibits several notable areas of distinction from the rest of the series.

Unlike *FINAL FANTASY VII*, *TACTICS* utilized more simplistically rendered 3D environments and highly detailed sprites for the characters. The decision to reverse the formula was dependent on three things: the need to rotate the playfield during battle to observe the game board, to create different elevations in the playfield for tactical considerations, and to focus on the characters, not the environment.

As in chess, *TACTICS* is turn-based, allowing each side to move and attack. The ability to create landscapes with elevations from which a player may have an advantage sets *TACTICS* apart from other real-time strategy games, which were historically 2D affairs. This created the ability to offer

an array of conflicts and forced the player to consider different strategies depending on the particular scenario, from the same basic group of commands.

Similar to other Final Fantasy games, however, was the employment of an engaging storyline that propelled the game's momentum and provided context for the battles the player engaged in. Set in a kingdom called Ivalice, the story unfolds after the Fifty Years War, in the shadow of a kingdom without a ruler and an heir who is still an infant. The ensuing power struggle for the throne follows the course of characters who seek the crown by becoming the guardian of the infant. Many of the attitudes displayed in the dialogue between noblemen and common citizenry reflect real-world class systems.

FINAL FANTASY TACTICS manages to balance the compromises of the PlayStation and deliver an experience that evolved the tactical RPG genre while staying true to its 2D-era heritage. The shift to 3D design is a case of the genre advancing forward from both an experiential and aesthetic point of view.

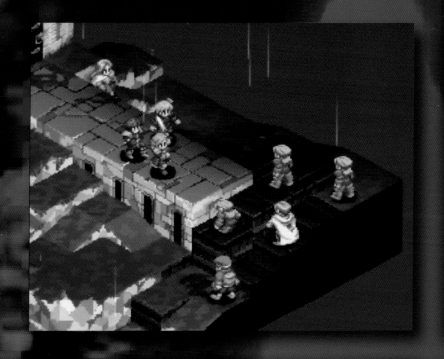

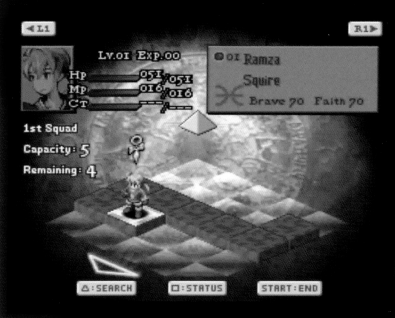

Black knight
What's going on?
It's been nearly an hour!

NEXT GENERATION

enture | Target | Tactics Action | Adventure | Target | Tactics Action | Adventure | Targe

The future is impossible to predict, but we have markers to help guide the way. With more than forty years behind it, the video game industry has amassed a vernacular that provides a foundation for creative expression in the medium. This foundation, which sits at the intersection of art and technology, provides a jumping-off point for developing new works of art, narrative, and social reflection. And it is ever evolving.

As video game platforms become more powerful, they provide the ability to render photorealistic environments, sophisticated and dramatic stories, fantastic worlds born from a designer's imagination, and the ability to play with, and against, real people from across the planet from the comfort of our homes. We push into the future, building on lessons learned, to provide the opportunity for experiences not yet dreamed of.

It is important to be mindful of the fact that video games are still an adolescent medium, and one that needs tending in order to grow and evolve. We are still in the early stages of the video game timeline. Over the forty-year existence of the home game, we have gone from the simple paddles of *Pong* to the photorealistic environments and motion-captured acting of *Uncharted 2*. By comparison, it was approximately forty years after Thomas Edison's introduction of the Kinetoscope that the first Mickey Mouse cartoon was created. On the evolutionary curve, video games have a rocket beneath them.

The only advantage that other forms of media have over games is time. This too will fade, and games will continue to become a deeper part of global culture, discourse, and expression.

The bookends of technology and art do not define this era; rather, it remains open-ended, progressive. This era demonstrates a maturation of the medium while laying the groundwork for new experiences yet to be unfurled.

This is the beginning of the future. This is the Next Generation of the art of video games.

Pick the lock.

Interrogate yo

nteract Ⓐ

wo comm

Tom Clancy's Splinter Cell

2002, Ubisoft Montreal

Tom Clancy's Splinter Cell, not written by but endorsed by the popular author, follows the story of National Security Agency operative Sam Fisher. Fisher is sent on a mission to avert America from going to war, and as a lone covert operative, relies on the use of stealth over brute force in achieving his objectives.

Previous games, such as the Metal Gear series by Konami, utilized similar narratives and tactics for dealing with hostile conflict. However, the Xbox console presented the opportunity for stealth-oriented games to make a huge leap forward in both realism and gameplay mechanics. The additional rendering power of the Xbox meant that artists could deliver realistic light patterns and shadows, providing both the perfect cover for Fisher and the possibility, if caught in the light, to be discovered by enemies.

Being able to hide in the shadows and manipulate light to the player's advantage defined a new approach to handling conflict. The player was encouraged and rewarded for the use of nonlethal force in achieving mission objectives. Rendering enemies unconscious and avoiding detection through acrobatic maneuvers became synonymous with the series. *Splinter Cell*'s accurate depictions of military and covert agencies coupled with realistic environments, an emphasis on stealth over conflict, and an engaging, believable story line resulted in a game that stood apart in a crowded genre.

r opponent.

Fable

2004, Lionhead Studios

Produced by world-renowned game designer Peter Molyneux, *Fable* places the player in the role of a young boy orphaned by the destruction of his village and family. The story is set in Albion, a familiar, Tolkienesque medieval environment, and unfolds through a series of quests and cut scenes that drive the narrative.

As in other Molyneux games, player actions are critical to the development of the character. The player is often faced with choices that present a moral dilemma, and the ensuing actions manifest themselves in the protagonist's appearance. The game character's changing physical attributes influence the reactions of Albion's residents, and their attitude towards the player character can run the gamut from fear to love.

Molyneux was striving to create a game in which each player has an experience that is wholly unique to him or her. The player's ability to execute free will and then live with those consequences make the choices significant. Moreover, the world itself is granted a sense of verisimilitude due to a complex weather system, day/night cycles, and continually changing seasons. With computer-controlled characters that have unique lives of their own, including families they raise and different ways of interacting with the player, *Fable* presents a story with a common arc but a special experience for each player in the world of Albion.

Panzer Dragoon Orta

2003, Smilebit

The fourth and final chapter in the Panzer Dragoon saga represents the culmination of the storyline and stands as a composite of the three previous games' design direction. Utilizing the rail shooter framework of *Panzer Dragoon II: Zwei*, the dragon evolution system from *Panzer Dragoon Saga*, and a strategic element that allowed the player to choose among three dragon forms resulted in a game that echoed past design in order to exceed it.

Producer Takayuki Kawagoe's swan song for the Panzer Dragoon universe was one of the most visually striking games to grace the Xbox, and it still holds up today. The earlier entries in the series employed on-rails gameplay and a forced perspective due to underpowered hardware, but the designers of *Orta* retained those elements in order to use the increased processing power of the console for the visuals, to stunning effect. What began as a design necessitated by technological limitations became an artistic boon for the Xbox.

The game follows the story of a young girl named Orta, an orphan who is determined to learn the truth behind her lineage and defeat the forces that want to use her for their own nefarious purposes or destroy her. The plot features numerous connections to the earlier games, particularly *Panzer Dragoon Saga*, and serves to complete the overarching narrative of the series.

By leveraging the same root game mechanics, design elements, and gameplay frameworks of its predecessors as well as elegantly weaving story elements throughout the game, *Panzer Dragoon Orta* stands as the zenith of a universe that spans not only multiple generations of video game systems but multiple generations of characters and histories.

HALO 2

2004, Bungie

Halo 2, the sequel to the game that helped define the Xbox, builds on the deep backstory of the Halo universe while managing to improve and refine almost every major mechanic of the game. In the same way that painting techniques evolve as artists experiment and become more familiar with their tools, so too do game designers follow an evolutionary path. The vivid environments, advances in artificial intelligence, and expanded use of in-game cut scenes were a result of the artists and designers learning how to coax more capabilities out of the Xbox.

The narrative follows the actions of Master Chief, an officer of the United Nations Space Command. The player, inhabiting this character, never sees what he looks like or knows his real identity, providing a blank slate on which the player can project himself to assume the role of the hero. This establishes a more personal investment for the player and adds weight to the game's intense combat encounters. A wide variety of science fiction works inform the game, most notably Larry Niven's *Ringworld*, James Cameron's *Aliens*, and Iain M. Banks' Culture series.

Themes of empire building, religion, betrayal, and assimilation drive the narrative and set the stage for the war that Master Chief and his companions must wage to stop the spread of an alien parasite known as the Flood. Underneath all this, *Halo 2* is a polished game boasting an excellent balance between story, gameplay, and superb sound design. Beyond the single-player experience, the game is also notable for its online multiplayer component, bringing people from all over the world together to interact via Microsoft's Xbox Live service.

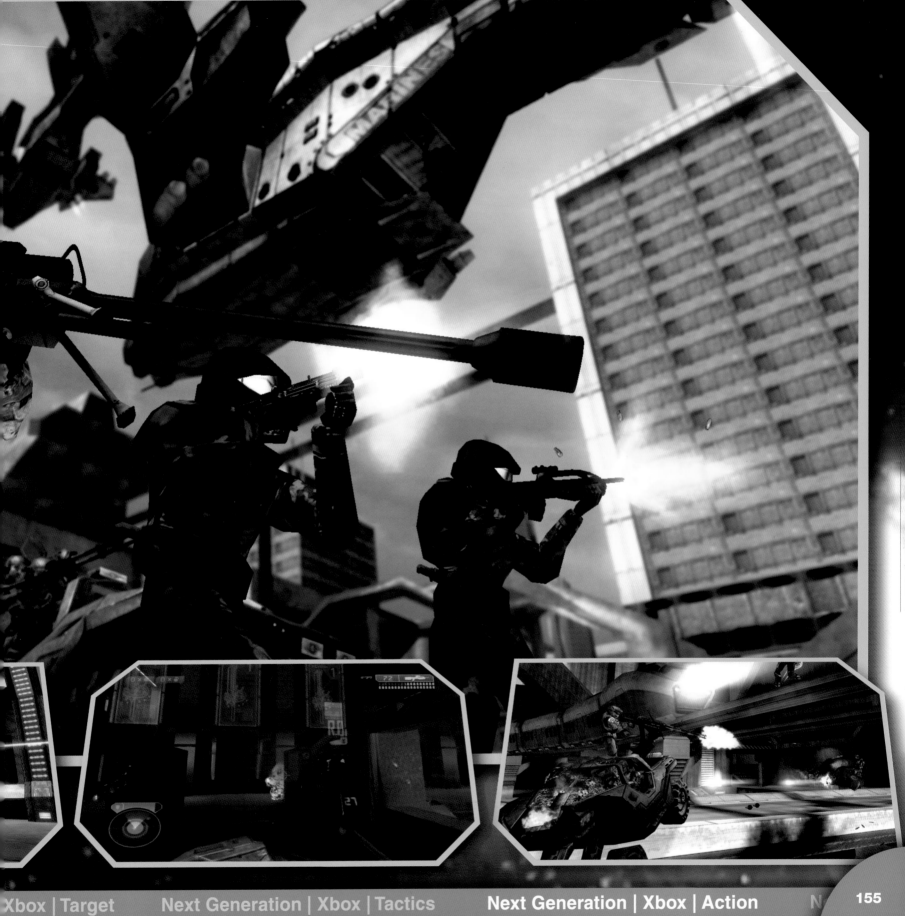

jenmaclean

I remember being seven years old and playing *Pitfall!* on my Atari 2600. It gave me the chance to be Indiana Jones, jumping over alligators, finding treasure, then getting killed by scorpions and hear that awful *mhhh* sound. It was just so engaging. For a kid with a huge imagination like me, it was a great way to put myself in a different place. I played these text-based games from Infocom for years because I could control where the story was going. I could put myself in the role. I was Hercule Poirot or whoever the main character was. That kind of immersion for a geeky little kid with a lot of imagination was an amazing experience.

A contemporary game that's had a profound impact on me is *Mass Effect 2*, which I've gone back and played and replayed. Again, the story is so involving. Being a woman, particularly, you can make your character Commander Shepherd—who is out there saving the galaxy—a male or a female. So I have this incredible protagonist. She looks like me. She's named after me. She does exactly what I tell her to do. She's been on all these amazing adventures. She's falling in love. And she's saving the galaxy. The fate of all humankind is resting on her shoulders, and she does it with grace and panache, with a pretty mean right hook as well. It's so much fun and so exciting, especially when you see her in combat and wonder, "Oh my goodness, everybody's swarming me. How am I going to get out of this?" Or you're falling in love with another character in the game, or trying to win the loyalty of a teammate. And if I see one of them die, the emotions that it provokes are profound. It's unequal to anything that you get on television or in books or movies.

If you ask me about games that I've worked on and which one is my favorite, I have two answers. There's a game that I still play, *Civilization 2*. I started working on it back in 1995. I was the lead tester. The catch line for *Civilization* is "build an empire to stand the test of time." That is a game built to stand the test of time. Sixteen years in and I'm still playing it. I love that game because every choice you make has a consequence; there are no throwaways. I get so invested in the civilization that I'm creating and so invested in the people, that I find myself having this strange emotional connection to all of my cities.

My second answer would be the games that I'm working on now at 38 Studios, of course—*Reckoning and Copernicus*. I love those games because you see the narrative behind the world, as it was created by Todd McFarlane, an award-winning comic book artist, and R. A. Salvatore, who's a *New York Times* best-selling author. These two guys—both incredibly masterful in creating worlds that people care about—will talk to you for hours about how important it is to have your players become emotionally invested in the story, and ways to do that. Whether using animation or writing, they really live it and breathe it into the game, which is so important for believability and emotional resonance.

I think that the impact of technology on the art of video games is overrated, frankly. You can have an incredibly moving emotional scene in a cartoon, just from pen and paper. Or look at Hemingway's famous short story: "For sale: baby shoes, never worn." Six words can create a powerful emotional response. With games, I look back at some of my experiences, with *Pitfall!*, *Civilization*, or *Mass Effect 2*, for instance, and I realize it was not important whether I played them on a big screen television or that I had latest game console. Rather, it was the feelings that the games evoked in me. Fundamentally, you don't need technology to produce those emotions. You don't need technology to create feelings—love and fear and hate and

passion. You need great storytelling. And storytelling can be done using visuals, through dialogue, or even in the packaging of the games. Infocom made amazing packages that had little tchotchkes in them, all in the service of telling a story. None of those things depend on technology.

There have been amazing breakthroughs in technology, however, particularly in mobile gaming and portable gaming platforms, such as the iPad and the iPhone. When I would travel I used to bring an iPod so I could listen to music. Now it's all about my iPad, because I'm playing games. Forget the movies, forget the music, forget being productive and checking e-mail—I am playing *Battleheart* and making sure that my cute little people are getting out there, beating the dungeons, and leveling up. The idea that you can take gaming anywhere with you and it can be in a device that fits in your hand . . . that's so powerful. It's a way to allow people to play games where they want, how they want, when they want. You're not stuck in front of a television or a computer anymore.

Games aren't just about blowing things up. Games aren't just about looking at pixels moving around and trying to get a high score. Games are a way to tell a story, a way to share your point of view. They are as much art as any form of traditional media—writing, painting, music, or movies. All of those things are about sharing your story with the world. When you look at a game, at the incredibly rich amount of love that everyone has poured into the game, you realize they're sharing a story with you.

Don't dismiss games. "Oh, it's just *Space Invaders*; it's just a bunch of pixels coming down and I have to blow them up." No—start thinking about the emotions behind it. Start thinking about the story. If these invaders from space are coming to your homeland, doesn't that give you a feeling of urgency? Doesn't that give you a feeling of excitement, so that you want to make sure you blow every one of them up because you don't want them landing on your planet? Start thinking about the stories behind all of these games. Ask yourself what stories you have to tell.

Hacked Mech
Health

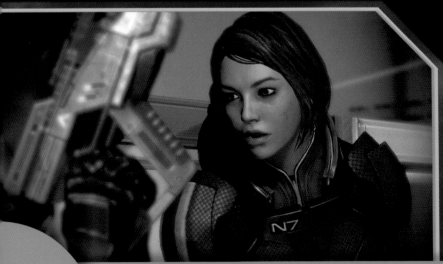

There's no time to argue.
I gave you an order!

Mass Effect 2

2010, BioWare

Mass Effect 2 is an extraordinarily complex and detailed space opera that asks the player to completely engross himself in the role of the protagonist, Commander Shepard. Cinematic in presentation and grand in scope, the Xbox 360 gave designer Casey Hudson the perfect digital canvas on which to paint this sprawling universe. Further, the elaborate customization options of the protagonist's gender, race, and skill set means that each player's experience is wholly his or her own.

Tasked with an epic adventure full of betrayal, intrigue, and a battle for galactic dominance, the intricate and ambitious design of *Mass Effect 2* is evident from the outset. Highly detailed environments, photorealistic characters, a soundscape that brings the environments to life, and rich voice acting immerse the player in a believable, fully realized world. The player's actions are equally responsible for that immersion, as the decisions that define the game's outcome are executed through the dialogue system—now a hallmark of BioWare games. The choices of the player determine how one's allies and enemies react and allow him or her to fall in love with the other characters (and vice versa)—and ultimately determine whether Shepard lives or dies at the game's conclusion.

Stunning graphics, complex issues, realistic character interactions, and even pacing keep players engaged in the compelling story unfolding at their hands. The connection to Commander Shepard intertwines with the morals, ethics, and emotions of the player, creating a bond between player and avatar that makes for a unique storytelling experience.

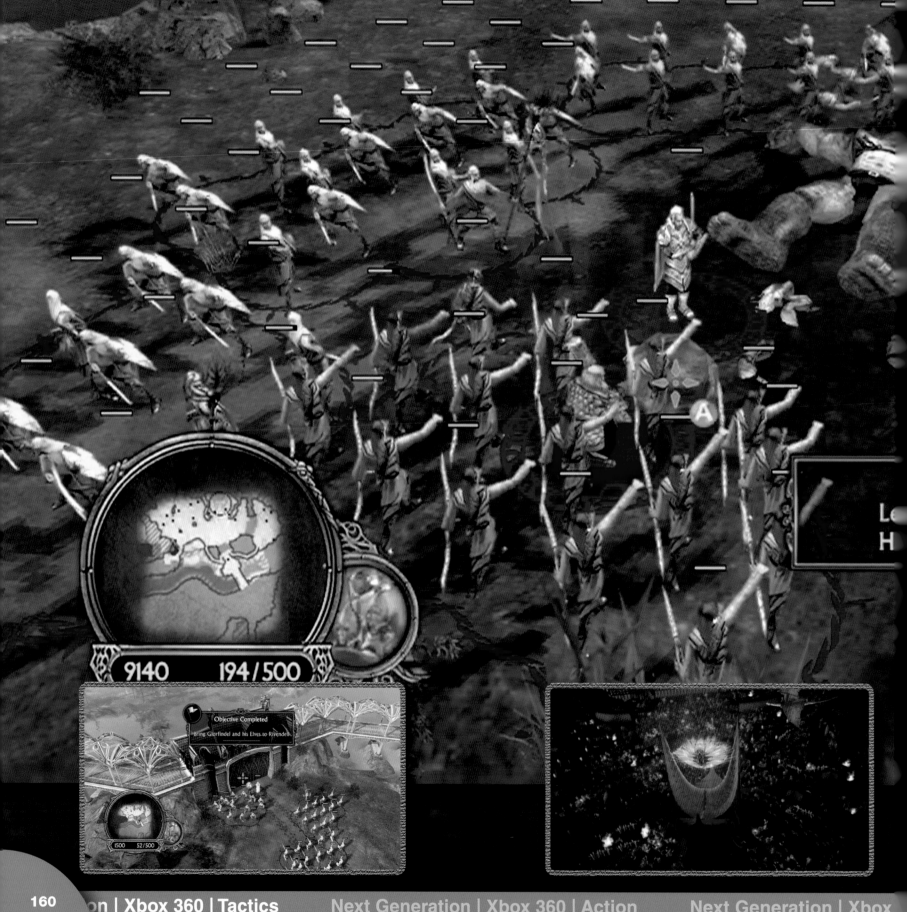

Objective Completed
Bring Glorfindel and his Elves to Rivendell

9140 194/500

1500 52/500

A

L

H

Gloin

/ Maximum Level: 10

3000

Lord of the Rings: The Battle for Middle-Earth II

2006, EA Los Angeles

Lord of the Rings: The Battle for Middle-Earth II thrusts the player headfirst into the deep and compelling world of J.R.R. Tolkien's beloved fiction *The Lord of the Rings*. The real-time strategy game's story follows the adventures of the Elven soldier Glorfindel as he ultimately seeks to end the War in the North and protect the Elven sanctuary Rivendell from falling to the army of the evil Lord Sauron.

The art direction for *The Battle for Middle-Earth II* evokes imagery from the film trilogy based on Tolkien's work, and is further informed by descriptions found in the novels, thereby achieving a visual link between the two mediums. The Xbox 360's powerful graphics system allowed for beautifully rendered environments, including realistic water and lighting effects, while simultaneously permitting on-screen a large number of characters engaged in battle. Players are able to realize the large-scale battles that have played through in their minds as they read or watched unfold in the movies.

One of the challenges in bringing such a well-respected and much loved franchise to the world of video games is the risk of alienating fans of the original works. By limiting the action of the game to events that are not described elsewhere, the writers were able to stay true to the timeline of the original work while offering a view into an unseen battle that tipped the war against Sauron.

Providing a convincing narrative that built on players' familiarity with the source material, leveraging the power of the Xbox 360 to realize the fantastical world, and utilizing compelling mechanics to make a real-time strategy game accessible on a console, *The Battle for Middle-Earth II* may be marked as a triumph.

BioShock

2007, 2K Boston

BioShock is a prominent example of the complexity that can be captured in video game narratives. Set in a fictionalized 1960s, the game revolves around the mystery of a dystopian, underwater city named Rapture. The player guides the actions of Jack, who discovers the underwater city after surviving a plane crash in the ocean and swimming to a lone lighthouse. The lighthouse provides a transport to Rapture and thrusts Jack into the dark and disturbing city and its beautiful art deco–inspired structures.

The world of Rapture was created as a utopian environment where man and science would not be bound by law or ethics. In the pursuit of knowledge without boundaries, scientists in Rapture created a stem-cell biotechnology dubbed "ADAM" that could alter the DNA of humans and grant them extraordinary powers. As with many utopian ideals, Rapture eventually fell into a dystopian state and was destroyed by mutated humans with an insatiable thirst for ADAM.

The game's narrative engages with contemporary ethical issues and questions. Stem-cell research, boundless scientific exploration, and political oppression are all facets of the story. Inspiration and influence from the writings of Ayn Rand and George Orwell as well as books such as *Logan's Run* are evident in the world the player uncovers, and his or her moral and ethical choices directly affect the game's outcome.

Electro Bolt

Beautiful, isolating, and desolate, *BioShock* manages to deliver an action game that forces the player into uncomfortable situations and requires him or her to think about the implications of one's actions.

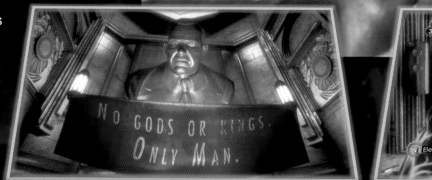

Geometry Wars: Retro Evolved 2

2008, Bizarre Creations

Geometry Wars: Retro Evolved 2 is an example of pure game design that rises above its simple presentation. Built on a "twin stick" control scheme first implemented in the 1982 classic arcade game *Robotron 2084*, the game also referenced a genre in which a single control device determines movement and shooting. *Geometry Wars'* success rests upon its approachable design and simple but vibrant geometric art, not from a meaty narrative that holds the game world together. It is this freedom that allows the player to connect with the frenetic action and get lost in unadulterated play.

Set on a simple grid floating in the void of space, the player must pilot his ship around the playfield and destroy attacking geometric shapes, all in pursuit of achieving the highest score possible. Each shape has a different attack pattern that the player must understand to effectively eliminate them all. An advantage of using such simple shapes is the ability for the system to render more items on the screen at once, including the amazing, fireworks-inspired explosions that result from a hit and work to distract the player from the frenetic action.

There are times when the art of video games cannot be understood using traditional metrics. Rather, it must be discovered simply by game participation—so the player may marvel at a stunning design or smile from the satisfaction of receiving a high score.

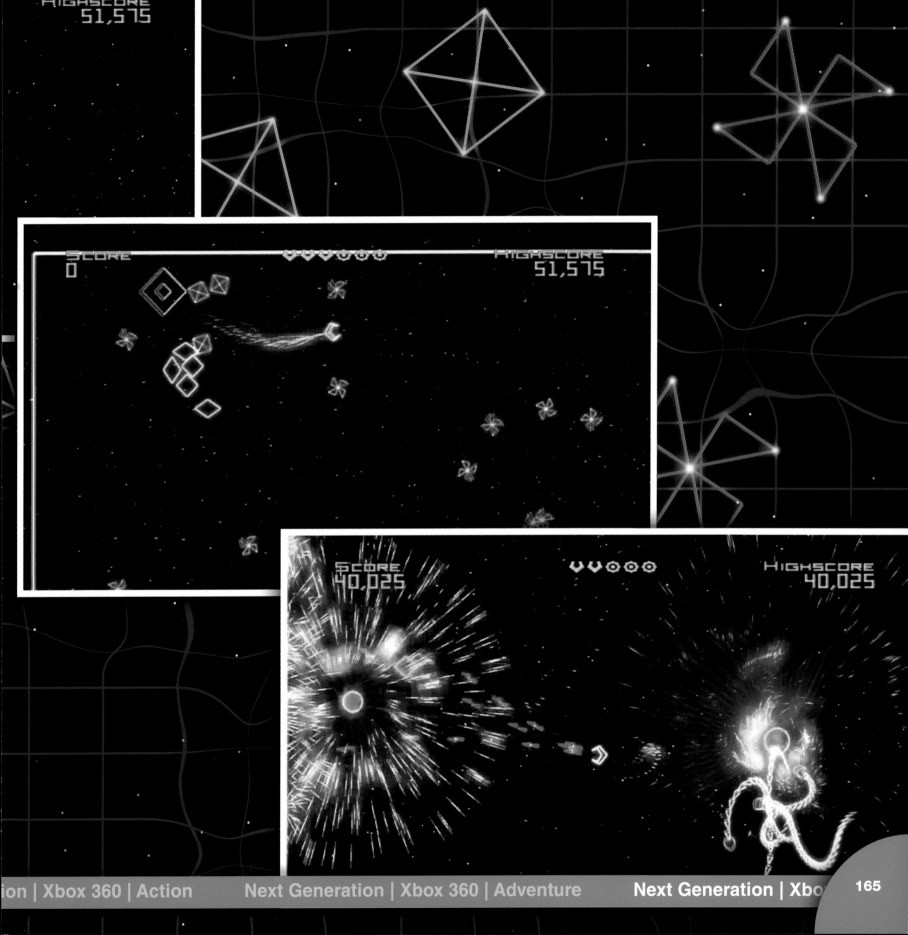

chris**charla**

Growing up, I was drawn to games. I love voyeuristic entertainment like watching movies, but when push comes to shove, I want to participate. I want to be part of the action. That's why I love games so much. I don't think I ever decided to work in video games; it just never occurred to me to do anything else. I never thought about working for an insurance company or something. The earliest conversation I remember having about what I wanted to do when I grew up was with a friend, and we had big plans. We would make text adventures and move to Boston to work at Infocom.

I was really into the Infocom games. They told a level of story that was interactive in a really deep way. When those text adventures went away, that kind of interaction in story design didn't come back until probably the past three or four years—and it is awesome to see it back. Those games were an early influence in terms of the kind of story I wanted to tell. So were Apple II games like *Conan* and *Starblazer*, which had this feeling of exploration. I want to recreate or help other people recreate that feeling. That's what makes me really excited about making games.

A title that recently had a profound impact on me was *Heavy Rain* from Sony, which is a stunning game. It's a really deep adventure with excellent game play. Fantastic art. It really elicited emotional responses. It was probably the game that most realized what I expected games to be like when I was a kid. I was immediately sucked into the fiction, and it just blew me away.

For games like *Heavy Rain*, the narrative is everything. The game exists in service to tell a story. Other games are more visceral; it's just about what my thumbs are doing, how fast my head is working. Only a real weirdo is thinking about the backstory for *Geometry Wars*. I'm one of those weirdos. I like to make up a backstory for

why my little geometric shape is there shooting other shapes, but it also depends on the game.

I work at Microsoft in the Xbox Live Arcade group, which is basically a system for the digital distribution of games. We've worked with a lot of indie developers, a lot of young developers making pretty small games, and they are completely changing the business model for how video games work. When I talk to these guys, their vision of a game is completely alien to the vision of some old walrusy guy who has been making games forever, and says, "The game's gotta be in a box! The game's gotta be built by a team of people!" We have single guys who have a vision, work on it for a couple of months, realize it, ship it on XBLA, and make hundreds of thousands of dollars.

We're back to the garage in some ways, which is just how games got started, with dudes working on their Apple II at home, putting a disk in a baggie and sending it out. Technology is just a box that you work in, and you try to maximize what you can do inside of it. The walls are so far out there now. There are so many different visions you can realize inside the technology that I think the raw tech is getting less and less important. The tools that you use to develop are now more important than the power in the systems; it's more about the artistic vision of the creator. The fact that technology has enabled us to get back to having a single auteur make a fantastic video game experience is amazing. To me, that is where the future is.

I think no one understands—even my generation, who basically grew up with games and totally love them—is how embedded the games have become in the fabric of not only pop culture but social culture. There's nothing wrong with saying videos games are entertainment. To me there's no shame in saying, "I'm an entertainer." So on the one hand they're fun, they're a diversion. If I'm bored for five minutes, I pull out my phone and quickly play a game. At the same time, just because it's entertainment doesn't mean it isn't an essential part of the cultural fabric, and a growing part of the cultural fabric.

In the same way that the printing press changed everything, and the same way talking pictures changed everything, there are whole generations of people who have lived their lives more or less defined by those developments. You can say, "That was my *Gone With the Wind* moment." That's the way we are now with games, especially the younger generations. So it's no insult to say video games are entertainment, but it's also completely missing the point if you don't recognize that they are completely ingrained in our culture now.

Flow

2006, thatgamecompany

Flow was created by designer Jenova Chen, in collaboration with fellow student Nicholas Clark, as part of the former's master's thesis at the University of Southern California School of Cinematic Arts. Chen's goal was to create a game that would dynamically change in relation to the player's abilities. This concept, known as dynamic difficulty adjustment, or DDA, provides a framework for adjusting the actions of computer-controlled entities to match the player's skill arc, resulting in a unique experience for each participant.

What separates *Flow* from other games in the genre is that there is no end state. The player takes on the role of a segmented, aquatic-based life form that can descend into, or ascend from, a deep ocean environment as desired. Encountered along the way are other forms on different planes that may be eaten by the player's organism, resulting in a longer tail and more ornate appendages as it evolves. The fluidity of movement, coupled with the ethereal musical score, creates an environment of beauty and tranquillity.

Chen based the gameplay design on the concept of "flow," first proposed by Hungarian psychology professor Mihaly Csikszentmihalyi in the 1960s, which describes the mental state of a person who is deeply focused and energized with an activity or task. Simply put, when a person gives all of his concentration to a specific activity, he or she becomes one with the system and operates at a higher degree of efficiency or skill. *Flow* tests this concept by paring a simplified, point-and-click target mechanic with a DDA-based system.

Beyond the science and philosophy, what *Flow* managed to become by some accounts is the first "art house" game. Balancing the psychology of interaction, an elegance in form, and a soothing soundscape, *Flow* provides players with an experience than transcends the term "game."

Portal

2007, Valve

Blend a first-person action game with a physics-based puzzle game, and what pours out is *Portal*. Taking place in the fictitious Aperture Science Enrichment Center, protagonist Chell awakens to find herself trapped in an abandoned laboratory environment, being led through a series of test chambers by a sentient Artificial Intelligence named GLaDOS. What ensues is a trip through a fantastical ballet of quantum tunnels and Newtonian physics. It is the mind-bending elegance of the gameplay mechanic that enables the environment to become a character itself.

Essential to Chell's escape is the Portal Gun, a device that gives the player the ability to create a tunnel through space, allowing them to step in one portal and instantly emerge from another. This requires the player to rethink how they can move through the world. The player can also use momentum to propel Chell out of a portal, as velocity and orientation are kept consistent between the two openings. As GlaDOS explains: "Speedy thing goes in, speedy thing comes out."

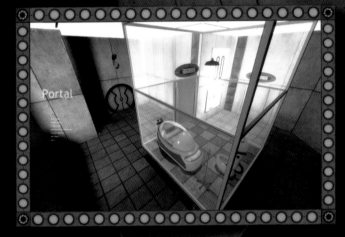

The careful consideration by the design team, led by Kim Swift, is visible in rooms with lights left on, coffee mugs in place, and chairs misaligned, all of which builds the unsettling sense that the facility was vacated only moments before the player stumbled upon it. Frosted glass windows above the player convey the feeling of constant surveillance by mysterious and unseen eyes.

Portal's environment is antiseptic, unnerving, and eventually starts to break apart at the seams; this coincides with the deterioration of GLaDOS' personality from pleasant to sociopathic. All the while its dialogue, delivered in a trilling sing-song, is funny, surprising, and makes the player eager for the next interaction—just as it leads Chell on with the promise of cake at the end of the experiment. *Portal* stands as a solitary experience, literally and figuratively, exemplified by its stark beauty, graceful physics, and dark sense of humor.

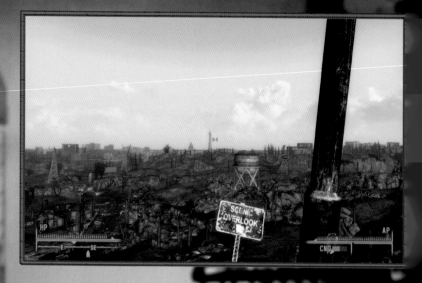

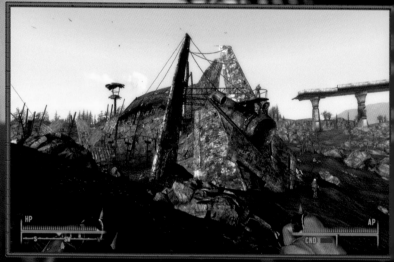

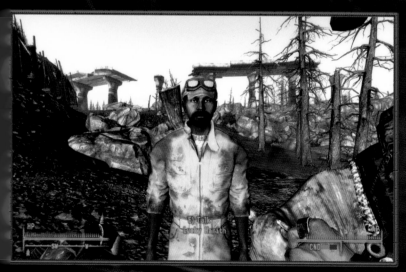

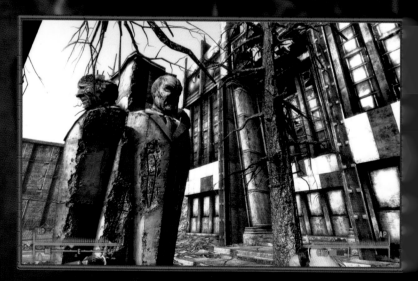

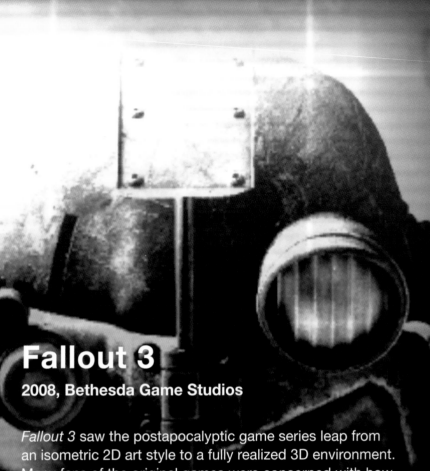

Fallout 3

2008, Bethesda Game Studios

Fallout 3 saw the postapocalyptic game series leap from an isometric 2D art style to a fully realized 3D environment. Many fans of the original games were concerned with how this transition would affect the strategic and turn-based foundation of the original series and feared that the new version would turn into a first-person perspective game like *Halo* or *DOOM*. Their fears were put to rest when the game was released and the sophisticated storyline, dark humor, social commentary, and the distinctive, thoughtful progression of the series remained fully intact.

After a nuclear war laid waste to the United States, mankind had retreated into underground vaults to escape the devastating radiation. The game takes place two hundred years later in a society that had not evolved past atomic-age aesthetics, as evident in the fashions of the survivors, the architecture, and the technology, such as the presence of vintage vacuum tubes. While technology continued to advance in the vaults, that progression merged with old designs and parts, resulting in a world that straddled two different points in time. It is in this environment that the main character "grows up," living his or her life—the player determines gender, race, and other characteristics at the start— inside a vault until the character's father suddenly leaves. The player escapes the vault to search for him, forced to survive amid mutants, warring factions, and violent border towns.

The setting for *Fallout 3* is a scaled-down version of Washington, D.C., with famous landmarks in roughly the same area as their real-world counterparts. Dozens of notable locations such as the Tidal Basin, the Washington Monument, the Jefferson Memorial, and the Lincoln Memorial are included, though in the game they are ruined by war. The Museum of Technology, a fictional institution, occupies the same location of the real-world Smithsonian National Air and Space Museum. The environment effectively demonstrates the devastation possible at the hands of science run amok.

The influences for *Fallout 3* come from a variety of sources: 1950s comics, science fiction, and the atomic age promise of technological advancement. The art style for the architecture is rooted in both real-world monuments and art deco set pieces. Nods to films such as *Mad Max* and *The Omega Man*, as well as documentaries on the Cold War, are all experienced in the dialogue and design of the game. Described as retrofuturistic, *Fallout 3* merges the styles, ideals, and politics of an alternate universe into a wholly personal and unique experience of virtual humanity as citizens emerge from the underground to atone for the damage they wrought.

Minecraft

2009, Mojang Specifications

In many ways, the art of *Minecraft* is not found in the game itself, but in the possibilities that the game offers. Essentially a building game, there is no real plot and no goals beyond one primal, instinctive, human endeavor: to create. The player begins in a virtually endless world, filled with pixelated blocks of various kinds. These blocks can be combined, or "crafted," to make more complex items. Not limited to the surface of the world, players may dig into the ground, creating support structures and mining more materials—hence the name *Minecraft*.

The beauty of the game lies in the creativity of the millions of players that are building in the *Minecraft* universe. To place foundations—upon which vast structures and cities may be built—is of huge strategic consideration. Complex systems may be created using virtual electrical circuits and logic gates. Add to this a sophisticated physics system, day/night cycles that present additional challenges for the player, and the threat of zombies, skeletons, and unnerving "creepers" that can drain your life, *Minecraft* presents a platform for creativity that few games manage to achieve.

The worlds in *Minecraft* exist for one very specific reason: because a creator willed it into existence. One of the joys offered by the game is discovering environments that others have built, marveling at the explosion of ingenuity and expression that appear in everything from a blocky sunrise to the one-to-one scale recreation of the USS *Enterprise*. Ultimately, the engaging way that the creations transcend the graphics allows *Minecraft* to stand apart as a vital platform from which art springs forth.

jesseschell

Video games are an important medium of expression for a number of reasons. First, they are always changing, so the opportunities to do something new are huge. Second, video games are the medium that subsumes all others. Ultimately they will become the übermedium. You can put everything into a video game. You can put a movie in, a book in, music in. You can put in just about anything, and video games are big enough to hold it all.

Regarding game design, one of the things I always say is that games are made up of four fundamental components. Every game has some element of story, some element of aesthetics, some element of rules or mechanics, and some element of technology. People always ask the great board game designer Reiner Knizia where to start when making a game. He'll say, "Well, you should always start in different places, because if you start in the same place, you always end up in the same place." Similarly, you can start with any element when making video games. You might start with a rule or a story. Sometimes you start with a technological idea.

The most important thing about technology is that it should be fundamental to the experience. I often call it foundational technology. Decorational technology is just that; sort of stuck on the outside. Things get really exciting when you have a foundational technology that allows people to do something that no other tool can implement. That's the most exciting time to use technology in video games.

I gave a talk one summer about how these things all fit together. Someone said, "Wait a minute, I heard those Pixar guys talk, and they said story's the thing—everything begins with the story." I thought that was interesting for the Pixar folks to say. Consider their first movie, *Toy Story*. Why is it about plastic toys? Did they decide it was the best story in the universe to tell? No. The answer was they had a technology that could render plastic toys really well. It couldn't render people or animals that well, but plastic toys they could nail. So they started there. What story can we tell about plastic toys?

The thing that people often misunderstand about story is that it is incredibly pliable. Game mechanics are just that—they're mechanical. They have moving parts. They can break. They can seize up if you don't get them aligned the right way. But story is malleable, like clay that you can wrap over things. So a story may be the inspiration to build the game mechanics, but then the story can also be the thing that fills in the holes and patches up everything, making the game solid and successful. The relationship between story and game playing is much more complicated than people realize.

One thing that very few designers concretely focus on is the idea of parents and children playing together. Lots of people make games for kids. Lots of people make games for adults. The idea of designing a game that parents and kids can play together is something that not enough people in the field think about. It's a really powerful idea, because in our society right now we have an entire culture that seems like it's actively trying to rip families apart. We have entertainment that's specialized. Everyone in the family has got his own TV. Everyone's got a little screen in his or her pocket. The divorce rates are higher than ever. Everything is conspiring to break up families. When you can create an experience that brings parents and kids together, it's a powerful one in which they feel like they did something important together. And it has a strong effect. Everyone in the industry says that they

want to make more emotional games. There is no greater emotional bond in the universe than the one between parents and children. When you can make something that fosters and grows that, it's important.

The places that do this best of all are Disney's theme parks. Those environments are designed to have parents and kids in a playful setting together. It was something we were very conscious of with *Disney Toontown Online*, which was ostensibly the first massive multiplayer game for kids, and the first one I had worked on. We focused on designing experiences in which a parent and child would come together. We still use this approach: how do we capture the theme park experience and get it into a game?

There are a lot of things I'd like to see video games achieve. I think the ability to integrate games and simulations into education is greatly underexploited. It is sure to be a significant part of the education revolution in the twenty-first century. But another thing I am so looking forward to is the creation of artificially intelligent characters that you can have meaningful conversations with.

It has been a dream of humanity since time immemorial to be able to create characters like this. I had a realization that these characters—who understand you and respond intelligently—are not going to come out of research labs. They're not going to be developed by big corporations. They're going to come out of games, and at the rate that our technologies are progressing, it will surely happen in our lifetime.

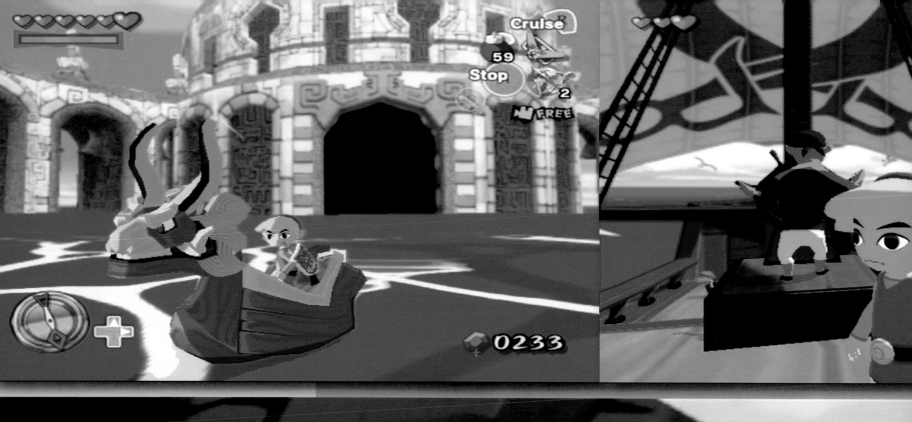

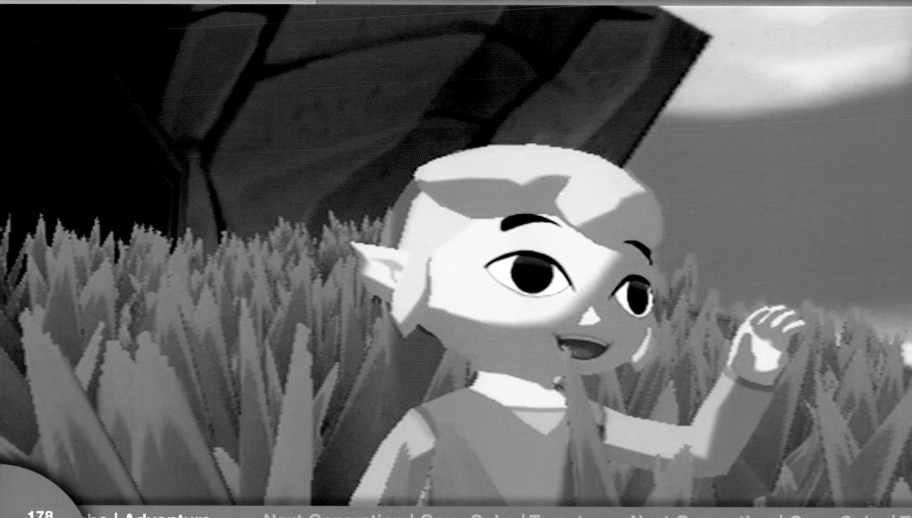

The Legend of Zelda: The Wind Waker

2003, Nintendo

Inspired by the childhood adventures of creator Shigeru Miyamoto, the Legend of Zelda series has always maintained an excellent balance of emotional plot lines and childhood wonder. Much of that sense of wonder comes from the inspired character design and whimsical interpretation of the land of Hyrule and its inhabitants, including the protagonist Link. Link's familiar character design and evolution provided an aesthetic consistency that players had come to expect with each successive game.

After sixteen years, many believed *The Wind Waker* would feature a more mature-looking Link as the next logical step in the progression of the series. However, Miyamoto decided to take the graphical style of the Zelda universe in an entirely different direction, opting for a cel-shaded look. The term refers to a style of 3D animation that makes characters and environments appear like hand-drawn cartoons. Players were shocked when they saw the art for the new game, and many believed that it spelled the end for the beloved franchise.

Cel-shading, however, afforded the designers greater artistic license and the ability to create a highly stylized world that required less processing power than a game attempting to be photorealistic. As a result, Link and the other characters had more animated facial expressions, which helped develop a stronger emotional connection between the player and the characters. The smoother animation and even more whimsical design drew players deeper into the world instead of being potentially distracted by flaws from graphically overreaching. Instead of heading into the uncanny valley of photorealism, Miyamoto opted for a simplified yet highly emotive world.

Metroid Prime 2: Echoes

2004, Retro Studios

Metroid Prime 2: Echoes places the player back into the role of intergalactic bounty hunter Samus Aran, the female protagonist of the Metroid series. Samus must investigate the planet Aether, which has split into light and dark dimensions, restore its light, and defeat her evil doppelgänger, Dark Samus. While building upon the backstory of the Metroid universe, *Echoes* inserted new elements into the familiar franchise. With interplay between the light and dark worlds and a decidedly more mature setting, the new version of the game was rife with conflict for the player to contend with.

Rather than recycle the same graphical and audio elements of its predecessor *Metroid Prime*, *Echoes* producer Kensuke Tanabe had new audio pieces written for the game. New efficiencies discovered in the graphics engine technology allowed the developers to fill the environments with more detail. These enhancements allowed the team to create a denser, more lush experience for the sequel.

The interplay between the light and dark worlds from which *Echoes* derives its name provides unique gameplay mechanics, in addition to establishing an aesthetic conceit. The dark world is a mirror image of the light world, but twisted and more dangerous. Actions taken by Samus in one world will impact and have consequences in the other one. The minimalist soundscape and atmosphere in both of the beautifully realized worlds set the player adrift in his or her own solitude.

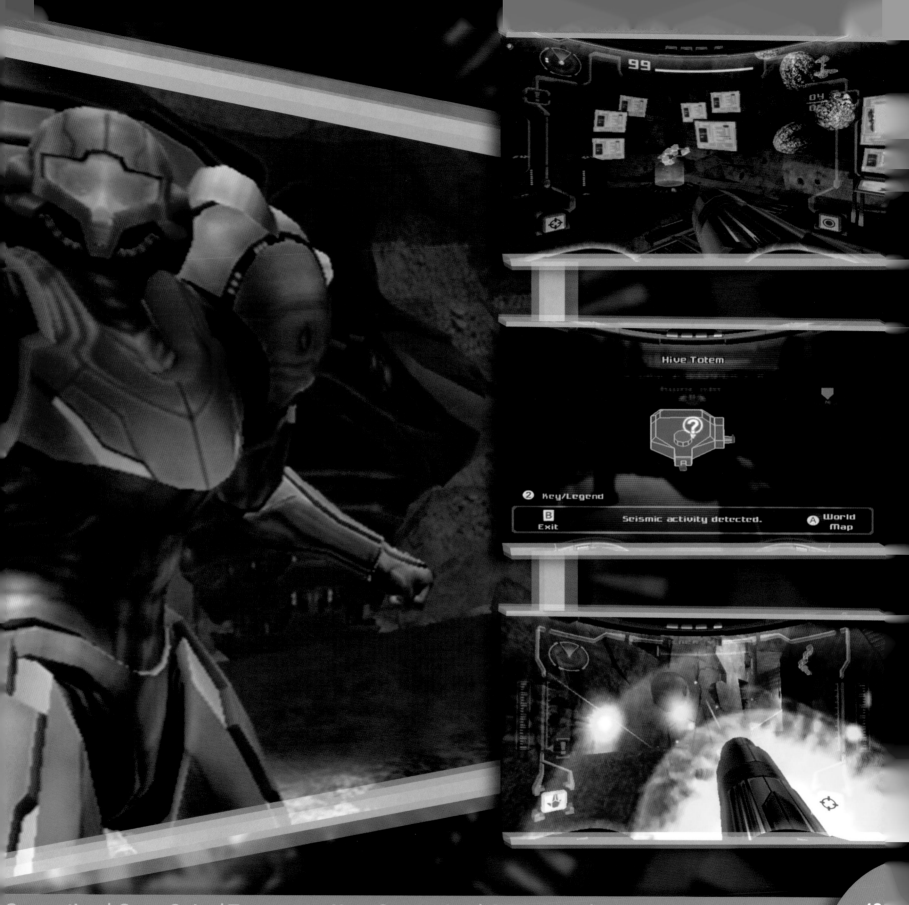

Hive Totem

② Key/Legend

B
Exit Seismic activity detected. Ⓐ World
 Map

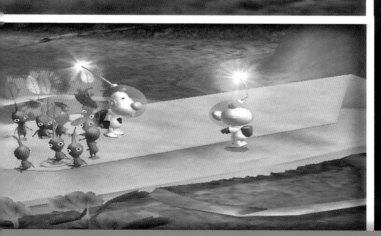

Pikmin 2

2004, Nintendo

The inspiration for the Pikmin universe comes from the most humble of places: one man's garden. Nintendo designer Shigeru Miyamoto was working in his garden in Kyoto, Japan, when he noticed a bunch of ants scurrying around. Observing the way they worked together, he realized that their activity matched an idea he and his team had for a game that revolved around gardening and the manipulation of tiny creatures. The plantlike Pikmin are evolved from this collision of ideas and resulted in the game's artistic direction—which included pictures of Miyamoto's own garden—of a miniature world that bugs inhabit, scavenging the remnants of mankind.

© 2004 Nintendo

In *Pikmin 2*, the player controls Captain Olimar, a miniature interstellar traveler who is searching for treasure. Olimar must grow and harvest the Pikmin and guide them to extract artifacts such as Duracell batteries, rotten oranges, bottle caps, floppy disks, and playing cards. The tiny creatures have a variety of skills that can be used to overcome obstacles; they player can evolve them by replanting and allowing them to grow into their new abilities. Once a group is assembled, the player can order them to perform certain activities required to complete a level.

The bug's-eye view of the world is a colorful, unconventional setting, and the sense of scale is emphasized by offbeat "treasures," such as when several dozen Pikmin attempt to extract and carry a battery back to Olimar's ship. The character design makes them instantly endearing to the player, and their symbiotic relationship with Olimar instills a desire to protect the Pikmin's well-being. Beautiful to observe and rewarding in gameplay, *Pikmin 2* connects the player to the beauty of the natural world, encourages an appreciation for creatures smaller than us, and provides a sense that there is more happening beneath our feet than we may realize.

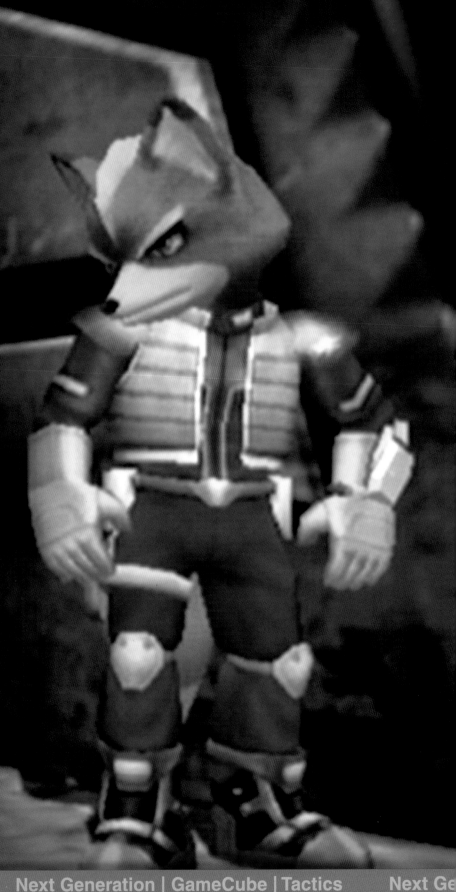

Star Fox: Assault

2005, Namco

Star Fox: Assault is the fourth Star Fox game in the series and the first to return back to its third-person perspective target roots. Although this entry received a lukewarm response from players, some of it may be attributed to the disillusionment of the previous Star Fox title, *Star Fox Adventures*.

Much of the game retains the familiar elements that fans of the series have come to know: an on-rails shooter game with a third-person perspective, beloved anthropomorphic characters, and the familiar Lylat universe setting. The increased processing power of the GameCube console afforded producer Tsuyoshi Kobayashi the ability to experiment with a variety of gameplay modes resulting in a greater variety of scenarios and ultimately expanding the substance of the Star Fox universe.

In the first two games of the series, the protagonist Fox McCloud was constrained to piloting his Arwing spaceship. *Star Fox: Assault*, however, finds the player battling the evil Aparoid race by air, in tanks, and on foot, enabling the player to control Fox himself, not just the ship he occupies. The concept for the Aparoid drew from similar villains in science fiction, such as *Star Trek: The Next Generation*'s Borg, as they seek to assimilate other races into their collective. The fight to defend the Lylay system from incorporation is the primary conflict of the story.

While somewhat flawed in its execution, *Star Fox: Assault* played an important part in reestablishing the Star Fox universe and its mechanics for subsequent games. The power of the GameCube allowed the designers to further immerse the player in this world and provide a narrative foundation for the continuing adventures of Fox McCloud.

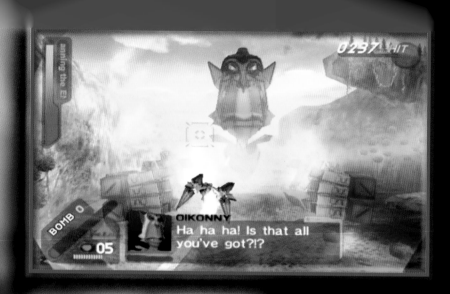

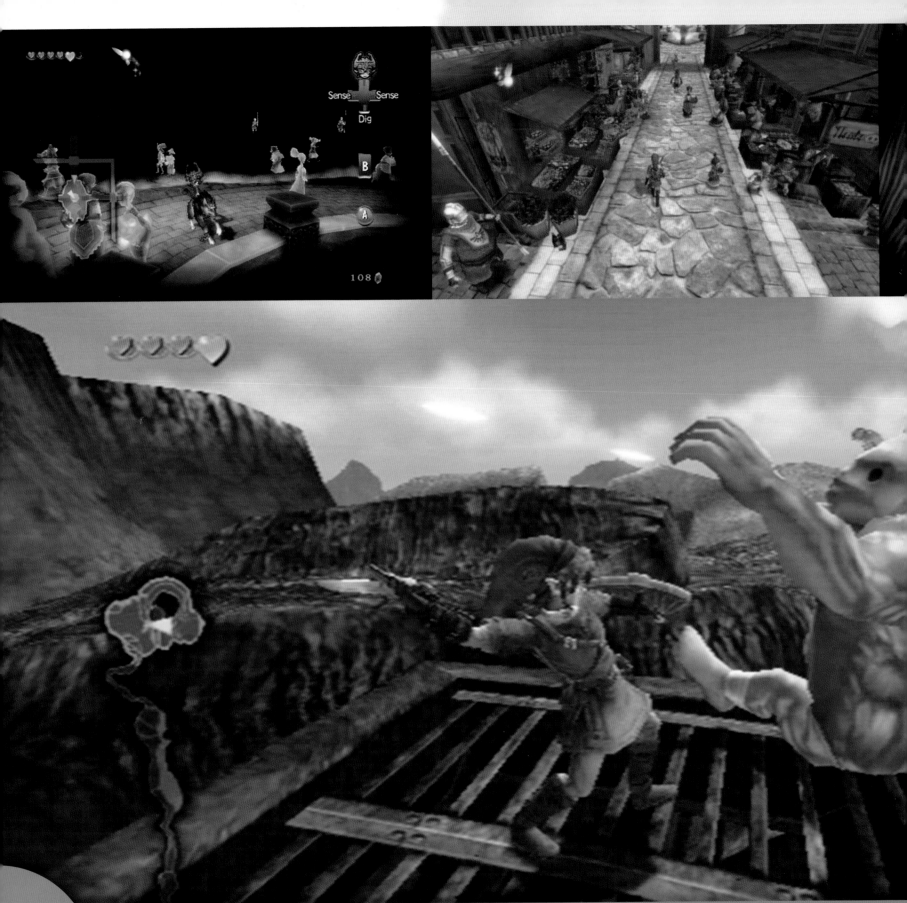

The Legend of Zelda: Twilight Princess

2006, Nintendo

The thirteenth installment in the long-running franchise, *The Legend of Zelda: Twilight Princess* is the first Zelda game for the Nintendo Wii and is regarded by many to be the pinnacle of the series. In *Twilight Princess*, the protagonist Link is a young adult who must defeat the malevolent Ganondorf and save the kingdom of Hyrule. A well-worn plot in the Zelda universe, this iteration set itself apart by bringing a darker and more complex story to the series.

Intent on appealing to a more mature—and Western—audience, director Eiji Aonuma approached series creator Shigeru Miyamoto with his desire to move the game in this direction in terms of both story and art. This was in direct response to the perception that the previous Zelda game, *The Wind Waker*, did not resonate with a significant demographic. The cel-shaded art style made the game appear that it was for children, not the audience that had grown up on Link's adventures. Miyamoto felt that the change would not be enough to bring players back and encouraged Aonuma to also improve upon the gameplay mechanics of past Zelda games.

Among the new features in *Twilight Princess* was horseback combat and the novel inclusion of gesture control via the Wii remote, allowing the player to control Link's sword. As Link explores the land of Hyrule and its twisted counterpart, the Twilight Realm, he changes between human and wolf forms, adding further depth to the gameplay. The dynamic art styles of the light and dark worlds helped to cement a different tone than any other Zelda.

From the expansive and more adult quest to the stunning contrast of light and shadows, *Twilight Princess* presents the familiar adventures of Link in a startling new manner that redefined what it means to adventure in the kingdom of Hyrule.

Expel the spirit above
the treasure chest!

Nice one boss♪

Wiii

Smart!
7000 / 7000
HirameQ
Ⓐ :Next

Zack & Wiki:
Quest for Barbaros' Treasure

2007, Capcom

Zack & Wiki: Quest for Barbaros' Treasure is a tactical adventure that has the player guide the protagonist, Zack, and his faithful flying monkey companion, Wiki, on an adventure to reach Treasure Island. To get there, they must help reassemble the body of the infamous Captain Barbaros, who agrees to take them to the island on his pirate ship. What ensues is a fantastical adventure filled with mind-bending puzzles and devious traps that the player must overcome.

The game's presentation relies on classic adventure stereotypes, from hidden treasure chests and Caribbean-style locales to deadly tropical fauna and pirate patois. The anime-inspired art makes use of deformed proportions to emphasize certain attributes of characters and objects, adding a decidedly Eastern flavor to the pirate-themed setting. The gameplay makes heavy use of the Wii's motion controls as the player is forced to move the controller in the same manner as the actions on-screen: a sawing motion when using a saw, turning the controller when using a key, and so on. This further draws the player into the action in a manner that a standard control scheme could not.

A puzzle game at its core, *Zack & Wiki* share similar mechanics with traditional point-and-click adventures such as *The Secret of Monkey Island*, another pirate-themed adventure game, albeit with a very different style. The unique visuals and the physical interaction of the player set the game apart and mark *Zack & Wiki* as a unique adventure in a sea of standard stories.

Super Mario Galaxy 2

2010, Nintendo

Super Mario Galaxy 2 follows a familiar plot: Mario's nemesis, Bowser, has once again kidnapped Princess Peach and it's up to Mario to rescue her. It is the simplest of motivators, but the story is incidental to the experience. The real substance of the game comes in the joy and wonderment of exploring the worlds laid out by designer Shigeru Miyamoto and his team.

Building on the formula set by *Super Mario Galaxy*, the sequel implements the same planet-traversing mechanic and side-scrolling 2D levels, but includes new power ups that add gameplay techniques to Mario's repertoire; it also reintroduces Yoshi, Mario's dinosaur companion, into the series. *Super Mario Galaxy 2* stands as the distillation of the best gameplay mechanics of all previous Mario games and wraps them in a luminous, candy-colored world that is both wondrous and instantly accessible.

Akin to an interactive diorama, the game effectively communicates the sense of scale in Mario's world. From the opening scenes where a towering Bowser kidnaps Princess Peach to the varied planets Mario explores, nothing feels out of place. The art direction sees a refinement of the iconic character, the environments radiate magically rendered details from lighting to architecture, and the puzzles and obstacles are intuitive but challenging. The result is one of the most critically acclaimed Mario games of all time.

Where many games pull reflection from society, politics, or ethics, Miyamoto's central design philosophy is to observe the world – to look for the hidden in the obvious, to seek adventure, and to smile. *Super Mario Galaxy 2* has no overarching message; rather, it pulls from the heart of the inner child and allows the player to be free to explore fantastical worlds, to delight in discovery, and, quite simply, to feel happy while visiting Mario's world.

Boom Blox

2008, Electronic Arts

Boom Blox, a cross between the block tower game Jenga and traditional target shooting games, utilizes a realistic physics-based engine to power its puzzles, which consist of knocking down or preserving block structures. The game was jointly developed by Electronic Arts producer Robin Hunicke and director Steven Spielberg. Spielberg's intent was to develop games that focused on strategy and creativity that he could play with his children. As such, his involvement as a designer included incorporating his children's suggestions.

The art direction takes cues from building toys like Legos; the environments, obstacles, and characters are all built out of blocks. This informs the rest of the game's world design. The graphics are bright and colorful, and they fit the themes of each level appropriately. The animation truly shines in this physics-based environment. Blocks tumble, collide, and slide with a high degree of realism. The characters that populate each level are a delight to watch as they react to the player's actions, run from falling structures, and sometimes taunt the player. All of this combines to create a sense of living toys that play with you as much as you play with them.

With no deep story to engage in or photorealistic worlds to explore, the goal of *Boom Blox* is really about creating connections with other players, especially young families, by providing a framework that encourages them to be together in the same room, interacting with each other and providing a healthy environment for competition.

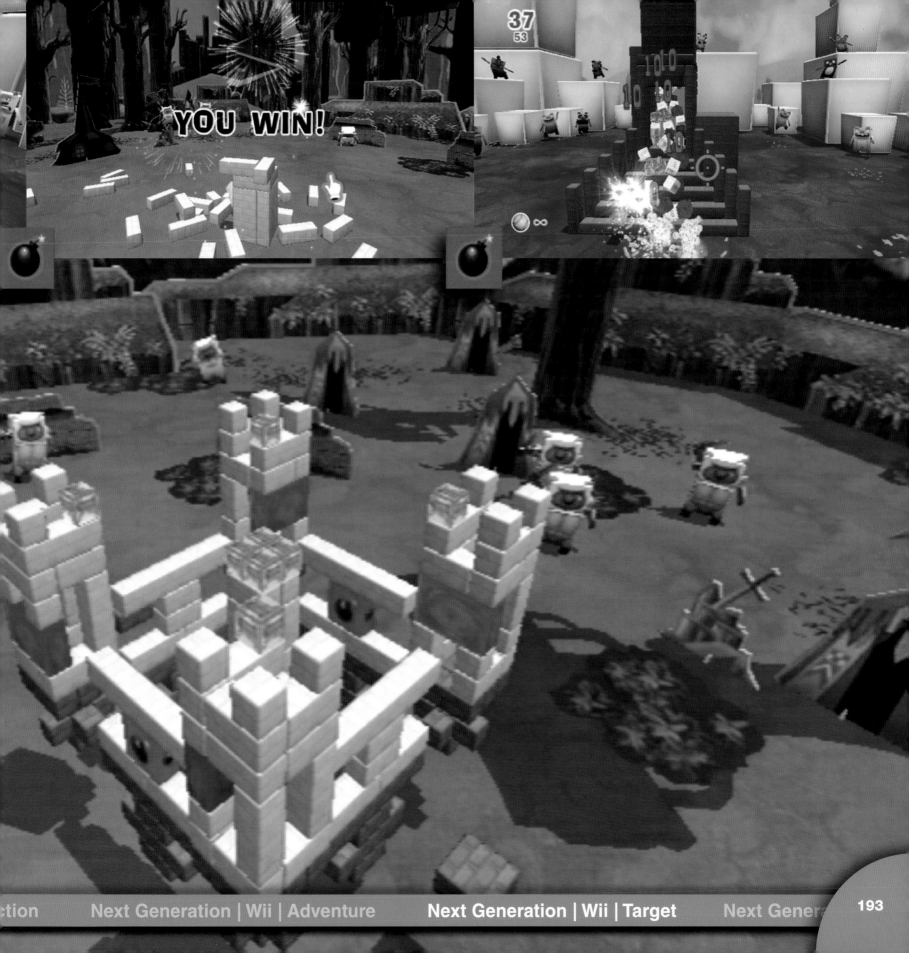

robinhunicke

When I was about seventeen years old I really fell in love with the poems of William Blake because both his writing and his illustrations were beautifully rendered. What could be better than not having to choose between painting and writing to communicate feeling? In my youth I was told you have to pick one thing. The longer I studied and the more I got interested in computers—and the connection between computers, art, and expression—I realized I didn't have to choose if I worked in video games. They connect everything.

What makes games creative as an expressive medium is that they take input from so many different types of people: you have sound designers, you have artists, you have programmers. When you put all those people together, you get a real synergy. The conversation about what's possible goes to the next level. It's not that everyone's a writer or that everyone is a designer, but the conversation about those things together—from all those points of view and all those walks of creative life—makes something that's more than the sum of its parts. The way we make games is like gardening. It's a lot about planting seeds and then seeing which ones grow, because you have to have a lot of people think about the idea and work on the idea for it to thrive. We are a really collaborative industry.

The hardest thing in my experience is collaborating in an effective way, an emotional way, in which you're open to everyone's suggestions, take feedback, and come up with the best idea—not because it's your idea, but because it's the best for the player. We're all complex individuals, and the same thing that makes it fun to play for one person may not work for another,

so it can make it difficult to come to an agreement. But when you are successful, it always has a great impact on the game. There is never a situation where a tense conversation resolves because everyone finally buys into an idea when the idea isn't great. I really believe that. It's all about coming up with the best concept.

Video games have the capacity to connect people and help them share their feelings, their thoughts, and their experiences with each other in a way that's fun, enlightening, and shows their true creative spirit. What we can do as an industry is help create experiences that show us our humanity, show us the value in other people. Our best goals are aimed at helping players understand each other, the way they play, and how important it is to play.

At thatgamecompany we focus on creating experiences that bring something new to our players. That means we have to start with a pretty lofty goal; something that's fresh and different. Our current project, *Journey*, is inspired by the idea that we want humans to connect and feel awe toward one another, to feel that they're small, but part of something bigger. That's a really big concept. The design process helps us take this big concept and mold it. At every stage we hone

in on its core value, the one meaningful piece that we really need to communicate through this work of art. We start out broad, we think about what systems we could create, things for the player to do, things they would feel. Is it walking through sand or hearing the wind? Is it seeing a huge vista and feeling tiny compared to it? Once we think about these things we usually use concept art, but we also use prototypes. We build little programs and test various game mechanics, and then try to actually put them together in the hardware.

At that stage of the process we're thinking about what items we could leave out. What can we take away from these ideas that would make it even closer, even more compressed, like a diamond. As we get toward the end of our process we implement individual pieces of the game and think about pacing—stretching out the narrative through the space. Once we have our systems, our environments, and our experiences, at the very, very end we will play through the whole thing and make sure nothing is broken.

We really care about giving our players the biggest and best experience possible. From the game's graphics and sounds to its controls and puzzles, we want players to feel like we gave them everything. That means you have to carefully consider the technology because it is the thing that gives you the power, but it's also something that can get out of control. We spend a lot of time thinking about the best way to use the technology, how to do the smartest thing in the shortest period of time with the biggest results.

The biggest technological leap that I have witnessed in my lifetime is networking—using games to play with other people over the Internet. Being connected to other people means that we don't have to work so hard at making the other player seem interesting. People are interesting just as they are. We're working

on that in our current project, and I'm really excited about the idea of connection. There was a moment when we were first testing the notion of two people meeting who didn't know each other. In the game you can't speak to each other or chat. The characters are completely mute so they can only indicate to each other or glow. When two players grow nearer to each other, they become physically lighter and will glow more brightly.

There was a moment between the two players testing the game when they were dancing on air together. Neither player had any idea who he or she was playing with, but they both knew no one in the world had seen this experience before. When I saw these two dancing together I realized that this connection is going to be really emotional for someone. Someone out there is going to have a genuine emotional experience because of that first encounter. That really blew my mind.

One of the most important things about games is that they can embrace a player and take his or her input as part of the story. In all the things I've worked on there's been an element of this expression, a personal viewpoint that comes across either in what you build, the way you play the game, or how you interact with another player. That's really important, because your words speak for you when you're with people. When you're playing a game, your actions and your choices should speak for you. *Boom Blox*, for example, had its own level editor. I loved the fact that you can create a tool set, give it to players, and they will impress you, surprise you. They can create something completely new with the tools and the environment that you've created. That's been a huge inspiration for me.

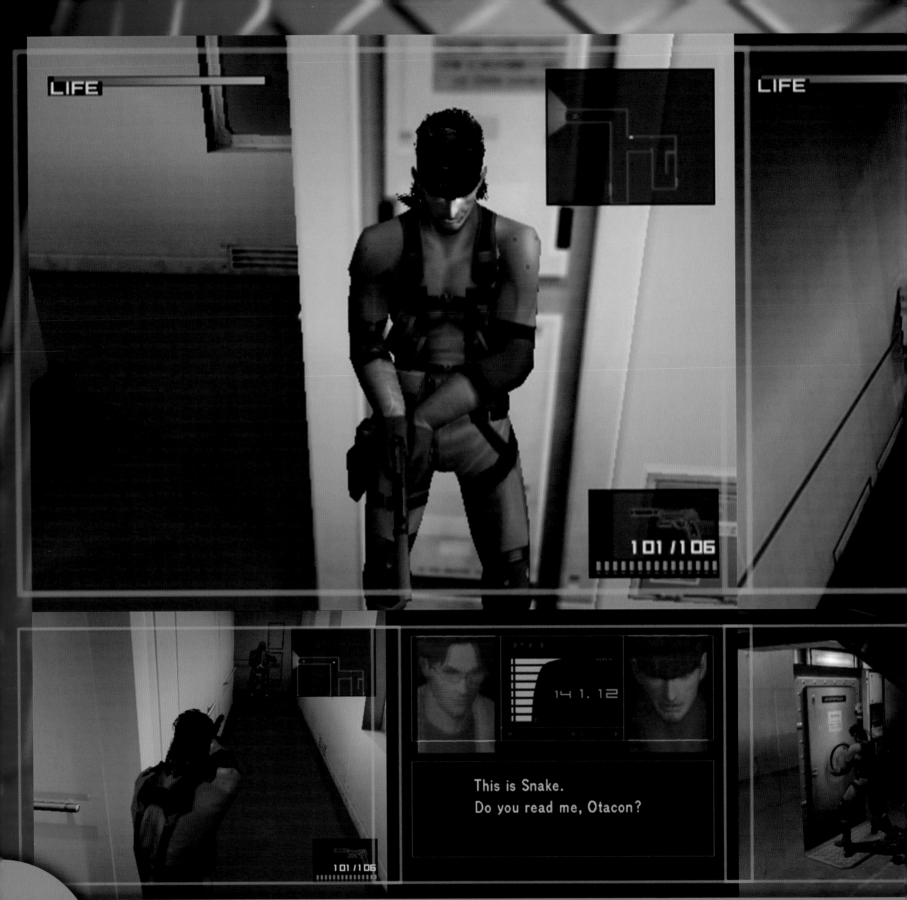

LIFE

LIFE

101 / 106

14 1.12

This is Snake.
Do you read me, Otacon?

101 / 106

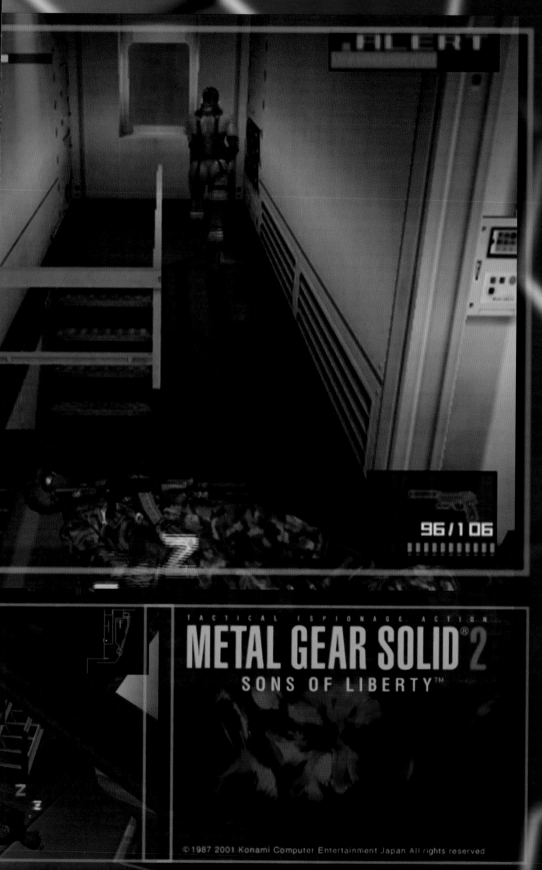

Metal Gear Solid 2: Sons of Liberty

2001, Konami

Metal Gear Solid 2: Sons of Liberty represented a massive leap forward for video games and the stories they could tell. The narrative revolves around series hero Solid Snake and another character named Raiden, who serve as the primary liaisons for the player. Using these two, the player must defeat a radical group known as the Patriots who are bent on eliminating data from the world, acting as digital censors in an attempt to control mankind.

Considered to be the first example of a postmodern game, *Metal Gear Solid 2* deals with artificial intelligence, nuclear arms, political conspiracies, and cyberpunk themes in its narrative, which is antiwar at its core. This is evident in the game's emphasis on stealth and avoidance rather than open engagement and deadly force. Building on the tactical espionage established in previous games, the player may utilize a variety of tactics to overcome conflict and engagement.

There are many echoes of real-world scenarios in the game. References to nuclear weapons inspections in the Middle East and the attack on New York on September 11th were present in the game's development, though some elements were deemed too sensitive at the time of release, and were removed. Influences concerning identity, perceived reality, and social engineering were derived from works like *City of Glass* by novelist Paul Auster.

Metal Gear Solid 2 is also renowned for breaking the fourth wall—the imaginary divider between audience and stage—by having characters acknowledge not only the players but the fact that they were participating in a video game.

Gradius V

2004, Treasure

Gradius V is actually the fourteenth game in the long-running Gradius/Salamander series by Konami. The few plot elements of the story that remain include the origin of the player's ship, the Vic Viper, and the identification of his enemies. Gradius is one of the few long-standing game series that established a set of mechanics that exist in virtually every release today. From the progression of selectable weapons to over-the-top bosses, *Gradius V*'s memorable gameplay continues the tradition set by its predecessors.

When the design team started working on the game, they were faced with a lack of internal resources at Konami. This drove the developers to use an external team to create the game under their direction. They needed a group that had a pedigree in the genre, and they ultimately turned to Treasure, a respected developer of some of the most complex shooters in the games industry. This collaboration brought a fresh perspective on an old series, effectively rebooting it.

The original *Gradius* was an arcade classic, and its gameplay and design helped define an entire genre. *Gradius V* respects the series' origins while wrapping itself firmly in the improved graphics and sound made possible by the PlayStation 2. It's a frenetic, intense, and challenging experience that makes it not just a tribute to the original but another classic of the genre.

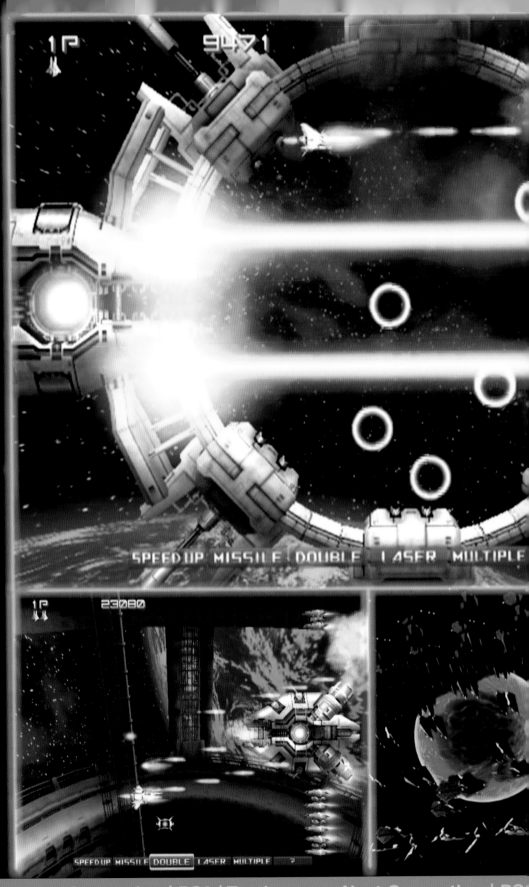

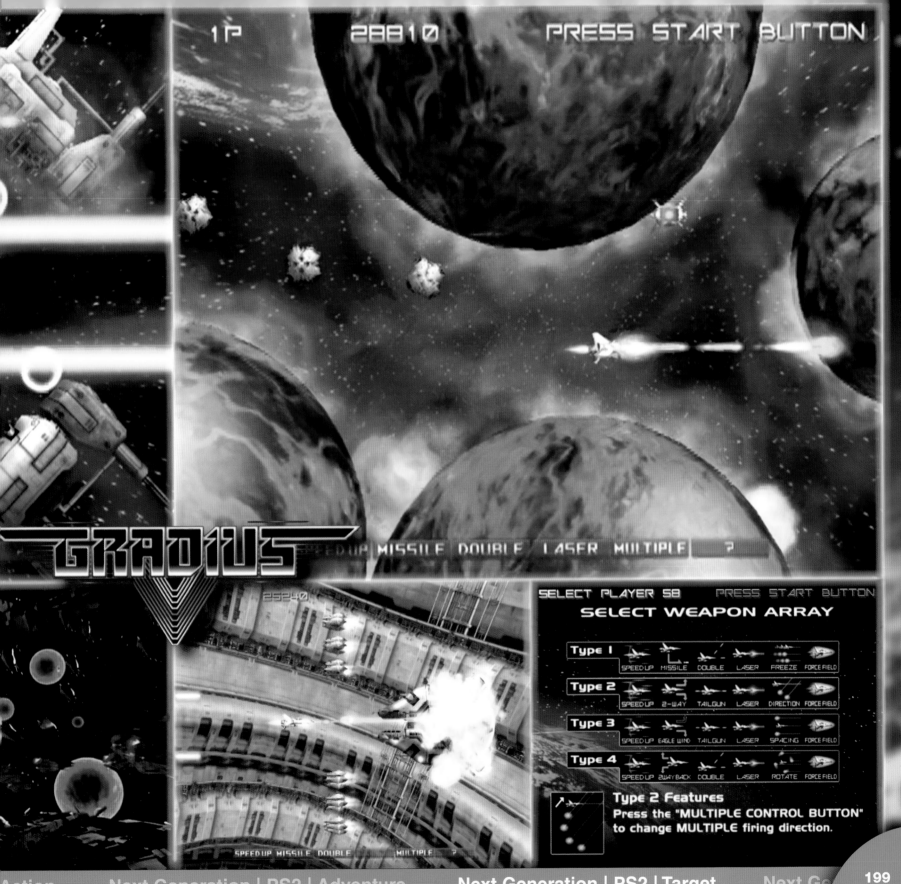

Shadow of the Colossus

2005, Team ICO

Shadow of the Colossus was the second game from developer Team ICO and is regarded as the spiritual successor to their first game, *Ico*. The game focuses on a young man named Wander who seeks to revive the body and spirit of his girlfriend, Mono. In a deal with a deity known as Dormin to bring the girl back from the dead, Wander sets off to strike down sixteen enormous creatures called colossi that inhabit a barren terrain known as the "forbidden land," as their souls contain a portion of Dormin's own essence. If Wander is able to complete the task, Dormin will bring Mono back from the dead.

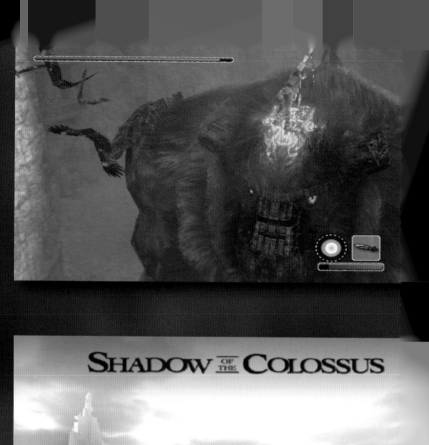

Shadow of the Colossus is a game of contrasts. The adventure frames the conflict of the protagonist against a beautiful but barren environment that lacks any inhabitants apart from Wander, his horse Agro, and the colossi that Wander hunts. Traversing the ancient, empty world evokes a feeling of isolation for the player that only increases as the expansive terrain is slowly revealed, and the quest becomes more desperate. The minimalist design—including a lack of music during travel— provides tension and a mood of ghostly presence.

Upon discovering the various colossi, the player may expect to be awed by their massive size and the fantastic character designs that makes them believable as living, breathing entities from a different world. While each colossus presents a different challenge in how to defeat it, they share many similarities. The player must scale each colossus and determine the appropriate area to inflict damage.

Shadow of the Colossus realizes its true potential in the rift that the game creates between the player's intentions and the consequences of his or her actions. Despite their magnitude and odd forms, each colossus that falls at the player's feet creates a sense of something wondrous lost to the world. This dichotomy is made all the more powerful when set against the pristine, haunting landscape.

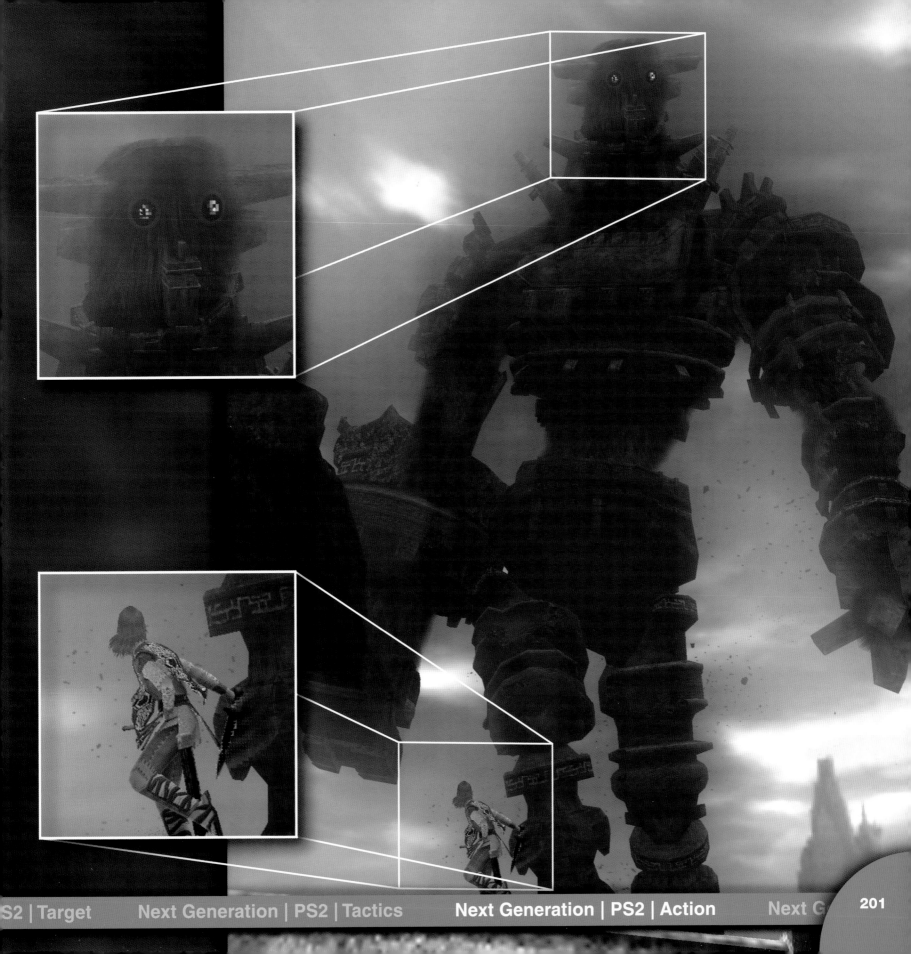

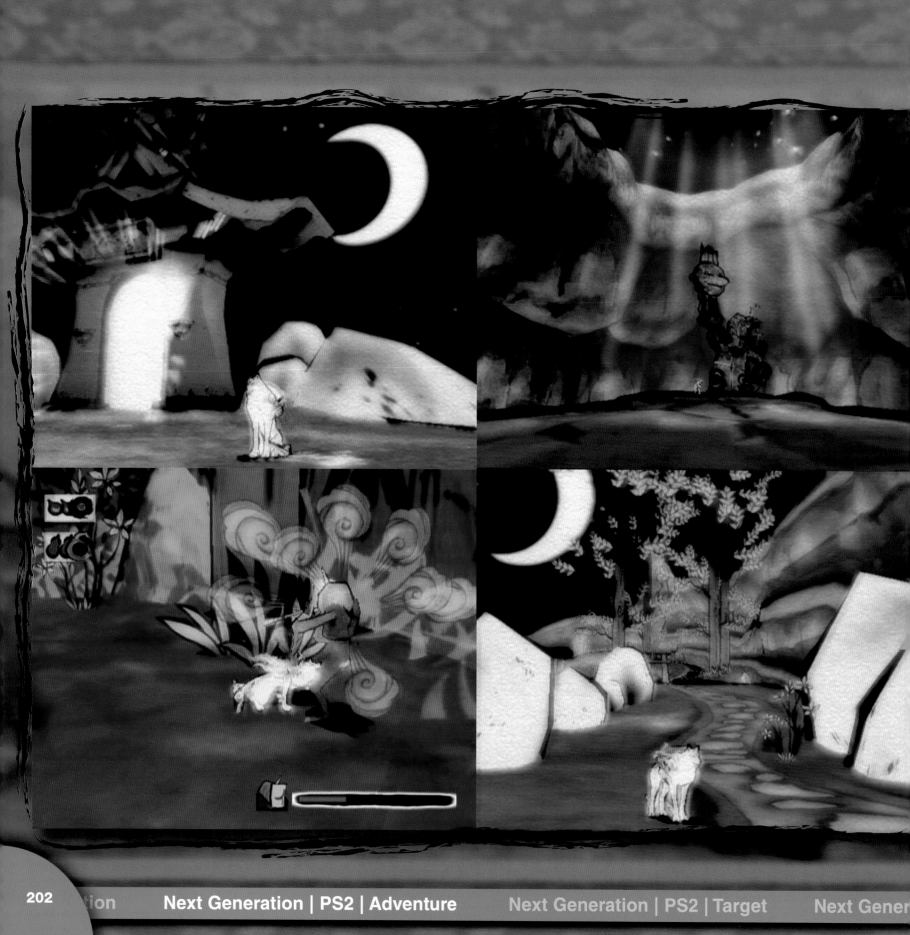

Okami

2006, Clover Studio

Okami is one of the purest examples of traditional art and storytelling in a modern video game. Taking the form of a white wolf god, Amaterasu, the player must rid a fictionalized historical Japan from the curse of the demon Orochi, defeat the demon Yami, and restore life to the land. The game used a variety of art styles and techniques that set it apart from its contemporaries.

Marrying a woodcut aesthetic and an ink wash style known as sumi-e, *Okami* looks like an ancient Japanese watercolor come

to life. Derived from those art choices, the concept of a "celestial brush" became central to the gameplay. This brush is called up by the player and used to paint kanji characters in the game playfield in order to perform certain acts or summon mystical powers. This control mechanic is a unique and creative element that smartly played off of and enhanced the aesthetic qualities of the game.

Designer Hideki Kamiya originally wanted to use photorealistic graphics for the game but found that they did not suit the sumi-e style essential to conveying the effect of nature regenerating. The PlayStation 2 was also not equipped to render the photorealistic environments that Kamiya desired, and so *Okami*'s art direction was sealed.

Much like the earlier adventure game *Pitfall!*, Kamiya started the game ideation for *Okami* by animating a single character running around in a jungle, with no clear reason why the player was there. The story slowly emerged from the environment while the gameplay mechanics developed as a result of the aesthetic decisions and system limitations of the PS2.

Uncharted 2: Among Thieves

2009, Naughty Dog

Uncharted 2: Among Thieves puts players in the shoes of treasure hunter Nathan Drake as he sets out on a globe-trotting adventure centered on Marco Polo's failed voyage of 1292. Drake was designed as the ultimate everyman, drawing influences from characters including Lara Croft and Indiana Jones as well as actors, such as the charm of Cary Grant and the attitude of Bruce Willis. Striving to develop a strong and relatable character capable of carrying a series, the game's creators took a tremendous amount of care and research for the amalgam that became Nathan Drake.

One of the more striking elements of *Uncharted 2* is the attention to detail in the characters' acting. To achieve a cinematic quality in the dialogue and action, the game's voice actors rehearsed together before recording in order to keep the pacing and tone accurate. For some scenes, they were recorded using motion capture technology to translate their physical

movements into the digital world. This increased use of actors to invigorate the narrative was uncommon, even in games with significant speaking parts.

Uncharted 2 is visually informed by the exotic locales of the narrative, which takes players to Peru, Istanbul, and Nepal. Due to the power of the PlayStation 3, creative director Amy Hennig was able to render the environments in a photorealistic manner with an extraordinary attention to detail. The locations take on a personality of their own, and Nathan's body responds fluidly to the numerous obstacles. From climbing to wading to sliding down a zip line, the animations of Drake's actions fit each environment well.

While there have been countless adventure games that focus on fortune hunting, *Uncharted 2* breaks new ground in art, animation, and acting, effectively bringing the player into an interactive movie instead of just an action game.

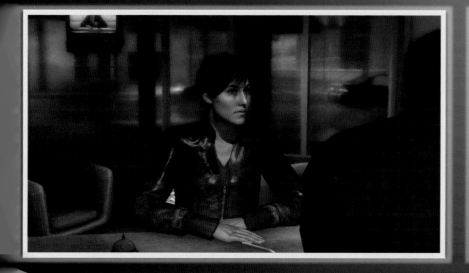

Heavy Rain

2010, Quantic Dream

Heavy Rain drops the player into the dynamic world of an interactive drama, alternating among the stories of four player-controlled characters who are linked to the crimes of the "Origami Killer," a serial killer who leaves each of his victims—all young boys—clutching an origami figure and with a single orchid placed over their hearts. The method of murder is always the same: drowning from a deluge of rainfall, which sets the stage for *Heavy Rain*'s story.

Director David Cage wanted to make a game that would force the player to "play the story"—one that would make the story essential, not simply a convenient reason for the players to engage in action. With narrative as the focus, Cage describes the motivation for the player as revolving around the perceptions of the main characters' actions and the moral choices the player has to make. The choices are not about selecting between good or bad actions but finding the balance between the two.

Influences in the game come from real-world settings, such as areas of low-income housing in Philadelphia, where Cage and his team shot photographs for use in developing the environments. The photorealistic characters put the power of the PlayStation 3 to excellent use, and the astonishing details, such as the reflections in characters' eyes and the depth and variety of skin tone, aid in creating believable, relatable digital actors previously unseen in video games. Similarly, the lighting and detailed environments help suspend disbelief and immerse the player in the tense story.

While video games often create narratives solely to support an underlying game mechanic, *Heavy Rain* relies on the opposite. A gripping and disturbing adventure, the game emphasizes moral choices that ultimately affect the outcome and the digital entities the player has developed a connection with. Never apologetic, *Heavy Rain* asks how far you would go to save someone you love, and it does not shy from the player's response.

Brütal Legend

2009, Double Fine

Brütal Legend transports players to a world of heavy metal music and a fantasy adventure only glimpsed through the gloriously sinister artwork of countless album covers. The game is less a parody and more of an homage to the culture, crafted with genuine love and affection for the music by game designer Tim Schafer.

Band roadie Eddie Riggs is pulled into a heavy metal universe after being injured in a stage accident. In this alternate world the player must help Eddie battle his way through the universe and overcome the Emperor of the Tainted Coil, Doviculus, thus freeing the land's inhabitants from his tyrannical rule. The adventure is littered with all manner of metal stereotypes from images of mountains made of bones to the flowing hair of headbanging singers.

The art design is a mix between anime-style super-deformity and the influences of fantasy artists such as Frank Frazetta and Derek Riggs, who provides Eddie's namesake. The exaggerated characteristics provide a cartoonish look to the main characters, bringing an element of humor to the often dead-serious and twisted world of heavy metal art. Eddie is modeled after and voiced by actor Jack Black, and *Brütal Legend* contains appearances from other real-life "rock gods," including Ozzy Osbourne, Lita Ford, and Rob Halford, along with other actors such as Tim Curry. With a track list of more than one hundred songs from seventy-five bands and over thirty-five thousand lines of dialogue, the game's sound design is appropriately potent.

Brütal Legend transcends its parts to become something more; it pokes fun at yet respects the source material from which it came. Focusing on the performance of the characters and the humorous dialogue, *Brütal Legend* makes the grave, foreboding worlds illustrated on heavy metal albums and custom-conversion vans inviting, approachable, and fun.

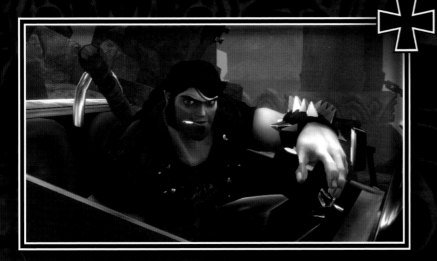

timschafer

I've been playing video games since I was very young—when my dad brought home a Magnavox Odyssey, which is very, very old. I got my own computer at a young age. I began programming and tried to make games, if not very successfully, but I was experimenting and still doing my own thing. It was a private activity; I was from a large family and was the only person very interested in technology and computers. I was the youngest of five kids, so I never got to choose what was on television; I couldn't choose where we went in the car or what we had for dinner—but no one else used the computer. I had my own world that I could mess around in with little characters and fantasy situations.

As I got older I thought I would become a writer. One of the reasons was because of Kurt Vonnegut. In high school I read his take on the world—which was both really sad and really funny at the same time—and it stuck with me. Every story I've ever told has had a sad part to it and a funny part to it, and I think that's just the way life is. So I always imagined I would write short stories for a living. I already knew how to program, though, so I picked that as a major in college. I studied programming and creative writing in college, and when I graduated I had no idea what to do with my life. I happened to see a job listing for a programmer who could write well, and I lucked into a job. My career started from there.

One of the first games I worked on was *The Secret of Monkey Island*. We were writing dialogue for it—test dialogue, we thought—because we were just learning how to program. So we were putting together scenes and inserting ridiculous dialogue because we thought it would be replaced. Then Ron Gilbert said, "No, no,

no, we're going to use that. That's the dialogue." This stupid dialogue, where we're telling modern-day jokes and making all sorts of non-pirate references? "Yeah, it's funny. We're going to leave it that way."

In *Monkey Island*, some of the cannibal dialogue came from the fact that my family was really interested in health at the time, so they talked about red meat a lot. It was the topic of discussion for my family at dinnertime. Indeed, you can find inspiration anywhere. A lot of my game ideas and environments are inspired by movies. *Casablanca* obviously was a huge influence on *Grim Fandango*. Film noir was a big influence on me in general. I made a game called *Brütal Legend*, which was about a fantasy world of heavy metal album covers, which came from my own teenage years listening to Ozzy Osbourne.

Grim Fandago was the first 3D game I'd made. I didn't like the way the early 3D appeared; it always looked like someone had printed an image of a body or face on some nylons and then stretched it over a bunch of cardboard boxes. It looked bad. But then I was looking at some calaveras, which are papier-mâché skeletons with bones painted on them, and they reminded me of what early texture mapping looked like. I was wowed; we could make a game with that weird 3D look, but

one that shows we're actually doing it on purpose. So sometimes you take technology, or the limitations of it, and use it to create a style.

In general I don't think technology has been a major inspiration for me. As with anything, ideas are the main source that progresses the games. You could have made *Tetris* on the Atari 2600, for example. It wasn't technology keeping this game, one of the most popular games of all time, from happening; it was just the idea. Someone hadn't had the idea at the time. Every round of technology will bring new games that wouldn't have existed before, but for the things I care about, story and character, they can be done in text or using technology that we had twenty or thirty years ago.

I've always been interested in narrative. It's fun to try to pull off in a video game world, because you're always wrestling to make something that's completely interactive but with a crafted element to it. I focus on a game's environment. I want people to get sucked into that world and stay there. Story, gameplay, beautiful art, and great sound—all these things are just tools to hook the player, to get her to come into your world and stay there for as long as she can.

I'll always remember when *Super Mario 64* came out. It was the first time I felt like I was freely exploring a 3D space. And I wasn't thinking about the technology, the 3D-ness of it, but rather the fact that it felt like a real place. That was always the dream, to go into an imaginary, virtual place inside the machine. Here I was running around a castle, and I was truly mentally transported to another place.

It was one of the first times in which I would think about the game when I wasn't playing it, and I wanted to go back to that world. That's one of the strongest feelings you can get when you're playing video games.

That's what you try to achieve with every game you make, a world so real that people miss it when they're not playing.

Life is broad, and games are very narrow right now. If we were to compare games to the movie industry, a lot of our current products are like summer action blockbusters. There are a lot of things that movies can be—from comedies to Victorian costume dramas. Similarly, there are a lot of things that could be done in games but aren't yet. Consider the emotional life of the average person. There are so many experiences that happen during one's day that we don't talk about in games, because it's hard to translate them into an action sequence, say. Designing ways of interacting with subtle emotions or experiences would be a way of expanding games' potential, certainly more than what they offer right now.

My daughter is only three. I like to show her what I do all day, so I bring games home and play them in front of her, and I try to teach her to use them. Video games can work just like all games, which are in some ways practices for real life. I can hear my daughter talking to her dolls, going through pretend situations with them: they're happy, they're sad, she wants them to cry. She's practicing emotions and doing all the things that games in general help you do. I think video games could do the same thing. Maybe not in their current form, but they could be a way of practicing things you can't do or cannot yet act out in your life.

What the video game industry needs are different points of view, different voices, making all kinds of games. That's how their potential will be fully realized.

Flower

2009, thatgamecompany

Part *Pac-Man,* part poem, *Flower* is a game that stands apart from almost every contemporary game in its genre. With the wind as the protagonist, the goal is to breathe life into the world. This is accomplished by guiding a stream of wind toward flowers that are found strewn across the environments. As more flowers are touched, the more petals are released to join the wind stream and heal the world around them. Grass grows, buildings straighten and regain their color, and life springs forth.

The inspiration for *Flower* comes directly from designer Jenova Chen's experience moving from his home in Shanghai, China, to California. Growing up in an urban landscape, he had never experienced the dynamic natural expanses that he found in California. Described by Chen as an interactive poem exploring the tension between urbanity and nature, the goal of the game was to allow players, weary after a long day of work, to bring nature into their home in a manner never before experienced.

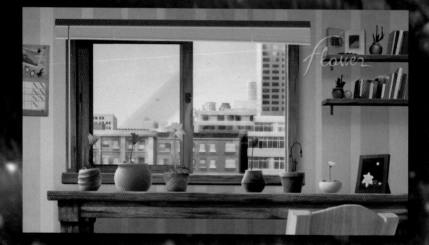

Replicating the sense of flying low to the ground, soaring high to marvel at the rolling hills, and getting lost in nature in general, *Flower* brings a sense of peace, wonder, and even sadness to those who embrace the experience. Luxuriant, vibrant visuals animate the dense collection of grass that is parted by the wind in the pursuit of releasing beauty to the landscape.

The musical score highlights different instruments for each level, the composition of which is revealed as players release petals to the wind. All of this serves to develop an emotional arc rather than a narrative one.

Beautiful to behold and capable of instilling a sense of peace and joy, *Flower* is an experience that hangs somewhere between poetry and dreaming, a moving journey that evolves the idea of play.

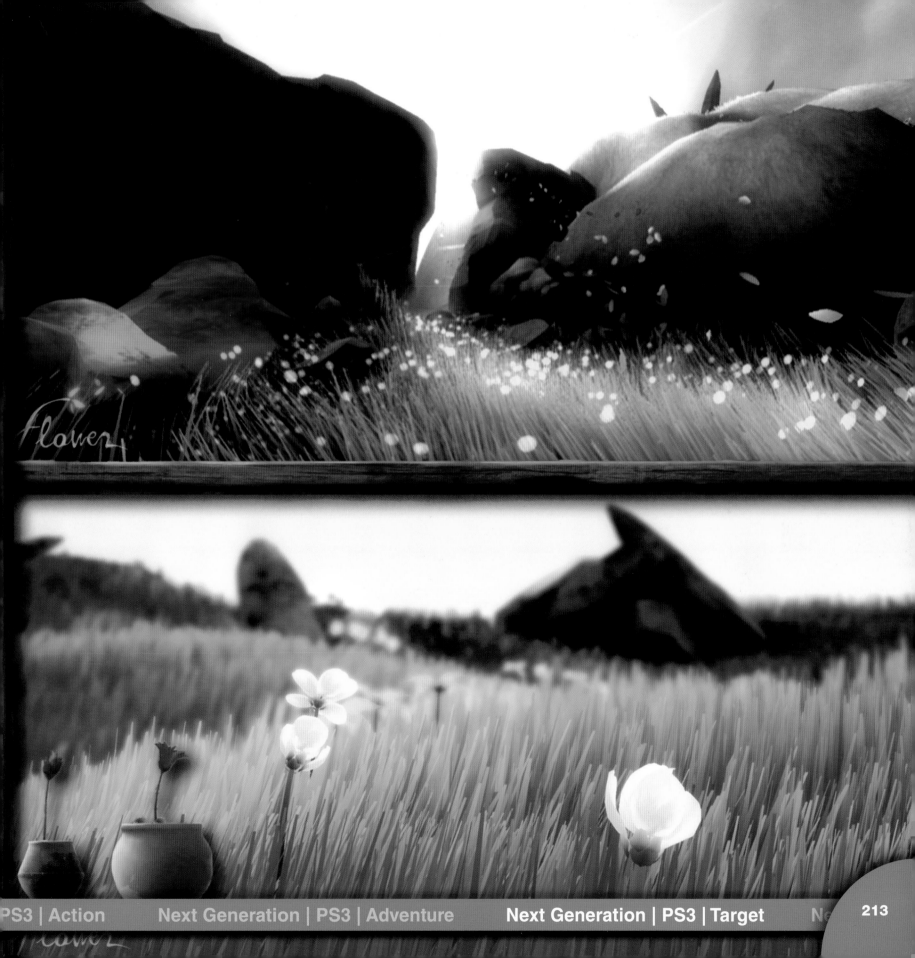

Flower

acknowledgements

Thanks to Pat for agreeing to work on this book with me. It is a rarity to work on something so meaningful with such a close friend. Thanks to my mom, Nancy Medford, for purchasing the VIC-20 for Christmas in 1980. It was the spark that ignited my love of computers, programming, and video games. Thanks to all of my family and friends who have given me support and words of encouragement throughout this project: my sister Stephanie and her husband Ed for the sweet Colecovision collection; my brother Ryan for the second Dreamcast and the PlayStation, as well as some memorable video game marathons; Mark DeLoura for the late-night rant sessions.

Thanks to Mike Mika for my Syzygy Pong board and for starting my mind racing about the preservation of video games after visiting your amazing video game room. To Chris Charla for many ideas, words of encouragement, and Incredibly Strange Games. To Meggan Scavio and the extraordinary team at Game Developers Conference for their support. To the Retronaut Podcast for keeping the fire alive for classic video gaming. To Seth Sternberger and 8-Bit Weapon for access to Commodore 64 gear and the amazing theme song! To Ralph Baer for creating the first home video game system. To Nolan Bushnell for making video games part of American culture. To Scott McNealy for taking a chance on me and allowing me to pursue the video games industry on behalf of Sun Microsystems. And to all of the video game designers, artists, and creators that pour themselves into their craft – your efforts have provided countless hours of laughter, excitement, and reflection. For this, I humbly thank you.

I would like to thank all of the staff at the Smithsonian American Art Museum for their support and belief in this exhibition, with special thanks to Georgina Goodlander, Betsy Broun, Michael Mansfield, David Gleeson, Dan Sonnett, Rachel Allen, Carlos Parada, Alyssa Reiner, Elaine Webster, Laura Baptiste, Rachel Mattos, Rachel Utsch, Ellen Paige Jones, and Claire Larkin. Your dedication, support, and belief in what I was trying to achieve with this exhibition means more to me than you know, and I feel privileged to have had the opportunity to work with such an extraordinary team.

Special thanks to Gavin O'Connor and Clark Wakabayashi from Welcome Books. Your support and efforts made this book a reality. You guys rock!

Most importantly, to my wonderful wife Michelle, I thank you for the patience, love, and support that allowed me to pursue the job of my dreams, the hobby of a lifetime, and an exhibition that enabled me to give something back to a group of artists and designers that have given so much to me. You are an amazing woman and I am lucky to have you in my life.

And to my three children—Alexandra, Melina, and Thomas—thank you for your hugs, your love, your laughter, and sharing in this journey with me. Remember, if you care enough about something, and work hard, you can achieve great things! I love you all!

—CM

Thanks to Chris, for involving me in this project. You are an inspiration to me in business, as a father, and as a person. Thanks to Mom and Davis for your continual love and support. Thanks to my little sis Tara and the most awesome niece and nephew in the world, Sara and Cody Hahl! Love you guys!

Thanks to Dean and Davis Factor for giving me a shot to learn and do something creative when they had absolutely no reason to do so. To Emily, Daniel, and Shannon Factor for your countless words of encouragement and love. And to my future in-laws Ernest, Aida, Andrew, and Ernie Coilette, for all of your kindness and for convincing Michelle that I'm good enough for her!

Thanks to Aaron "Cpl Hotpants needs a tail gunner" Missner and our time in Police Quest and Tribes 2. Thanks to Chris Rose for at least one hundred hours of GoldenEye and Halo mayhem. Thanks to Daniel Gomez for even more Halo and Portal 2 fun.

Big thanks to all the girlfriends and wives that let us play: Michelle Melissinos, Pam Missner, Missy Rose, Tina Gomez, and my Michelle. Our uncountable hours in World of Warcraft together are some of my fondest gaming memories. I love you all.

—PO

credits

BioShock and Sid Meier's *Pirates!* images courtesy of 2K Games, Inc, and Take-Two Interactive Software, Inc.

Pitfall! and *Pitfall II: Lost Caverns* courtesy of Activision Publishing. All trade names and trademarks are properties of their respective parties. All rights reserved.

Combat © 1978 Atari Interactive, Inc.

Fallout and *Fallout 3* courtesy of Bethesda Softworks, a ZeniMax company.

StarCraft © 1998, Blizzard Entertainment, Inc. All rights reserved. StarCraft is a trademark or registered trademark of Blizzard Entertainment, Inc. *Diablo II* © 2000 Blizzard Entertainment, Inc. All rights reserved. Diablo is a trademark or registered trademark of Blizzard Entertainment, Inc.

1943: The Battle of Midway, *Okami*, and *Zack & Wiki: Quest for Barbaros' Treasure* courtesy of Capcom Entertainment, Inc.

The Bard's Tale III: Thief of Fate, *SimCity*, *SimCity 2000*, *Mass Effect 2*, *Lord of the Rings: The Battle for Middle-Earth II*, *Boom Blox*, and *Brütal Legend* © 2010 Electronic Arts, Inc. All trademarks are the property of their respective owners.

DOOM II courtesy of id Software, a ZeniMax company.

Advanced Dungeons & Dragons, *Star Strike*, and *Utopia* courtesy of Intellivision Productions, Inc. *TRON: Maze-a-Tron*, Intellivision Productions, Inc. Courtesy of Disney.

Metal Gear Solid © 1990 Konami Digital Entertainment. *Metal Gear Solid 2: Sons of Liberty* © 2001 Konami Digital Entertainment. *Gradius V* © 2004 Konami Digital Entertainment.

Fable and *Halo 2* © 2004 Microsoft Corporation. All rights reserved. Used with permission from Microsoft Corporation.

Minecraft courtesy of Mojang Specifications, copyright Notch Development AB.

Pac-Man TM & © NAMCO BANDAI Games, Inc.

Metroid Prime 2: Echoes, *Pikmin 2*, *Super Mario 64*, *Super Mario Brothers 3*, *Super Mario Galaxy 2*, *Super Mario World*, *Star Fox*, *Star Fox: Assault*, *The Legend of Zelda*, *The Legend of Zelda: A Link to the Past*, *The Legend of Zelda: The Ocarina of Time*, *The Legend of Zelda: Twilight Princess*, and *The Legend of Zelda: The Wind Waker* courtesy of Nintendo of America, Inc.

After Burner, *Chu Chu Rocket!*, *Gunstar Heroes*, *Panzer Dragoon Orta*, *Panzer Dragoon Saga*, *Panzer Dragoon II: Zwei*, *Phantasy Star*, *Phantasy Star IV*, *Rez*, *Shenmue*, *Sonic Adventure*, *Star Trek*, and *Zaxxon* provided courtesy of SEGA Corporation. © SEGA. All rights reserved.

Flow, *Flower*, *Heavy Rain*, *Shadow of the Colossus*, and *Uncharted 2: Among Thieves* courtesy of Sony Computer Entertainment America LLC.

Tomb Raider © 1996 SQUARE ENIX CO., LTD. All Rights Reserved. *EINHANDER* © 1997, 1998 SQUARE ENIX CO., LTD. All Rights Reserved. *FINAL FANTASY VII* © 1997 SQUARE ENIX CO., LTD. All Rights Reserved, character design: Tetsuya Nomura. *FINAL FANTASY TACTICS* © 1997, 1998 SQUARE ENIX CO., LTD. All Rights Reserved.

Jumpman courtesy of System 3.

Space Invaders © 1980 TAITO CORPORATION. All Rights Reserved.

Worms Armageddon courtesy of Team 17.

Tom Clancy's Splinter Cell © 2010 Ubisoft Entertainment. All Rights Reserved. Splinter Cell, Splinter Cell Conviction, Sam Fisher, the Soldier Icon, Ubisoft, Ubi.com, and the Ubisoft logo are trademarks of Ubisoft Entertainment in the U.S. and/or other countries.

Portal © Valve.

Published in 2012 by Welcome Books®
An imprint of Welcome Enterprises, Inc.
6 West 18th Street, New York, NY 10011
(212) 989-3200; Fax (212) 989-3205
www.welcomebooks.com

Publisher: Lena Tabori
Project Editor: Gavin O'Connor
Designers: Patrick O'Rourke and H. Clark Wakabayashi

For credits related to the video game art, see page 215.

Library of Congress Cataloging-in-Publication data on file.

ISBN 978-1-59962-110-4

For more information about this book, please visit:
www.welcomebooks.com/artofvideogames

First Edition
Printed in South Korea
10 9 8 7 6 5 4 3 2 1